LEAPING TALL BUILDINGS

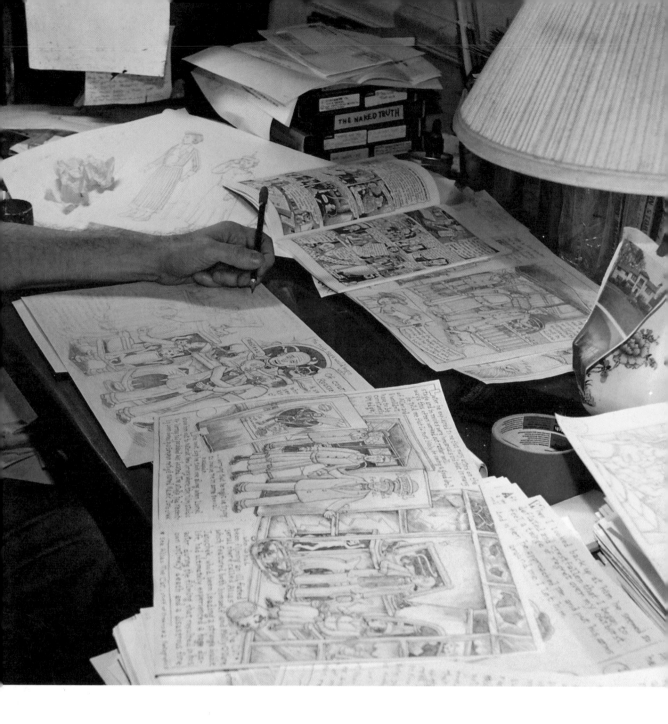

LEAPING TALL BUILDINGS

Kim Deitch's work space, NYC, 2008

The Origins of
American Comics

CHRISTOPHER IRVING *words*
SETH KUSHNER *pictures*

ERIC SKILLMAN *design*　　**TOM DE HAVEN** *foreword*

CONTENTS

Jeffrey Brown drawing Change-Bots, Chicago, IL, 2011

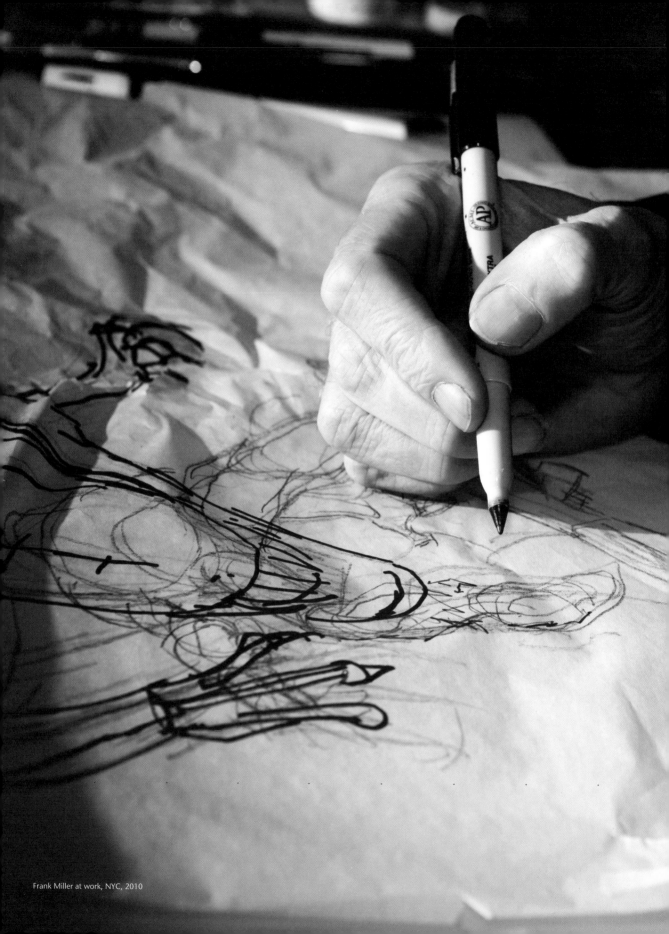

Frank Miller at work, NYC, 2010

FOREWORD *by Tom De Haven*

My heroes have always been cartoonists. Growing up in the late 1950s, early '60s, I couldn't have told you who pitched for the Cubs or the Yankees or named the original seven astronauts, but I sure could've told you who drew every single comic strip (even the ones I didn't like or follow) in the daily newspaper and named the creators of virtually every comic book jammed into drugstore spinner racks—or at least I could've for those comic books that actually included credits. When I was about ten, my mother told a friend of hers, "Tom wants to be Chester Gould when he grows up!" No, Mom! I didn't want to *be* Chester Gould—what did she think I was, an idiot?—I wanted to draw comics *like* Chester Gould: I wanted to be a cartoonist. Never happened, but my obsession with the profession of cartooning and with those who follow the calling has never left me. Never.

Over the years I've been fortunate to have met and talked with a good number of cartoonists, even chatting briefly on the telephone, twice, with Gould himself during the last year or two of his life; he was very ill at that time, and a bit confused, but by God did the man ever come to voluble life the moment I mentioned his creation of the two-way wrist radio! (When I met Art Spiegelman in May of 1985, the first thing he said to me, even as we were shaking hands, was "Did you hear that Chester Gould died yesterday?" and instantly I knew we were going to hit it off just fine.) Point is, I love hearing cartoonists talk about what they do and how they do it, telling (or better yet, *swapping*) stories about themselves and their careers, their predecessors, their collaborators and peers, their friendships, feuds and vendettas, and, of course, their "business," the business that can lead its practitioners to veneration or obscurity, splendid studios in cliffside mansions, or an early, boozer's grave.

If you really want to know what it's like to make comics day after day, year after year, either follow the calling yourself (good luck!) or else clear your calendar for the next several months and arrange to sit down with, oh, 50 or so of the very best working cartoonists in the world and just…listen. Closely. You can do that or you can just turn the page: because Christopher Irving has done the careful listening for you, and Seth Kushner—what a photographer!—has created a stunning album of accompanying portraits. I've pored over my fair share of books about comics and their makers, but I've never seen one quite like *Leaping Tall Buildings*.

Despite its subtitle, this isn't just another book about the "origins" of American comics, although it certainly covers that, as well as the maturation and various branchings of the art clear through to the digital age. Really, and most valuably, this is a book (and a gorgeously designed one, I might add) about the myriad sorts of concentrated and specialized *thinking* that goes into the creation of comics, thinking that is articulated throughout with vitality, humor and unfettered personality by dozens of consummate professionals.

Now go, hang out with some heroes.

Tom De Haven is the author of eighteen books including the Derby Dugan Trilogy of novels, *It's Superman!*, and *Our Hero: Superman on Earth*.

Joe Simon's art supplies, NYC, 2009

The 1930s were the turbulent decade that redefined American culture, as the country was thrust into the Great Depression. Sparked by the stock market crash of October 1929, many Americans found themselves jobless, homeless, and hopeless. Because of the social strife, a new popular culture emerged that looked to the future with the optimism hard for America's citizens to find in their everyday lives of poverty and social turmoil. Escapism was the only medicine that Americans could afford; because of this, desire for fantastic stories, film, radio, and comic strips thrived.

The daily comic strips (printed in large, black-and-white tiles during the week, and in vibrant color on Sundays) became the nation's uniting form of entertainment, reflecting the harsh life of the Great Depression's landscape in the socially relevant *Little Orphan Annie*, or depicting a more glorious tomorrow in *Buck Rogers*. As early as the 1920s, comic strip story lines were printed and bound between two covers as collections, and by the early '30s, there were a couple of attempts at packaging original comic strip material. This new hybrid form, the comic book, quickly took root on the newsstands as cheap entertainment for kids.

Publishers cropped up left and right, some in offices that were literally old broom closets, a few with bona fide offices, and many from dubious backgrounds. The publishers had no problem with disappearing before paying, nor did they usually care about the quality or content—what they did care about, however, was ownership of the characters and strips and making a fast buck.

The talent creating these new comic book stories were either high school kids or washed-up illustrators. Soon, these legions of young comic book artists, feeling out their growth in the industry's own awkward puberty, began grouping up in studios designed to solely package material for publishers or finding spots in assembly-line styled "bull pens."

But the real success behind the comic book, the one thing that arguably saved the industry, time and time again (and has bogged it down just as many times) debuted in 1938, on the cover of DC's *Action Comics* #1. Clad in blue with red trunks, boots, and cape, stood Superman, hoisting a car over his head as if it were made of papier-mâché.

The superhero was born, and his blend of pulp and comic strip action would quickly dominate this developing four-color storytelling medium. Other genres would emerge alongside it, as this bastard medium of junk culture would eventually grow up and become an art form without parallel.

These are the pioneers of the medium and their stories, both tragic and triumphant, starting with two dreamers in Cleveland, Ohio…

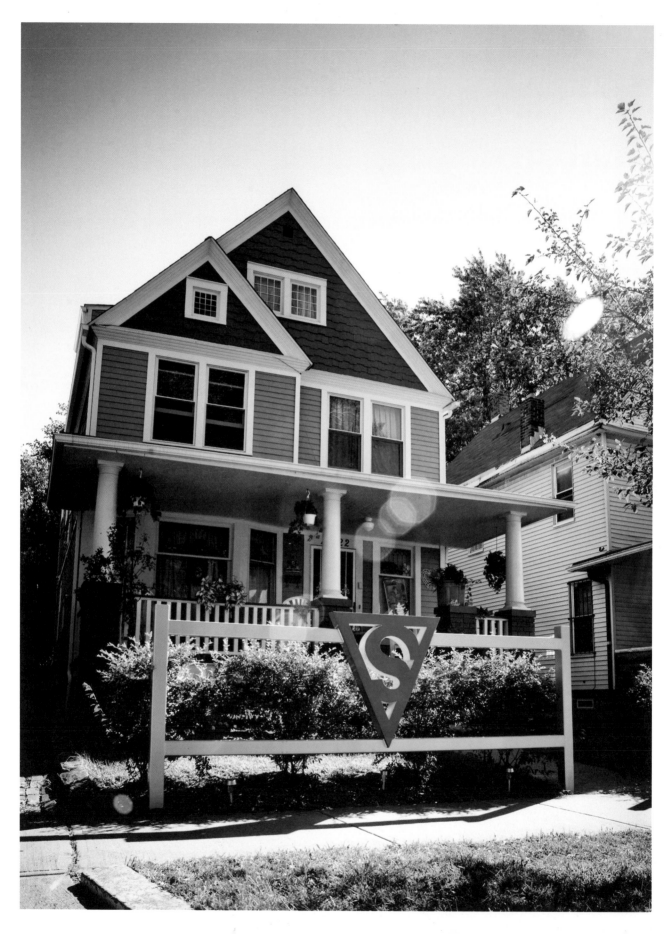

Superman didn't work just because of Jerry Siegel's clever writing, or Joe Shuster's awkward art style.

The frenetic and contagious energy of those early stories and their inclusion of the reader as Superman's pal—in on the dual identity gag as Lois shuns milksop Clark Kent, not knowing (like we do) that underneath his suit lies the Man of Steel's distinctive costume.

Introduced by Jerry's cousin in Cleveland, Ohio, the two bonded over their mutual love of science fiction and comic strips. Together, they created their own pulp stories and strips, including two stabs at a "Superman"—one a villain, the other an adventurer. Then, there's Jerry's grand tale of Superman's 1934 genesis: the story Jerry told time and again was of waking up in the middle of the night, writing all night, and then rushing to Joe's house in the morning to create Superman.

They sold the strip idea for $130 as a comic book and signed away all rights. When *Action Comics* #1 came out in 1938, Superman was the cover boy, holding an auto over his head as panicked onlookers fled away towards the viewer. Superman's success put the costumed hero in charge of the comic book medium, and Jerry and Joe found themselves busier than ever, having to hire out assistants in Cleveland to produce enough Superman stories to keep National happy.

As Superman continued to succeed for National, Siegel became more and more frustrated in feeling they weren't receiving their fair cut of the profits. In 1947, they sued National for $5 million and ownership of Superman, a court case that ended in a $100,000 settlement if the pair agreed to cease pursuing all rights. National removed the pair's credit from all Superman items and blackballed them from the company.

Joe soon disappeared into obscurity, while Jerry had a short return to writing Superman in the '50s; but it was short-lived, as editor Mort Weisinger's tyrannical nature became unbearable, and he migrated to Archie Comics in 1964. A year later, he challenged National's copyright renewal on Superman. It was denied in court, but Siegel and Shuster weren't done with their apparently never-ending battle.

LEFT
The Jerry Siegel House in Cleveland, Ohio, where Siegel first conceived of Superman one sleepless night in his attic bedroom.

BELOW
Superman rescues Lois Lane—before it becomes too much of a habit. This art from *Action Comics* #5 (Oct. 1938) showcases Shuster's early, more detailed style. ©2012 DC Entertainment.

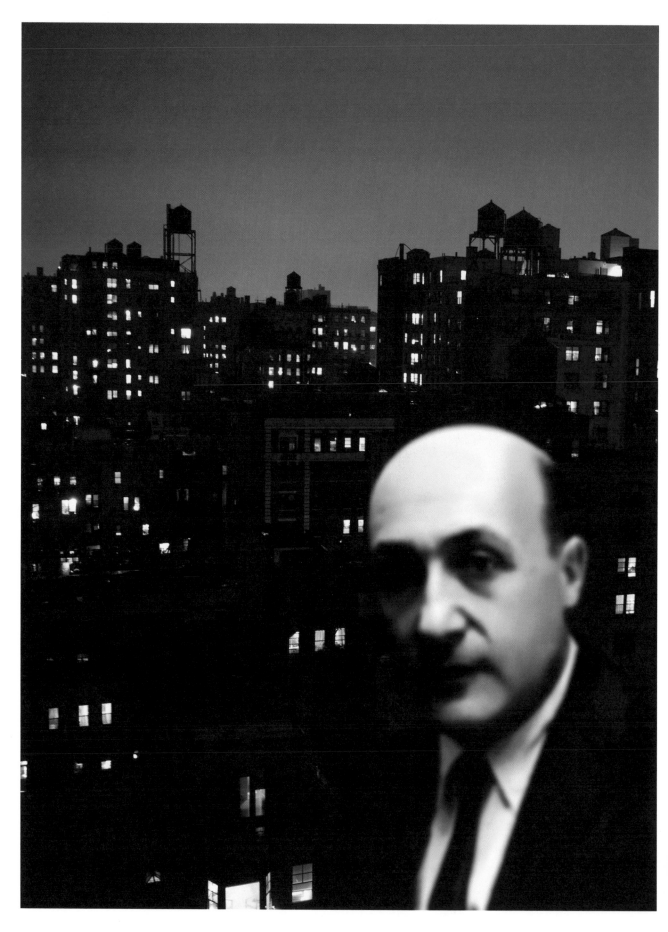

"I don't like to go back," Will Eisner once admitted. "I'm constantly in a forward momentum, looking to explore.

"I just don't have time to think about, or wish I could go back to do something I've done before." In 1936, Eisner (then going by Bill) bumped into his high school classmate Robert Kahn, a flamboyant cartoonist with aspirations of the trappings afforded the star comic strip cartoonists—assistants to do all of the work, money, and celebrity. (When he co-created Batman three years later, he was at least on his way to two of those.) Kahn referred Bill to a new comics magazine looking for contributors: *Wow, What a Magazine!*

Bill arrived at the *Wow* editor Jerry Iger's office—situated in a shirt factory—to find Iger on the phone with the printer experiencing a hang-up printing the new *Wow*. Bill tagged along to the printer's with Iger and quickly removed problematic burrs on the printing plates, salvaging the print job and earning himself a position as Iger's production man. Like many comics rags at the time, *Wow* didn't make it beyond a fourth issue, and both Eisner and Iger were without work. Eisner borrowed money from his father to start a new business with Iger, one that would cater to the burgeoning comic book industry.

"When *Wow* magazine died, two issues after I started with it, I formed a company called Eisner and Iger, and we would produce content for comic book publishers coming into the field," Will explained. "One of the things we did was daily strips for small newspapers, and so forth. What was happening at that time is that the pulp magazines were dying, and the publishers who were publishing them were looking around for other things to publish within that genre, and that was how we got them interested in comic books."

At first, it was just Will pushing a pencil and snapping a brush under countless *nom de plumes*, but eventually, they gained a small staff that included two future comics superstars: Eisner's old friend Kahn (now signing as the less Jewish sounding Bob Kane), and a tough young scrapper named Jacob Kurtzberg, a few years shy of changing his name to Jack Kirby. They packaged material for any publisher who'd pay, creating new characters of all flavors.

In 1939, Quality Comics publisher "Busy" Arnold and the Des Moines Register and Tribune Syndicate approached Will about creating a comics insert for Sunday newspapers. Selling out his half of Eisner and Iger, Eisner saw a chance to break out of the expectations of the juvenile world of the comic book by taking the format into the Sunday newspapers. Eisner wanted to go beyond the costumed "mystery man"

LEFT
Original Will Eisner photo
© Will Eisner Studios, Inc.
Photo illustration by
Seth Kushner

newly rampant in the young medium of comic books, so much that he found an interesting compromise to his publisher's demand for one: He would garb his pulp-like crime fighter, Denny Colt, in a mask and gloves and call him the Spirit.

"I'm sorry I did the mask," Eisner admitted. "It got in my way over the years, it didn't help the story, and interfered with what I considered the reality. When you draw a character walking down the subway wearing a mask and a blue suit, and being ignored or accepted by the people in the subway seemed a little far-fetched."

The Spirit quickly evolved from being the central protagonist of action-driven stories, to eventually becoming the catalyst in *other* characters' stories, sometimes walking on for a mere panel or two, yet still affecting the lives of antagonist and protagonist alike. He went from a formulaic mystery man to a unique, driving narrative force.

Even the surroundings went beyond set pieces and became characters unto themselves: logos became immersed in architecture or pieces of paper blowing in the wind, rain fell in thick sheets, buildings swayed like living things, and shadows wrapped around and dramatically embraced their darkness around everything. The opening splash page that opened each story was a cross between a movie poster and a first narrative panel; the Spirit logo was worked into the cityscape's buildings, or the front page of a newspaper, becoming as much a part of the environment as the story itself.

The regrettable mask became grafted onto the Spirit's face, conforming to the ridges of his brow; whether he was surprised, shocked, or angry, it became his trademark. Eisner and his crew embraced the absurdity of the Spirit and his world and, in doing so, were able to give the contrasting drama a greater punch.

"I was merely trying to develop or expand the human realistic quality of *The Spirit* for the most part," Eisner pointed out. "I was dealing in realism. The Spirit himself, as a superhero character was not terribly important to me. Many people don't understand that the Spirit character was a peg on which to hang the whole thing."

The Spirit continued his fight on crime until 1952, when Eisner left the then-flailing comic book industry proper to pursue packaging educational comic book material, as well as editing *PS Magazine* for the Army.

Maybe it's best that Will Eisner did leave when he did: the market was becoming too restrictive for the experimentation that was his trademark. But, when those restrictions were blown to Hell, Eisner would come back.

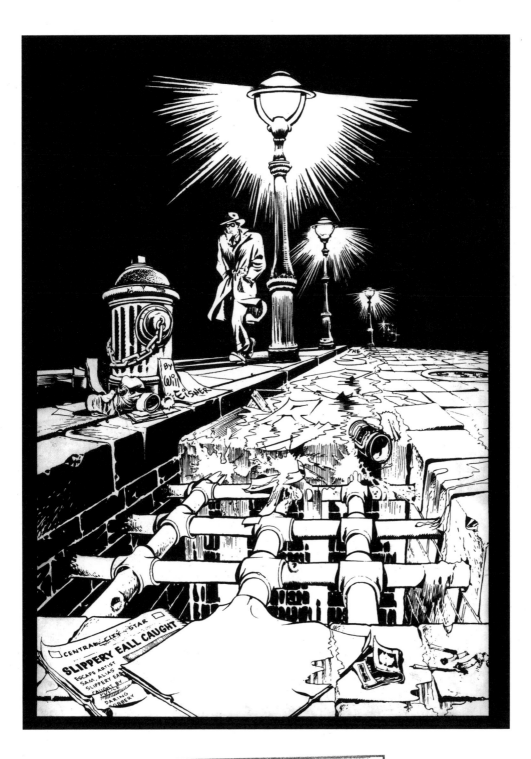

JOE SIMON
NYC, 2009

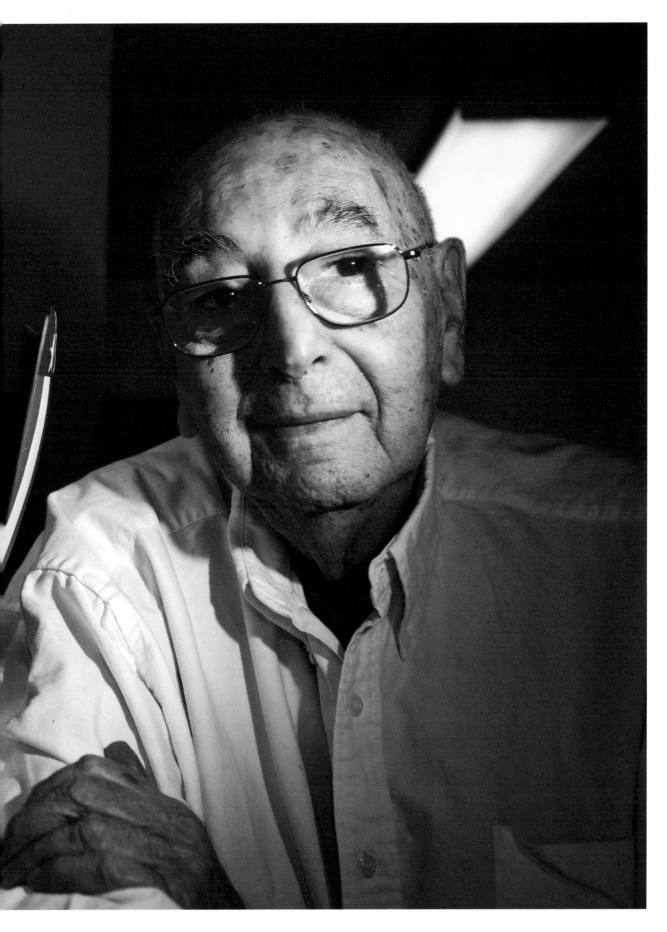

"I was the sacrificial lamb," Joe Simon says of his first job, at fly-by-night publisher Fox Comics in 1940. "I came in, and we had no staff and I had to do all the covers. I didn't have a letterer, I didn't have a writer, I didn't have an artist. I knew nothing about comics.

"Hardly anybody did those days, anyhow, except the guys that came out of newspapers or feature syndicates." It didn't take long for the enterprising Joe to start moonlighting for other companies. After a short while, he brought in a partner in Jacob Kurtzberg, who was pushing a pencil as one of Fox's staff. After a bevy of other pseudonyms, Kurtzberg settled on a new moniker—Jack Kirby—and the Simon and Kirby team was officially born.

They were an unlikely pair: Joe was tall and lanky, while Jack was short and barrel-chested; Joe a talker, while Jack was quiet. Where Joe was raised in Rochester, Jack grew up in the tough streets of the Lower East Side (as illustrated by Jack in his 1983 autobio comic: *Street Code*). Their personalities complimented one another, a balancing act of Simon's business savvy with Kirby's intensity.

The Simon and Kirby style developed into their trademark melee of action on the page: punches were thrown with arms wide and feet four feet apart, characters broke the dimensional wall of panel borders with a leg or an arm breaching into another panel, and panels weren't relegated to mere boxes, but sometimes circles and odd shapes of the artists' own invention.

RIGHT
Note the diagonal left-to-right flow of this early *Captain America Comics* splash, starting with Cap at bat, and ending with the yellow-weighted villainous pitcher. From #7 (Oct. 1941) © 2012 Marvel Entertainment.

Despite who did what, the duo worked together in a seamless and synergistic manner, to the point where it's often tough to pick apart who contributed what. The build-up of their moonlighting work burst out in a red, white, and blue explosion on the cover of Timely Comics' *Captain America Comics* #1, dated March, 1941 but out the December before. Slugging Hitler, the flag-emblazoned super patriot was the first superhero to premiere in his own title (as opposed to in the pages of an anthology), and the first to openly battle the Nazis in comics.

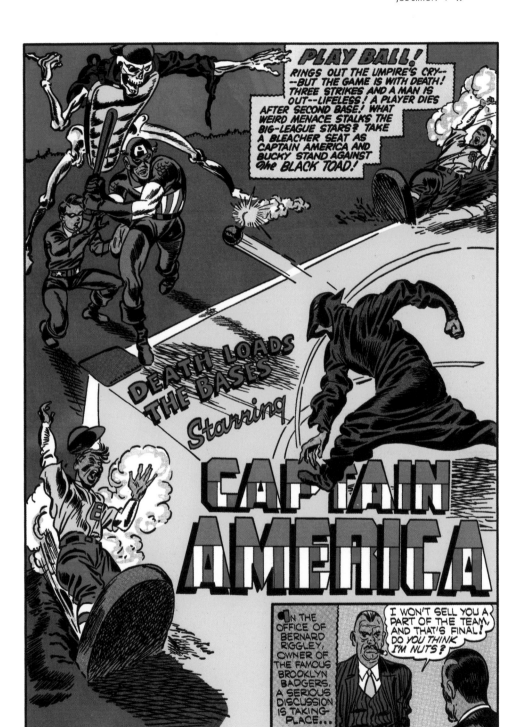

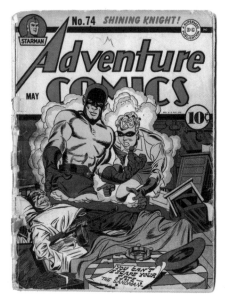
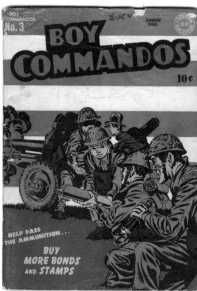
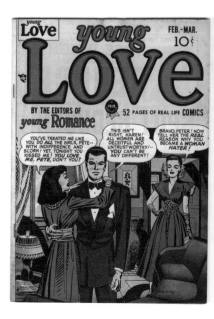

"We'd have the main character be second banana to the villain, and that's how Captain America came out," Joe reflected. "I picked Adolph Hitler as the ideal villain. He had everything that Americans hated, and he was a clown with the funny moustache, yet guys were ready to jump out of planes for him. He was the first choice, and his antagonist would have to be our hero, and we'd put a flag on the guy and have Captain America.

"Jack brought everything to life, and I thought he was fantastic."

Simon and Kirby's royalty on *Captain America Comics* was 15% for Simon and 10% for Kirby. An accountant at Timely, Morris Coyne, revealed the truth about the actual royalties to Joe:

"Morris told me that I was really getting the royal treatment on the royalties, and that [Goodman] was putting the expenses of the whole office on *Captain America*," Simon states. "It really burned me up.

"Everybody wanted us in the business, so I made a deal with Jack Liebowitz at National Comics. We had a contract with them, while we were working on [*Captain America*] #10. We decided to stay and finish that issue. They found out about the new deal, and the brothers surrounded us while we were working on *Captain* #10,

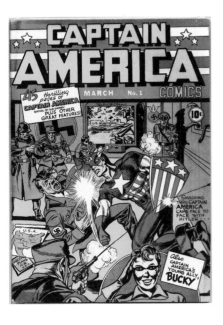

and they fired us. They said, 'You better finish this issue!'" Joe laughs.

Simon and Kirby's jumping ship to National yielded some of their best work for a major company: *Boy Commandos*, the revamped *Sandman*, and *Newsboy Legion* all feature a Runyonesque and more literary quality that the strictly two-fisted *Captain America* didn't have room for.

"We were really scoring gigs at the time, in 1942," Joe says. "We were the phenomenon of the comic book business: they asked to put our bylines on the covers. It was the first time it was ever done in comics.

"There were a lot of times when artists were unemployed in this business, and we had to make our own jobs by creating something off the beaten track, a new type of hero or something entirely different like *Young Romance*. We were the guys that were up to the task."

Simon and Kirby continued to do comics for about another ten years, creating new genres during the turmoil of the post-war comic book industry. They introduced romance comics with *Young Romance* #1, following up with *Western Romance* and *Young Love*. When they jumped onto the horror bandwagon with *Black Magic* and *The Strange World of Your Dreams*, they weren't knockoffs of EC Comics' *Tales from the Crypt*—but more cerebral and suspense-filled, dealing in implied horror just as much as sheer.

They even had their own company for a brief time around 1954, Mainline, and published their Western superhero *Bullseye*. When the industry ultimately went belly-up shortly after, Simon and Kirby parted ways, briefly reuniting in 1959 to develop superheroes for Archie Comics. Simon went on to edit parody magazine (and *MAD* competitor) *Sick* and continue to pop in and out of comics. Joe Simon passed away on December 14, 2011. At age 98, he'd just finished his memoir and was still knee-deep in comics.

Kirby found himself knocking on the door of the former Timely Comics, now run by a clarinet-playing office boy from his *Captain America* days—Stan Lee—and another iconic comics team would be born.

LEFT TO RIGHT

S & K gave second-rate crime fighter Sandman a first-rate life when they took him over, with their first work in *Adventure Comics* #74 (May 1942). © 2012 DC Entertainment.

S & K introduced the "kid gang," a genre that continued throughout the '50s. *Boy Commandos* #3 (Summer 1943). © 2012 DC Entertainment.

As superheroes were dwindling in sales, the romance comic (and its female readers) helped keep the comic industry afloat. From *Young Love* #1 (Feb–Mar. 1949). © 2012 Joe Simon and Jack Kirby Estate.

The debut issue of *Captain America Comics* (Mar. 1941). If Superman and Batman are icons of the Great Depression, Captain America is *the* icon of WWII. © 2012 Marvel Entertainment.

"When I was 17, I was selling ice cream to have money for my first semester [of college]," Jerry Robinson says.

"I had a cart full of ice cream that I had to haul, that summer of '39, to my territory in the suburbs. I had to pedal the whole time, and by the end of the summer my mother thought I wouldn't last: I was down to 78 pounds. She persuaded me to take $25 from my hard-earned royalties from selling popsicles, to go to the mountains to fatten up so I could survive the first semester of college…

"The fad was to decorate a painter's jacket with drawings. It was made of white linen, and I used it as a warm-up jacket for tennis. I was at the courts and I felt a tap on my shoulder and [someone] asked if I did the drawing. The voice said, 'Those are pretty good.' It was Bob Kane.

"I had applied to Columbia, Syracuse, and Penn and was accepted at all three; I couldn't decide on where to go, and finally decided on Syracuse, which was more of a college town. Kane said, 'Oh, it's too bad, because if you'd come to New York, you could work on this comic book with me.' I'd never read comic books."

Following the success of Siegel and Shuster's *Superman*, artist Bob Kane took National Comics' editor Vin Sullivan's challenge to create a new superhero over the weekend. Kane's first version of his crime fighter Bird-Man soon changed to Bat-Man; he wore a red bodysuit, domino mask, and had stiff bird wings coming off his back. When he recruited writer-collaborator Bill Finger, Finger recommended a distinctive bat-eared cowl and a change from stiff wings to a long cape. The resulting black and gray-clad figure, The Bat-Man, swung over a city at night, with a thug captured in an awkward headlock as two other thugs on a rooftop look on in awe. The impressive image was swiped by Kane from an Alex Raymond *Flash Gordon* strip, but Sullivan either didn't care or know, and the image graced the cover of May, 1939's *Detective Comics #27*. Even though Finger arguably contributed as much as Kane, Kane received sole credit as the creator of Batman.

Still holding onto dreams of becoming a journalist, Robinson started working for Kane as a job meant to just put him through school at Columbia University, where he finally attended. Robinson's touch is first seen and felt in *Batman* in the third story, as Kane's crude pencils gained the added dimension of Robinson's heavy shadows. Finger and Kane

LEFT
Jerry Robinson, NYC, 2009

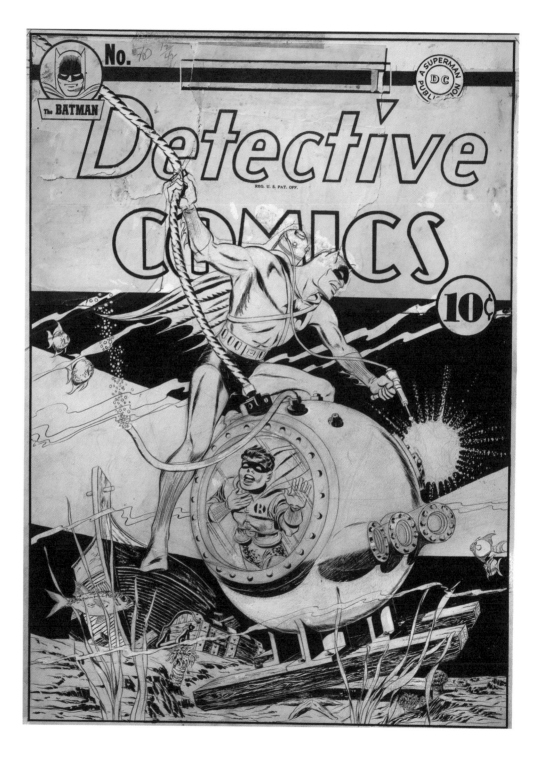

may have defined *Batman*, but Robinson helped to cement *Batman* as living in a world of long and sinister silhouettes. For Robinson, it was a time to absorb and filter out new influences, all introduced through *Batman* scribe and friend Bill Finger.

"Bob may have been a fine talent," Robinson laughs. "But Bill became my friend, and my culture mentor. I was a really young kid, 17, just out of high school and in New York for the first time. I just really knew how to get from the Bronx to Columbia and back. He took me, for the first time, to the Met, to MoMA, to foreign films, to the Village. That was exciting. I was a sponge that soaked everything up."

Robinson's two major contributions to *Batman*? The sidekick Robin the Boy Wonder, who soon inspired a legion of kid sidekicks, and the dark clown the Joker. Robinson's early Joker lacked a sense of humor. Clad in dark purple with black bags under his somber eyes, the Joker was an ironically-named character, more somber than Batman despite the bright clown makeup on his face. His look was lifted from the 1928 silent film *The Man Who Laughs*, starring Conrad Veidt, while Robin's costume is identical to one worn by Flash Gordon's girlfriend Dale Arden in a 1937 story line (ironically the same one that Kane swiped his first *Batman* cover image from).

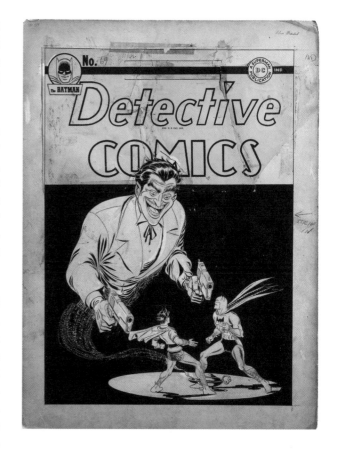

Robinson remained with Kane for a brief time, soon jumping over to work directly for National, and also partnering up with friend Mort Meskin on several other comic book accounts.

Jerry Robinson eventually left comics and found success as a newspaper cartoonist, through his science fiction strip *Jet Powers* from 1953–55, in *The New York Daily News,* with his strip *True Classroom Flubs and Fluff* from the 1960s–80s, and even became president of the New York Cartoonists Society in 1967.

Robinson came back to the comic book industry in the '70s, when two old friends needed him the most. His actions would further cement the legacy he left behind after his death on December 7, 2011.

LEFT
Robinson's scene of Robin the Boy Wonder trapped in a bathysphere evokes a mood of claustrophobia. From *Detective Comics* #70 (Dec. 1942) © 2012 DC Entertainment.

ABOVE
Robinson's Joker wouldn't have a "bang" flag come out of the barrel, but hot lead. From *Detective Comics* #69 (Nov. 1942) © 2012 DC Entertainment.

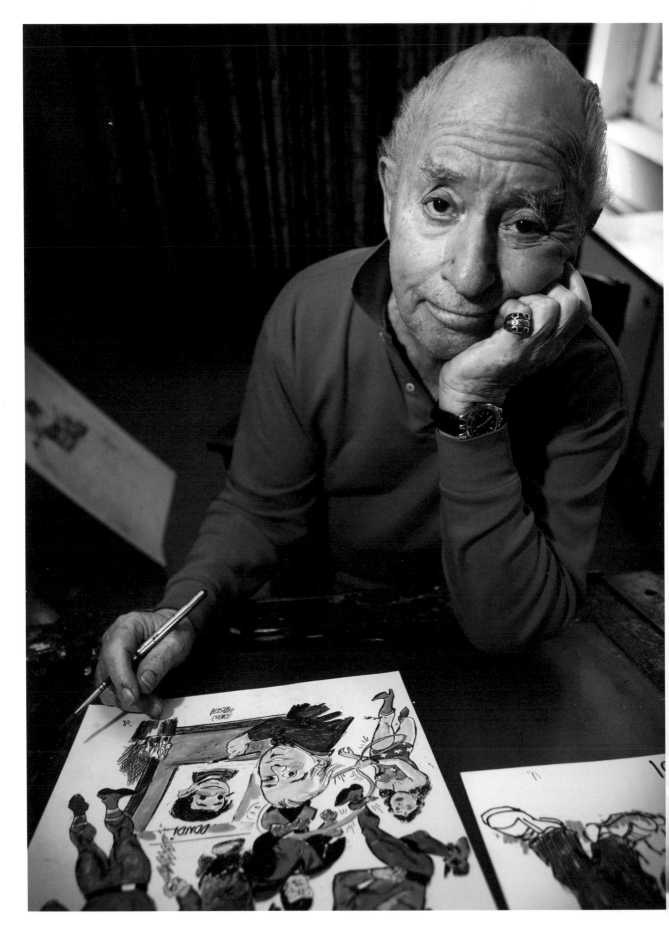

"In those days, there were no stars,"
Irwin Hasen says. "There were just
plain guys working out of the Depression,
trying to make a living as cartoonists.
We never thought of making star-quality
characters, we just did our work.

"The syndicated newspaper strip was secretly the dream of the young cartoonists; they wanted to get the hell out of comic books. They worked hard in comics, but I was always on the cusp of wanting to have my own comic strip. It happened."

Hasen's earliest work, in its crudest form, included the first appearance of obscure character Catman: a superhero donning a leopard-print toga, mask, and paw-like gloves. Irwin was later the second artist to draw *Green Lantern* for publisher All-American Comics, and also co-created boxing superhero Wildcat in *Sensation Comics* with writer Bill Finger in 1942.

Finger, devoid of a byline on *Batman* was given one on both *Green Lantern* (with original artist Martin Nodell) and *Wildcat* with Hasen. Finger embodied the sensitive and tortured creative type who lacked the ability to handle himself in the cutthroat industry of 1940s comics. While both characters enjoyed the normal shelf-life of a 1940s superhero, neither came close to attaining the popularity of his most beloved creation, Batman.

"Bill was a very delicate guy, and I don't use that word in a pejorative sense," Irwin notes. "He was a very good-looking, handsome, little guy…a short man. I'm 5'2" and he was maybe 5'4". He was a very elegant dressed man, erudite and tragic. I use that word in a very sad sense, because Bill was always behind on his work, he was always behind the eight ball, and always late on his deadlines, always in debt, but the sweetest, gentlest guy you'd want to meet, and such a creative guy.

"He was always late and always needed money," Irwin notes. "It was his bane his whole life. He died broke, of course. That's the only story I can tell you about

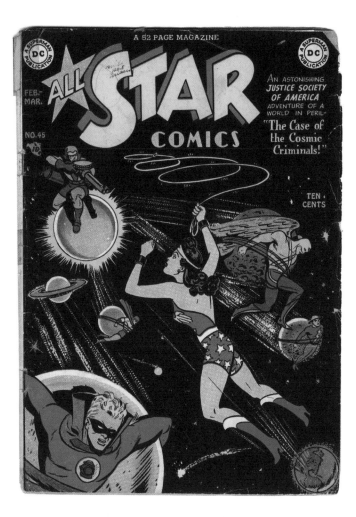

this short-lived giant. Among all the writers he was the most creative."

When Irwin returned from serving in World War II, he worked in comics for a few more years, and then co-created the comic strip *Dondi* with writer Gus Edson in 1955. The daily, about a war orphan with button eyes, let Irwin leave the comic book industry for the more respectable daily newspaper.

Through *Dondi*'s existence into the 1980s, Irwin kept out of comics, the next wave of their popularity passing him by while he spent time drawing the button-eyed orphan.

Life was good for Irwin Hasen.

"I didn't care about comic books," Irwin admits. "God bless 'em, they got me started. All my friends are comic book artists. I know all of them. I don't think there are any other group of people that are any better than cartoonists. You know the business people of the world are in another cold, compressed world. Cartoonists are full of love and light and life, and they're like children grown up."

After becoming a fixture at comic book conventions, Hasen came back to comic books in producing the daring graphic novel *Loverboy,* about his swinging days as a middle-aged bachelor in New York City, and his fascination with taller woman.

Age, it's abundantly clear, is not slowing the charming Hasen down.

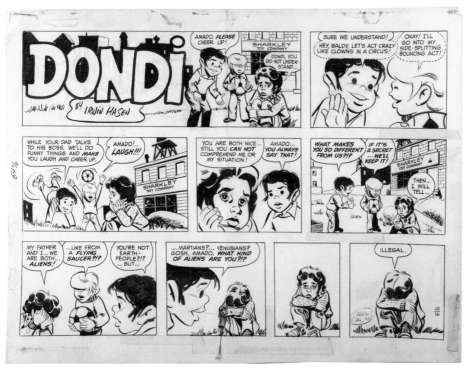

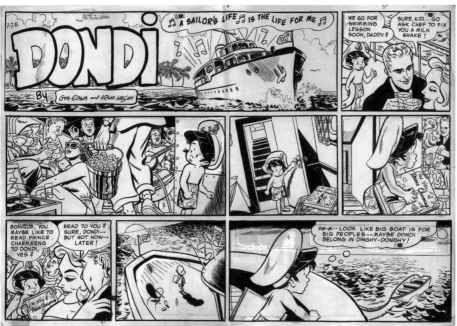

Harvey Kurtzman was a nut, a self-described madman of a cartoonist, a control freak, a humorist with a satirical overbite, and an enemy of the establishment's cozy post-World War II Americana.

His work looked deceptively spontaneous but was laid down with the precision of a craftsman. From his anti-war war comics to his satire, Kurtzman fooled us all into crying or laughing when we least expected to.

Kurtzman's EC Comics titles *Two-Fisted Tales* in 1950, and war comic *Frontline Combat* the following year, were injected with a visceral realism that sometimes ended in tragedy for the protagonists. *Two-Fisted* offered a more psychological take on mens' adventure stories. *Frontline Combat* took a psychological and tragic look at war, eschewing the glorification displayed in other war comics. They were a stark contrast to the publisher's more gratuitous horror books like *Tales from the Crypt.*

Kurtzman later approached EC Publisher William Gaines with a new title that would require less energy to produce than the research-intensive war stories. Branded as "Humor in a Jugular Vein," Kurtzman's new comic book *MAD* would feature parodies, pastiches, and flat-out humor stories. Using the same stable of artists as the war books—Wally Wood, Johnny Craig, childhood pal Will Elder, and John Severin—*MAD* parodied everything from other comic books to pop culture, and redefined satire for a new generation.

In May 1954, comics were in trouble, thanks to television-ready crusading Senator Estes Kefauver. Teaming up with psychiatrist Fredric Wertham, author of *Seduction of the Innocent*—a "medical study" on the supposed cause-and-effect of comic books to juvenile delinquency—Kefauver held televised Senate hearings aimed at censoring the comic book industry.

Gaines was the only publisher to appear on the stand, hoping his presence would either galvanize the industry, or take the wind out of Kefauver's sails. Neither happened—hopped up on Benzedrine, Gaines was confronted by Wertham on national television. Kefauver now had something for the media to latch on to with interest, and it became a

LEFT
Original Harvey Kurtzman photo: © 2012 Hewetson & © 2012 Harvey Kurtzman Estate. Photo illustration by Seth Kushner.

FOLLOWING PAGE, TOP
Kurtzman's *Hey, Look!* one-page comics for Stan Lee at Timely are bite-sized pieces of cartoon brilliance. © 2012 Harvey Kurtzman Estate.

FOLLOWING PAGE, BOTTOM
Appearing prior to *Mad,* Kurtzman created the cowboy spoof *Pot-Shot Pete* in 1950. © 2012 Harvey Kurtzman Estate.

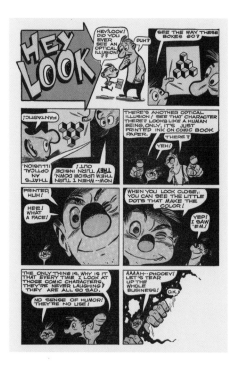

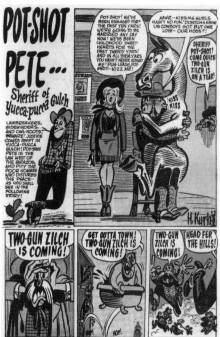

media circus that painted comic books as an evil corrupting post-War America's children, with Gaines the "worst" of the publishers.

Several publishers joined up and created a new Comics Code Authority, a self-censoring board with a set of guidelines to maintain "decency" in comics. The Code practically neutered EC Comics by banning any and all violence or luridness in comic books.

Meanwhile, *MAD* continued to sell as well as a comic book (in sales of near 750,000), despite the killing of the crime and horror lines. Kurtzman had always dreamt of producing a magazine and he got his wish when *MAD* went from full-color comic to black and white magazine with 1955's issue #24. Harvey's run on the new *MAD* only lasted five issues, after Gaines refused to give him more control in the only profitable publication EC had left.

Playboy publisher Hugh Hefner came to the rescue with an apparently unlimited budget and offered a new magazine to Kurtzman. Titled *Trump* by Hugh, Kurtzman's new magazine was produced by himself and a small army of *MAD* alums—Jack Davis, Al Jaffee, Wally Wood, Will Elder, Russ Heath—and new recruits Irving Geis and Arnold Roth. Produced in slick color, *Trump* hit newsstands in '57, but was quickly killed at the second issue due to the collapse of *Playboy*'s newsstand distributor, a high budget, and *Playboy*'s move from New York City to Chicago.

Kurtzman, Roth, Jaffee, Davis, and Elder then joined forces on an independent creative venture—a new magazine where each would take a financial stake, with Davis opting in creatively but not financially. Hefner, as a gesture of good will over the loss of *Trump*, gave the *Humbug* staff rent-free use of new offices.

Humbug was Kurtzman and his gang finally having 100% creative freedom, a trade-off for being buried in debt. *Humbug* only lasted eleven issues.

• • •

Reduced to living on unemployment, Harvey's post-*Humbug* days were spent scurrying for freelance work to pay the bills

and support his family. Harvey created a paperback of original comic stories, *The Jungle Book,* which was a critical accomplishment and early progenitor of the graphic novel format but not commercially successful.

If Kurtzman's *MAD* sparked the Underground Comix movement of the mid to late '60s, his next magazine *Help!* was not only further encouragement for the likes of young *MAD*-inspired cartoonists Robert Crumb and Gilbert Shelton, but an aggregator for that new generation.

Two years into *Help!*'s run, Hefner came back into the picture, offering Kurtzman a new strip for *Playboy. Little Annie Fanny* took the Kurtzman satire and placed a shapely blonde dead in the center. By the time *Help!* wrapped with 1965's #26, Kurtzman was ready to pursue the cheesecake cartoon more freely.

The confounding thing about *Annie* is that, technically it was Kurtzman's greatest (and longest-running) achievement. Paired back up with lifelong friend Elder, *Little Annie Fanny* was painstakingly written, laid-out, designed, and painted at a rate of fifteen pages a year and a staggering $3,000 a page. Each page alone involved several stages of development, as well as several layers of paint (including watercolor and tempera, as applied by Elder). Both Hefner and Kurtzman were incredible perfectionists, and the strips were in a constant state of revision.

Annie ran until 1988, as Elder's sight began to fail him and Kurtzman began to succumb to Parkinson's disease. He passed away on February 21, 1993, having not only changed the course of pop culture, but also inspired comic books to go beyond juvenilia and become something greater.

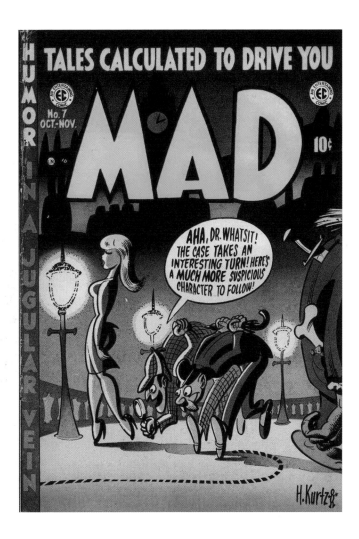

ABOVE
MAD #7 (Oct.–Nov. 1953) features Kurtzman's parody of Sherlock Holmes (aka Shermlock Shomes). Like many Kurtzman heroes, they're oblivious to the world around them. © 2012 DC Entertainment.

"I have to make a confession: I'm really just a journeyman," Al Jaffee says from his New York City studio. "I make a living. I don't look to legacies, and I don't see long-term value.

"I never saw long-term value to any of my work. I think I feel the way a newspaper journalist feels, that it's just for today or tomorrow, and then I forget about it.

"I would just try to do the best job each day. I know it sounds simplistic, but that was the attitude I had. Now, it's pointed out to me."

After over 50 years, Jaffee remains a mainstay at *MAD Magazine*, as much a presence as the magazine's own mascot, Alfred E. Neuman.

"When you do creative work, I don't think you can ever get permanent and say, 'This is what I do, and if nobody wants it, to hell with them.' No! You're available and you employ all the old burlesques for a while."

Those burlesques took the stage at EC Comics in 1955, as Jaffee joined up under editor Harvey Kurtzman on *MAD Magazine*. It was a short-lived stint; Kurtzman's falling-out with publisher Gaines led to his leaving *MAD* and trying a hand with stillborn magazines *Trump* and *Humbug*. Jaffee joined up with him on these, but it was a short-lived affair as both had folded by the time Al returned to *MAD* in 1958. He had just launched his syndicated strip *Tall Tales* that year, and also moved out to Long Island with his first wife.

His first breakout feature in *MAD* stemmed from Jaffee's rapier wit: *Snappy Answers to Stupid Questions'* form follows one character answering the other's obvious question with one of a handful of "snappy" quick-witted answers.

"Snappy answers are not natural to me," Jaffee admits with a laugh. "I'm afraid of insulting people, I think they're going to hit me…It's a way of letting off steam in the printed page. The reason it was so popular is that everyone, at some point in their life, wants to say something like that but they can't."

His marriage crumbling towards the mid-'60s, *Snappy Answers* was likely therapeutic for Jaffee. Packaging *Snappy* in small, digest-sized paperbacks that became dog-eared by eager *MAD* readers, *Snappy* sold around 2.5 million copies and spawned seven follow-up books.

Jaffee made his most indelible and longest-lasting mark on pop culture when he came up with the Mad "Fold-In." Printed on the inside back cover, the Fold-In was a twist on the full-color fold-outs of the higher class magazines like *Life*.

The Fold-In is an image that, when folded over and into itself, forms a different image, answering a satirical question relating to politics or pop culture. The first one featured Liz Taylor and Richard Burton, soon followed by presidential candidates Rockefeller and Goldwater merging to form an image of Richard Nixon.

Jaffee still does the Fold-Ins the old fashioned way, by hand, doing thumbnails on a four-up page of rectangles, representing the entire Fold-In and the final product. The punch line is actually the first conception by Jaffee: he comes up with the punch line (or final image) first, and then plans the rest in before transferring it to the final art board for drawing and painting. In his late 80s, even with hands that are starting to shake, Al Jaffee's artwork shows

that he still hasn't left his prime.

And the Fold-Ins prospered, coming out month after month, year after year, poking fun at politicians or movie starlets. Before anyone knew it, the hundreds of Fold-Ins created a timeline of American history, political satire, and entertainment. Picking up an old *MAD*, back cover folded and smelling of mothballs, always provides a visual time capsule on the inside back cover.

The Fold-Ins are the only standbys from *MAD*'s great period. The magazine is now owned by Time Warner, and even has an entire office in the same building as DC Comics. Where publisher William Gaines published it as a black-and-white newsprint magazine without any ads (to remain objective), *MAD* is now a glossy, full-color treatment with mainstream advertising. It just went quarterly after about 50 years as a monthly.

"It's a bit different than it was before," Jaffee notes of his home magazine. "The black-and-white magazine was a cheap newsprint magazine that could be rebellious and nip at the heels of the full color fancy magazines…Now, of course, *MAD* has had a complete turn from a caterpillar to a butterfly. It has all the fancy production because digital color production is cheap now. So, *MAD* has to go to full color, and it takes the edge off its rebelliousness."

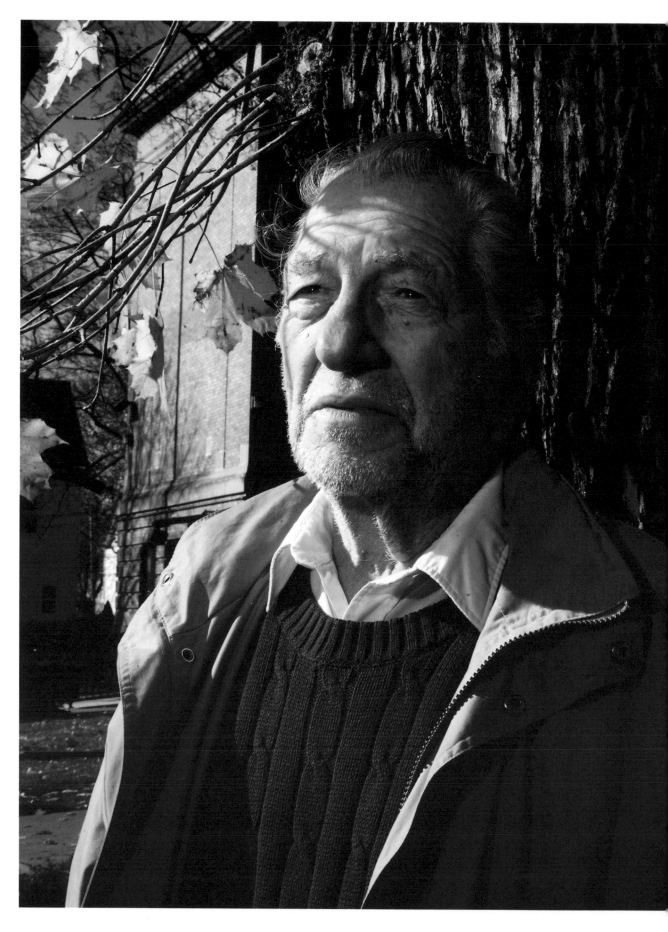

JOE KUBERT
Dover, NJ, 2009

"The newspaper strips at that time were really what everybody strove for," Joe Kubert says. "Every artist that was working for comic books was looking to do that.

"It was an adult media because it was read in the newspapers and used by the papers in a competitive effort to get readers, and it also paid a helluva lot better."

Joe Kubert was twelve when he started in comics in the 1940s and grew up in the comics industry, part of the second wave of cartoonists, a generation merely six to eight years younger than their predecessors. Haunting editorial offices with portfolios, scraping for work and aiming for a chance to break in, they shepherded the comic book industry and form throughout the tumultuous 1950s and reached their prime the decade after.

Kubert neither romanticizes the past ("To try to analyze what was going on at the time? It never entered my head."), nor is he stuck there.

After working for Will Eisner one summer in 1941, sweeping floors and making art corrections for twelve and a half bucks a week, Kubert found work with All-American Comics as an artist on *Hawkman*. In contrast with his current work, Kubert was then cartoony and awkward, his character heads unnaturally large and the muscles sculpted out in sharp curves.

It was the work of a teenager and was left behind as Kubert matured in time to face the struggling comics industry of the '50s. Crime and horror genres were forced out and superheroes had lost their popularity and were all but buried (the three exceptions—Batman, Superman, and Wonder Woman—were all published by National Comics). Another of Kubert's colleagues, Carmine Infantino, came from the same generation, his early work possessing heavy shadows and a thick contour line. As Kubert's work became more dramatic and realistic, Infantino gave up focusing on rigid draftsmanship to further develop design in his drawing, creating an unparalleled geometric and dynamic visual style.

RIGHT
Kubert's textural inking makes the battlefield that much more believable. From *Our Army at War* #198 (Oct. 1968). © 2012 DC Entertainment.

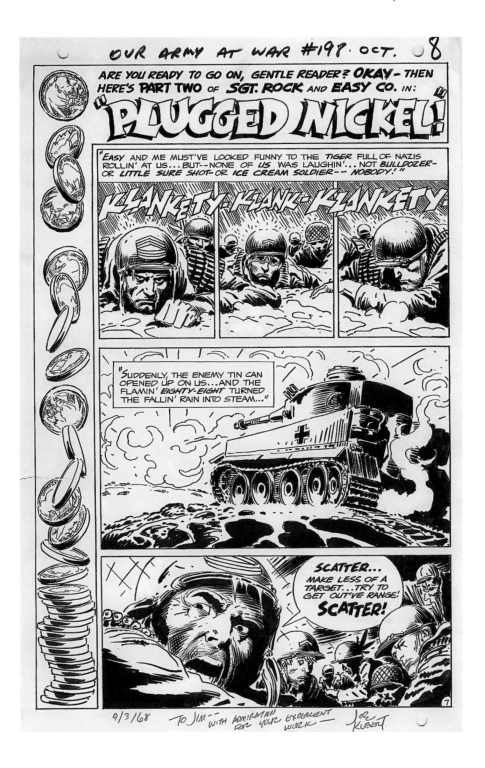

National Comics editor Julius Schwartz decided to bring back the superheroes for a new generation of kids, starting with a new version of old superhero the Flash, and he pegged Infantino and Kubert to draw it.

Emblazoned on the cover of 1956's *Showcase* #4 is the new Flash, a red-suited and cowled figure leaping off of an unwinding roll of movie film. The story inside, written by Robert Kanigher and drawn by Carmine with inks by Joe, introduced police scientist Barry Allen, who is chronically late for everything—until he's simultaneously blasted by a random bolt of lightning and doused in chemicals, and gains the powers of the super-fast Flash.

Infantino's panels were told in wide-screen, giving a cinematic sense to the story, and using the space around the character to further reinforce his speed.

Kubert's inking cemented Infantino's pencils, giving the strip a more real-world feel than the other superhero strips that came before. It was as if superheroes had graduated from the stylization of the *Dick Tracy* movie and to the realism of the *Dragnet* TV show overnight.

The Flash's return was successful enough to soon prompt a reimagining of old superhero Green Lantern, followed by others like Hawkman (with Kubert once again drawing the winged character) and the Atom. By 1960, the reinvigorated heroes were assembled in team-up book *Justice League of America*. The Flash's lightning was the catalyst of change in comic books, heralding the return of the superhero genre.

In spite of his *Hawkman* work, it's Kubert's war comics that redefined him from being a superhero artist. *Sgt. Rock*, *Unknown Soldier*…they were all once or often graced by his thin pen line and harsh brush strokes. The soldiers in a Kubert war comic weren't glorified because they were handsome: they were glorified by surviving the grit around them, fighting in the face of the odds as much as their enemies. Not since Kurtzman's *Frontline Combat* had an artist made war seem so terrible and real.

• • •

RIGHT
Kubert's distinctive art was felt in all genres at National Comics: from superhero, to war and fantasy. © 2012 DC Entertainment.

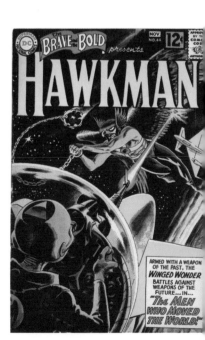

Joe Kubert's founding of the Joe Kubert School of Cartoon and Graphic Art in Dover, New Jersey hearkens back to his days as a kid going from comics company to company, meeting as many of his creative heroes as possible.

"When I was a kid, the people who were in the business were very kind and would help you in many ways," Joe says. "But when I talked to these guys, they told me what I needed to do and so on. I always felt that if there was one place for someone who was seriously into this work to gather all of that information that would be a very good thing. I had the idea in the back of my head for a very long time, but I was never prepared to give up doing my own work for the sake of starting a school.

"I wasn't looking for a substitute for my own career. If it were ever a question of running the school or doing my own work, the school would not exist."

The Kubert School has turned out a virtual army of comics pros, including Joe's sons, Adam and Andy.

"They're now teaching here," Joe states. "I'm very proud of what they're doing. As far as I'm concerned, what Adam and Andy are doing, and the fact that they enjoy the same things that I do, is nothing short of a miracle. I don't think anybody can tell or suggest to you that you're going to get into a profession like this. But, once you're into it, it's very difficult to talk you out of it. It gets you and becomes a really strong part of your life and, to me, the fact that Adam and Andy have the same feeling towards it that I do, is nothing short of a miracle."

"I was a creature of the newspaper comic strips, which I worshipped, and they were iconic," Jules Feiffer reflects. "This was extraordinary talent doing extraordinary stuff, and with comic books, it was more like early rock 'n' roll—we felt anybody could do it.

"These were artists, particularly in the early days, who drew very crudely, particularly Joe Shuster (who I loved, particularly in his early *Superman* work and before that with *Slam Bradley* and *Spy*), whose stuff I could imitate and almost do as well at. It was that way with others: Bob Kane could barely draw.

"There was more of the possibility of a future for yourself, because these guys were in print and so could I be. Easily, the outstanding one in comic books from the very start was Will Eisner. He was head and shoulders beyond everybody else. He was somebody to admire, and also daunting to imitate.

"I loved comic books and, if you read enough of them, they'd give you a sort of caffeine high."

Now in his early 80s, Feiffer has profited from that early sense of hope, that caffeine high brought on by cracking open a cover and smelling the newsprint of a new comic book. A hardcover book he wrote in 1965, *The Great Comic Book Heroes*, is the first book about comic book history, combining Feiffer's reminiscences of the Golden Age of comics with reprints of pivotal stories from the 1930s and '40s.

But that's the tip of the iceberg for the prolific Feiffer: while starting in the early days of the comics industry, Feiffer transcended to become a multiple-award-winning cartoonist (including the coveted Pulitzer), playwright, and screenwriter (garnering an Oscar).

• • •

LEFT
Jules Feiffer, NYC, 2009

"I responded so strongly to Eisner when I was a kid, because nobody made city streets during the Depression years look more real, graphic, and internalized," Jules reflects. "Eisner was the cartoonist of weather: a lot of rain falling, a lot of wind with papers flying. Nobody did that."

In 1946, Jules started with Will Eisner, when *The Spirit* was at its peak. Will had just come back from the war and took the strip back over from his army of ghostwriters and artists, reinjecting life into the then-bland crime fighter. Feiffer provided backgrounds, as well as stories for the classic strip.

"We were never friends in the sense of being intimate, but we always had regard for each other in being friendly and occasionally having dinner," Jules admits. "There was also a chronic competitiveness and rivalry and, as I got bigger, Will could get a little nasty about it."

Feiffer laughs. "It was never serious, and we were always warm to each other."

Working for Eisner was an education for Feiffer, at the feet of one of the men who invented the comics medium.

ABOVE AND RIGHT
Jules Feiffer's cartooning
is akin to drawn theater,
with a minimum of
backgrounds, and a focus
on monologue.
© 2012 Jules Feiffer.

"He was amazingly affable and outgoing, and interested in the form, and knew everything about the medium, far more than I ever did," he says of Eisner. "He knew not just how to pencil and ink and write, but he knew what happened to it after it went off to be printed. He had worked in print shops, and he took me down to print

shops to show me how it happened, and I never understood. I had to pretend, as I had in school, that I got what he was talking about. But from that day do this I still don't know how it happens. He knew it all, and knew the terminology, and was fascinated by the form. He was not just a good artist, but a true craftsman and had a great scholarship about him. He was in at the birth of everything."

In 1956, after failing to sell a strip of his own, and drawing in a simplistic and loose style reminiscent of a children's book, Feiffer offered a strip to fledgling independent paper *The Village Voice*—for free. His strip, initially titled *Sick, Sick, Sick*, featured Feiffer's sharp, intellectual wit in a format that combined biting social commentary with his loosely drawn figures. Borderless, and told in sequences of six to eight panels, the strip featured little (if any) backgrounds, and were the drawn stage of his own personal theater.

• • •

Neither snotty or navel-gazing, *The Great Comic Book Heroes* is a reminiscence told in Feiffer's own inimitable style. *Heroes* is bookended by Feiffer's personal reminisces of the Golden Age of comic books in the '30s and '40s; the sweet cream filling is a bunch of reprints of old comics, from *Superman* #1 to a reprint of Will Eisner's *The Spirit*.

When *The Great Comic Book Heroes* came out, it was the first book of its kind, and received mixed reviews from critics as Feiffer's celebrity as the cartoonist of *The Village Voice* helped it stand out.

"It's interesting: a lot of well-known people wrote about it critically, because I had written the book that they'd intended to write but had never gotten around to. I was impinging on their territory, and you could see that they were really pissed off at me."

Feiffer's crowning achievement with *The Great Comic Book Heroes*, in his eyes, involved giving back to his mentor, Eisner, who had given up traditional comics at that point in his career.

"I think that originally it was nostalgia, and then as it hit a generation of young readers, it served to validate the seriousness of their interest as opposed to the condescension you'd normally expect from grown-ups or from the culture. The book was taken seriously, so the form gained a new lease on life and new respect, none of which interests me particularly, except in what I did to redeem Will Eisner's career. That was, for me, a major interest in that this was a guy who was no longer heard of, was completely forgotten, had forgotten himself and was no longer doing comics. I was happy that, in a sense, I was able to bring him back from the dead or, at the very least, from exile."

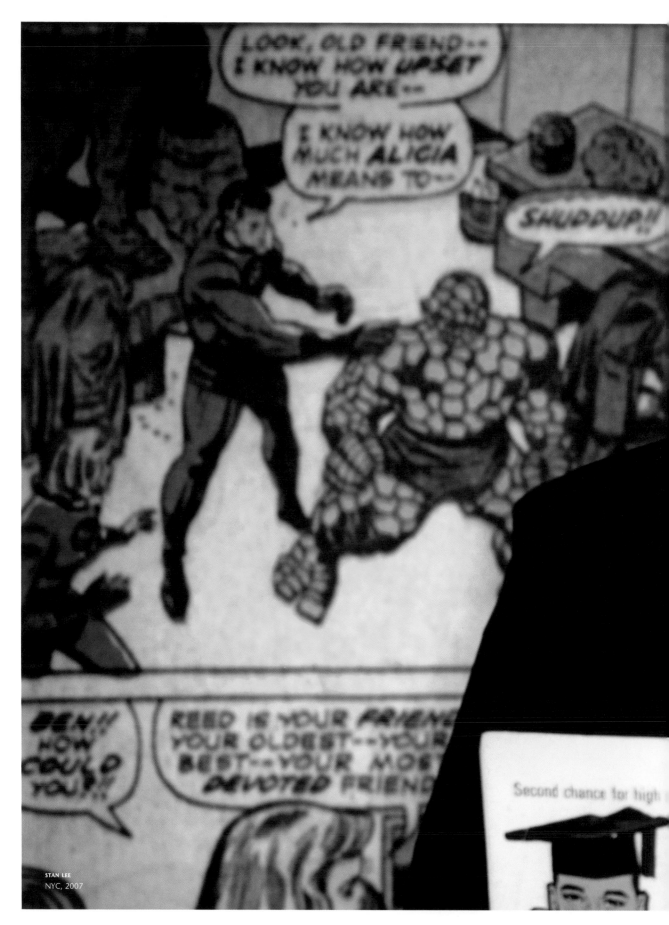

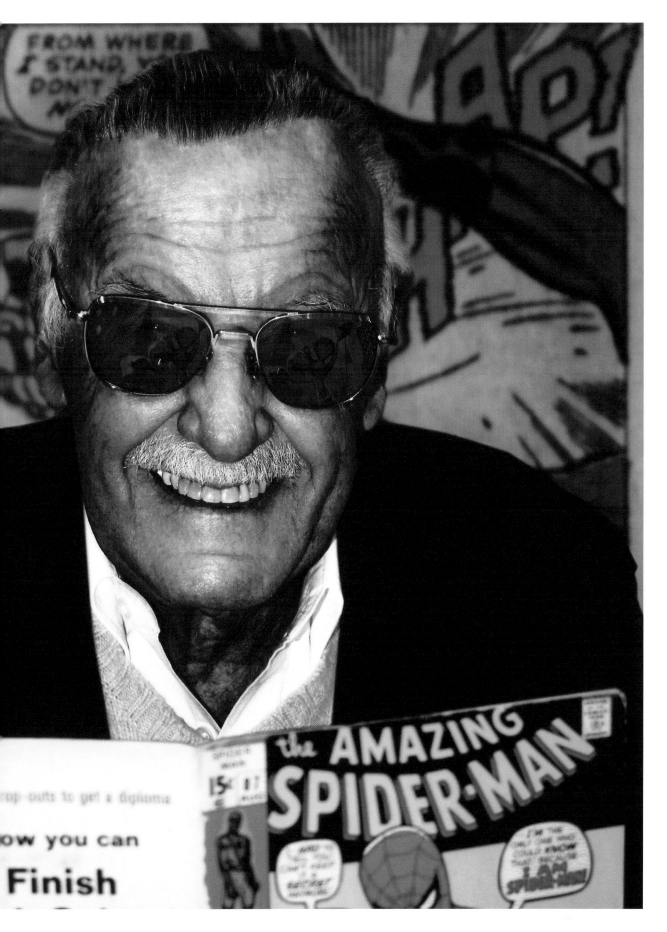

"I was ready to be a media star when I was twelve years old," Stan Lee says with his usual gusto. "It just took all this time for the world to discover me."

Stan Lee is more than just a comic book visionary. The first self-made man of the comic book industry, whose chutzpah sometimes eclipses his earlier struggles in the unforgiving comics world of the 1950s, Stanley Lieber started working as an office boy at Timely Comics at age eighteen and fresh out of high school.

"There really was no one to teach me," Stan says of the early days. "I had to pick up everything by myself…There really wasn't too much to learn, because none of the books were too good in those days," he admits.

Even though he was "Stan Lee" as far back as the '40s, he was yet to grow into Stan "The Man" Lee, the spokesperson for comics. That changed when publisher Martin Goodman, inspired by National's success with super-team *Justice League of America,* prompted Stan to create their own superhero team. It was 1961, and it was time for Stan to make lemons out of lemonade.

"The launch of the *Fantastic Four* was when I finally did a book the way I wanted to," Stan reveals. "Up until then, Martin was totally convinced that comic books were read by very young children or semi-literate adults…It was a job, and I wanted to keep my job, so I did what he said. But it was with the *Fantastic Four* that I decided to do books the way I thought they ought to be done."

Jack Kirby, twenty years after falling out with Goodman over *Captain America*, was back with Marvel. When Lee collaborated with him on FF, the duo produced the first superhero team as rife with infighting as with combatting monsters and villains. Exactly a year later, Stan and artist Steve Ditko plugged a teenage superhero into the cover and pages of a dying anthology title called *Amazing Fantasy*'s last issue.

Spider-Man was a success, marrying Lee's conversational narration with Ditko's spooky artwork. Where most superhero strips were colorful, Spider-Man managed to be both colorful yet wrapped in inky blacks; even the theme of the story—"with great power comes great responsibility"—is driven in with the murder of Spider-Man's

RIGHT
Lee and Steve Ditko's *Amazing Spider-Man* is comics' first coming-of-age superhero tale. From #19 (Dec. 1964). © 2012 Marvel Entertainment.

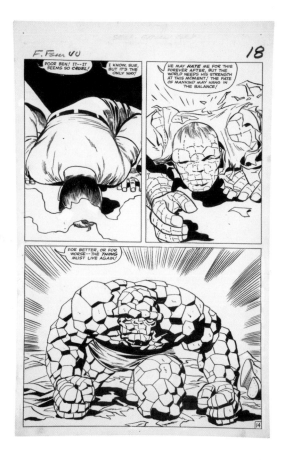

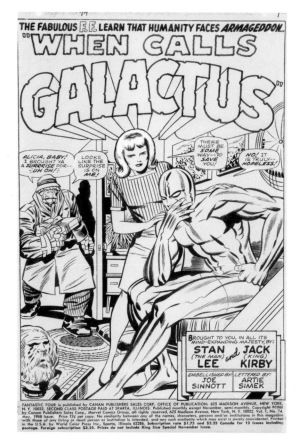

loving uncle, killed by a burglar the hero could have stopped earlier.

More heroes came out of the woodwork of Lee's hyperactive and busy mind and the hands of his co-creators and artists—Iron Man, Daredevil, the X-Men, and Thor, the Norse god of thunder. Stan wrote most all of them, working in what's come to be known as the "Marvel method" of storytelling: an utmost collaboration of writer and artist. The results were successful only because of Lee's ability to work with and around his artists, as well as each artist's impeccable sense of visual storytelling and character.

"I never wrote a script, sometimes I would write a page outline, but most of the time we just discussed it," Stan recalls working specifically with Kirby. "[The artist] would go home and he would draw his 20 or 22 pages based on what we had talked about. He would send the pages in, and inevitably, there were things that Jack would have added that we never discussed, which were all wonderful. I had the fun of putting in the dialogue and captions; it was so easy to write the copy for anything Jack drew, because I would look at his drawing and it would inspire me to write some good dialogue because the characters looked as though they were saying things that mattered. It was just such a pleasure to write stories based on the artwork that Jack had done."

ABOVE LEFT
The Thing, designed by artist Jack Kirby, was given comedian Jimmy Durante's voice by Stan Lee. Inks by Vinnie Coletta, from *Fantastic Four* #40 (Jul. 1965). © Marvel Entertainment.

ABOVE RIGHT
The Silver Surfer, fully conceived by Jack Kirby, became a sticking point between he and Lee. Inks by Joe Sinnott, from *The Fantastic Four* #74 (May 1968). © 2012 Marvel Entertainment.

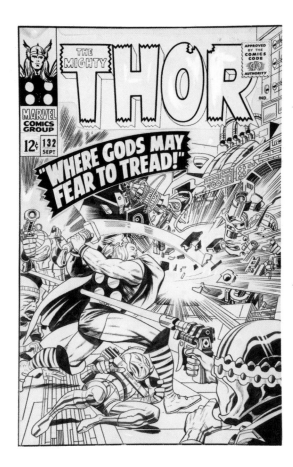

Stan and company at Marvel were producing relatively high-brow superhero books, featuring characters with believable faults, foibles, and hang-ups. It also helped that Stan employed a narrative voice that spoke directly to the readers, one that injected personality into his stories. Steve Ditko had been given co-plotter credit on *The Amazing Spider-Man,* and left in a dispute with Lee over the identity of master supervillian Green Goblin. Ditko walked out after #33, causing Lee to replace him with the more classic John Romita. Kirby would also leave Marvel, wanting more creative control over his comics, jumping ship to National to create his *New Gods.*

By 1972, after Goodman sold Marvel, Stan took over as Publisher, with Lee's protégé Roy Thomas taking over as Editor-in-Chief. Stan remained the face of Marvel and continued to chime in with his monthly "Stan's Soapbox" columns.

Stan moved out to California in 1981, serving as producer on film and television projects for Marvel. By 2000, the Marvel superheroes became box office draws, and Lee appeared in a string of Alfred Hitchcock-like cameos. While the Marvel movies have introduced new non-comic book reading audiences to their characters, they've also introduced Stan to a new generation.

ABOVE LEFT
Spider-Man enjoyed an atmosphere unlike any other superhero comics of the time, thanks to Ditko's inimitable style. From *The Amazing Spider-Man* #10 (Mar. 1964). © 2012 Marvel Entertainment.

ABOVE RIGHT
Lee gave his and Kirby's Thor a pseudo-Shakespearean language that lent the comic further charm. Inks by Vinnie Colletta, from *The Mighty Thor* #132 (Sep. 1966). © 2012 Marvel Entertainment.

Jack Kirby was having a hard time in the late '50s, like everyone in comics.

Work was hard to come by and Jack found himself back at Timely Comics, working under Stan Lee. The energetic Lee teamed up with Jack on everything from monsters to science fiction, drawn in Jack's trademark, bombastic style, complemented by Stan's equally bombastic dialogue.

However, while Lee and Kirby melded together well on paper, it came to a boiling point for Jack, as he felt deprived of the recognition he'd earned as co-storyteller with Lee. The outgoing Stan soon became viewed as Marvel's creative powerhouse and media darling, while Jack was viewed as merely an artist of the successful line of books.

Jack's later days at Marvel were rife with more and more frustrations, as Kirby saw characters like the Silver Surfer (fully created by him and dialogued by Lee in issues of *Fantastic Four*) taken over by Lee and artist John Buscema. There was even more heaped upon Jack when Marvel's new owners, Perfect Film, tried to force him to sign a contract that would take most of his rights to ownership.

Things had changed over at National: artist Carmine Infantino was elevated to Editorial Director, giving the old company a creative shot-in-the-arm. He was savvy enough to lure Kirby over from Marvel in 1970, with the promise of enough autonomy to write and draw his own books.

In 1971, Kirby launched his *Fourth World* books, which are collective examples of what happens when a creative powerhouse goes untethered. Told through four titles, they're a beautiful disaster, energetic and stocked full of original ideas and concepts, not fully coming together at the end, but packing a conceptual wallop still felt a few decades later.

The concept-heavy books were the first interlocking comic book titles, full of action and an enormous cast. It's as if the cork keeping all of Jack's own ideas dating back to Marvel had popped off and spilled out onto the pages. It wasn't necessarily pretty, but it was powerful!

Fourth World wasn't the success National had hoped for. The problem may have been in Jack's being given so much free reign; Jack may have needed a Joe Simon or a Stan

RIGHT
Jack Kirby bust, NYC, 2010.
Bust by Bowen Designs.

Lee to keep him in check, just as Joe and Stan needed a Jack Kirby to make their work more grandiose.

Jack's DC tenure wound up short-lived, as he boomeranged back to Marvel for a brief time. From there on, Jack's career took him all over the place, from animation work to creating *Silver Star* and *Captain Victory* for new, creator-owned publisher Pacific Comics.

Jack was no longer a presence at Marvel, fighting them in court to get the return of his original artwork. By 1987, Jack finally regained most of his artwork from the publisher he'd helped build, but some remained missing.

When Jack died of heart failure on February 6, 1994, he left behind an influence on all artists since, and an indelible impression on generations of fans. Jack Kirby didn't just steer the birth of comics: he also steered the direction of pop culture.

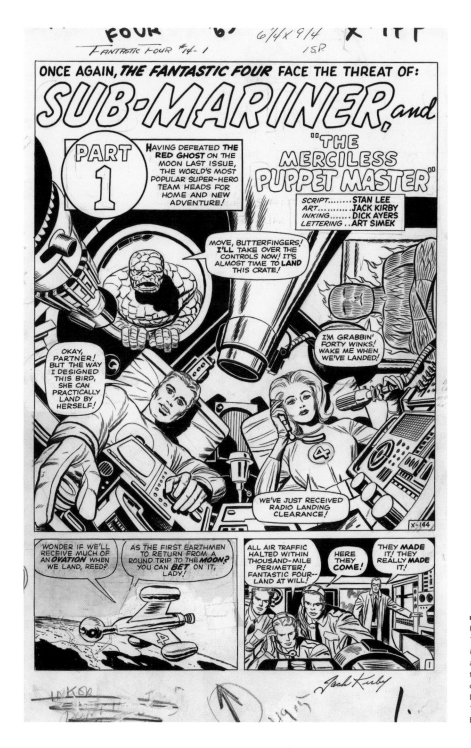

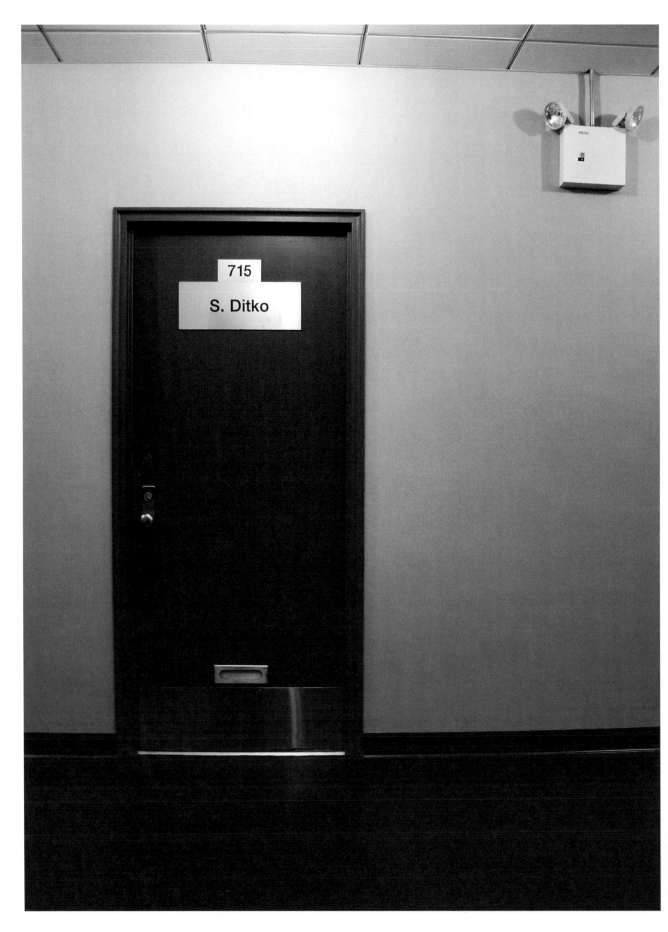

Like his comic book heroes, **Steve Ditko** stands apart from society while pursuing his philosophical and moral beliefs—rooted in author Ayn Rand's Objectivism—views that took root in his work shortly after his falling-out with Marvel Comics over the direction of *The Amazing Spider-Man.*

Under Ditko's distinct and moody art style, *Spider-Man* was the story of a social misfit who lived in a dark and challenging world. Both Peter Parker and Spider-Man suffered the slings and arrows of society, respectively his school mates and the media. To read *Spider-Man* was to relate to the unluckiest guy on the planet, awkward with girls and overly burdened with adult responsibilities thrust on him at a young age. When Stan Lee and Steve Ditko parted ways over the identity of a super-villain, it gave Lee and beautifully lush artist John Romita carte blanche to make Peter Parker sickly handsome—and instantly less relatable—more on par with a leading man than the character's original conception as an everyman. Ditko similarly abandoned his trippy and mystic hero Dr. Strange, who also went to other hands.

Ditko returned to his original comics home, publisher Charlton Comics in Derby, Connecticut in 1966. Even though the page rates were the lowest, Charlton offered creative freedom, as well as prompt payment on all work. Editor-in-Chief Dick Giordano had Ditko revamp old superhero the Blue Beetle as a crime fighting inventor borne out of the death of his predecessor—the first true legacy hero in comic books. *Blue Beetle* was a mostly traditional superhero book, similar to Ditko's work on *Spider-Man.* At first, the Blue Beetle waded into criminals regularly, his fists contorting and swaying to meet their chins, but it would soon mature as the cartoonist's beliefs began to emerge in print.

His faceless hero The Question soon erupted out of the back pages of Blue Beetle's own title—a television news reporter who stood on principle alone (much like Gary Cooper's stoic Howard Roark in the film version of *The Fountainhead*). The Question story in *Blue Beetle* #4 has often been cited as the start of Ditko's Objectivism, as The Question willingly leaves two villains to drown rather than save them.

LEFT
Steve Ditko's office door, NYC, 2009

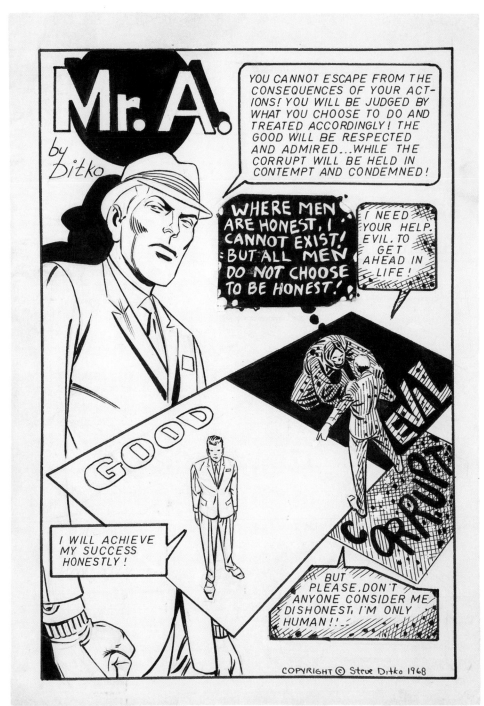

Objectivism came out full force in the next issue of *Beetle*, as Blue Beetle fought a costumed villain to protect art that projected the ideal man, the heroic figure that society gave up on aspiring to.

Former EC artist Wally Wood gave Ditko a shot at a new character, Mr. A., in Wood's self-published *Witzend* in 1967. Mr. A. was Ditko's ultimate mouthpiece for Objectivism, not hindered by editorial policy or the Comics Code, taking The Question and slapping on a metal faceplate rather than a featureless mask. In his debut story, Mr. A. dispenses his personal philosophy—that there can be no gray, but only good or evil—while meting out his brand of justice.

Never before had cartoonists taken the superhero archetype as a philosophical vehicle, and *Mr. A.* is perhaps the first sign of Ditko's refusal to compromise, one had that likely taken root from his frustrations over *Spider-Man* and *The Question*. Years later, the extreme superhero became a cliché, but Ditko's morally hard-line superheroes predated them by at least a decade.

Steve Ditko continued to do work for DC Comics, having moved there with former Charlton editor Dick Giordano; The Creeper was a macabre superhero who affected a laugh and bombastic supernatural dialogue when not investigating crimes for a local news station, while Hawk and Dove (perhaps the most significant heroes of the Vietnam era) were two brothers whose pacifistic and violent tendencies collided as much as their supervillians. His trademark weird style was there, his characters existing in inky shadows, limbs distorted at grotesque angles. Ditko may not have drawn like a perfect draftsman, but he drew *effectively* in his distinctive and almost surreal style.

Now living in semi-retirement, Ditko never makes appearances, politely refuses interviews, and creates his own philosophically-heavy comic books under a small publisher. The only clues to understanding Steve Ditko are copies of his comic books… And that's how he prefers it.

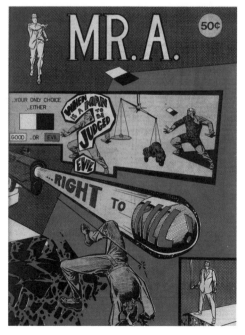

"The longer you work at it, the better you get, right?" Gene Colan posited. "Like anyone else, you start at the ground up. There was so much I did not know, but I got a lot of help.

"Anyway, they were great years. I must have been in there for three to four years, before the bottom dropped out and we had to take what we could get."

After returning stateside from the second World War, Gene Colan went back to Timely Comics, where he cut his teeth for a few years. It wasn't long before Stan Lee, under orders from publisher Martin Goodman, was forced to let the art department go.

"There were some tough times, like with any business, and there are the good and the bad," Gene noted. "You have to just get through it."

Colan had a stint at National Comics and, when Stan got his new Marvel Comics off the ground, Gene returned under the pseudonym Adam Austin, as a superhero artist. As superheroes were changing Marvel, Marvel would soon change Colan.

"Stan allowed the artists to be themselves," Gene said. "Stan was running the show, and whatever style they wanted to work in was all right with him. Sometimes, if a particular artist sold a lot of books, he'd want other artists to draw like him. I refused to do it, and said, 'Then get that artist, and not me.' I wasn't going to change, so he just left me alone. It was pretty easy to work with Stan: he was very youthful, and he still is."

Perhaps it was the Marvel-wide influence of head artist Jack Kirby, or perhaps it was Stan's desire for more dynamic artwork, but it was at this point that Gene Colan went from being yet another comic book artist to becoming the fluid and distinctive artist he is now. Characters are realistically drawn, but with a sketchy quality that makes them come more alive. Gene's work became more cinematic, with something new and daring in his pencils, something experimental and atmospheric.

RIGHT
Gene Colan, Brooklyn, NY, 2010

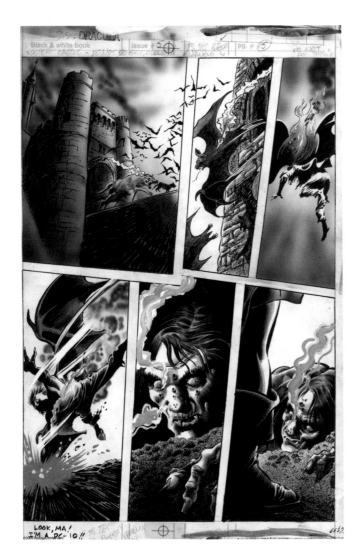

"I enjoyed the characters while I was doing them, but I sort of made believe that I was a filmmaker, and I loved to tell a good story, but not in a typical way. I would try to find something that would interest me and not the same old stuff all of the time, in the same cut and dry method of illustrating a plot.

"As a matter of fact, I never read the stories, and would only read the first three or four pages. So long as I could deal with it like that, I could deal with it. I would read the next three or four. If something came up that I needed to know about, I would sense it and read beyond that and see what it was that I needed to know about. I never wanted to be hit with a surprise, suddenly. I can handle it better the other way."

By the '70s, the stifling Comics Code had just been amended to allow the presence of horror in Code-approved books, and Marvel jumped on the bandwagon with a series of new monster comics and magazines. When Gene Colan heard that a Dracula comic was in the works in 1972—*Tomb of Dracula*, with writer Marv Wolfman—he pursued Stan Lee about getting the art chores.

A year after *Tomb of Dracula* debuted, actor Jack Palance coincidentally played the Count in an unrelated 1973 Dracula film; Colan was prescient in casting the tough guy as the famous vampire for *Tomb,* a sign of the filmmaker inside.

"I felt, being a big film buff, who would fashion into a good Dracula? What actor would be good?" Gene posed. "I thought Jack Palance, without a doubt, had to be Dracula: he's really tall. He played him later.

"Jack Palance had a way," Gene comically shivered.

Wolfman and Colan created an army of vampire hunters, many related to the

characters from Bram Stoker's original novel. *The Tomb of Dracula* followed their pursuit of the vampire; of course, you can't put a good monster down, and the book went on until 1980 with the good guys only "almost" getting him.

Gene also drew the satire comic book *Howard the Duck* in the late '70s, which burst out into a daily comic strip. But, as far as Gene is concerned, it was second banana to *Tomb of Dracula:*

"*Tomb of Dracula* is the one I concentrated on the most, and for the longest time," Gene said. "Marv Wolfman was easy to work with. He wrote it and, if there was anything in there I couldn't understand, I just gave him a call. I lived out in New Jersey and he was in the city somewhere. He would talk about it and make some changes. He was an easy person to work with: there's nothing worse for an artist than to be uptight with an editor, because then you don't know what to give them, because you want to give them the right thing."

Over the next few decades, Colan's work was shot straight from his pencil artwork, evolving into his painterly shaded style.

"It's a realistic style," Gene pointed out when discussing his trademark look. "My stuff is more straightforward, more like 'This is my impression, an illustration but of real life.'"

Gene had suffered from health problems, prompting the industry to unite regularly to help the uninsured Gene pay off his medical bills by the early 2000s. After several bouts of illness, Gene Colan passed away on June 23, 2011, having left his own indelible impression on comic books in everything from his powerful pencil strokes to his gentle manner.

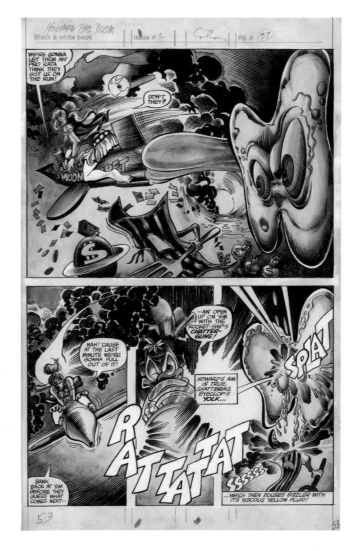

"I have no contemporaries," **Neal Adams** admits. "Basically, I sparkplugged all the old guys. They were like, 'What's he doing? Fancy panels and all that stuff? What's that?'

"They got a kick out of it, and I met all the old guys, and made friends with all the old generation. I was the unexpected thing, sort of like you're in a family with five kids and then mom gets pregnant again."

Sandwiched between the older generation and the one that surfaced in the mid-'60s, Neal found himself the lone cheerleader and catalyst for change in what was then a static world.

As Neal Adams' style emerged in the '60s, it was as a photorealistic cartoonist with modern graphic design leanings, on books like *X-Men*, *Batman*, and *Deadman*. Adams and writer Denny O'Neil not only brought a pulp grimness back to *Batman*, but added social relevance with the buddy comic *Green Lantern/Green Arrow*.

"[Denny] didn't come anywhere near superheroes," Neal observes. "He wrote that book about America. Everything that he did was about real people and real personal situations…None of the characters came out, but he was fighting the real world, and with another real world character. I've got to say, we got pretty gritty, and into the gutter, very, very heavily."

In the pages of *GL/GA*, the pair jabbed at the president and vice president, corporate America, over-population, and (most famously) drug abuse.

"One of the reasons comics were so dull was that the Comics Code made them dull," Neal states. "There were so many things that you couldn't do, and one of those was that you couldn't deal with drugs…

"One day, we were running out of subjects for *Green Lantern/Green Arrow* to deal with…I thought, 'This whole ride is going to end soon, so I think we should have a drug issue.' So, I went home and did that first cover, with Speedy having shot

LEFT
Neal Adams, NYC, 2009

FOLLOWING PAGE, TOP
For a time, Adams was National's premiere cover artist. Inks by Dick Giordano, from *Superman* #235 (Mar. 1971). © 2012 DC Entertainment.

FOLLOWING PAGE, BOTTOM
Adams made *Deadman* an experimental supernatural book. From *Strange Adventures* #208 (Jan. 1968). © DC Entertainment.

up, with Green Lantern and Green Arrow in the background, with Green Lantern saying, 'See, schmuck, what happened to you?' I brought it in, penciled and inked, and gave it to editor Julie Schwartz. Of course, Julie dropped it because it was too hot to handle and sat back in his chair, with frightened eyes, saying, 'We can't publish this. What are you doing?'

"So I took it in to Carmine Infantino and he dropped it in confusion. I, clearly, had gone over the deep end. Then I took it to the executives of the company, who looked at me as if I was crazy and basically all said, 'You're crazy, you can't do this. Forget it. It will never, ever happen. You are nuts.'"

Around the same time, Stan Lee at Marvel wrote the anti-drug issues of *The Amazing Spider-Man*, which were published without the Comics Code seal of approval. And the industry didn't implode after all.

"Since the publishers were the ones to write the Code, they called an emergency meeting. Within two weeks, they had rewritten the whole Comics Code. Carmine came down the hall and said, 'Do the book,' so we did it."

• • •

Arguably more important than his contributions to the visual side of comics is Adams' activism towards creator's rights. It came to a full boil around 1975 when Neal Adams and Jerry Robinson stepped up to bat to help out Jerry Siegel and Joe Shuster. Warner Brothers had bought out National Comics earlier in the decade and were producing a mega-budget Superman movie, with none of it going to the Man of Steel's now-destitute creators.

Siegel was working as a postal clerk in California for $7,000 a year, while the unemployed and practically blind Shuster was living an even more destitute life. More Clark Kent with his typewriter than Superman, the bitter Siegel knocked out a ten-page letter that was mimeographed and sent to a thousand media outlets.

While Jerry wanted financial reparations for Superman for the two of them, the real prize was something denied for 40 years—restoration of their credit as Superman's creators. Jerry was finally given media attention in *The Washington Star*, which led to an interview on *The Tomorrow Show* with Tom Snyder—an episode caught by Jerry Robinson, who won the involvement of the National Cartoonists Society. Robinson got the ball rolling behind-the-scenes for Jerry and Joe, with Neal Adams' help.

"Realizing that something had to be done about it, and that there was probably not anyone who was going to do anything, I called up Jerry and Joe," Neal recalls. "I called Jerry first, since he'd sent the letter, and I offered to help in any way I could, by offering to represent them to anyone I could in a non-legal way, and plead their case to the public."

"[Jerry had] been fighting it for years and was bitter and unhappy. He had a heart condition and was holding up as well as he could under those conditions. I didn't quite understand how it could have gotten to that sorry state. I worked at undoing it."

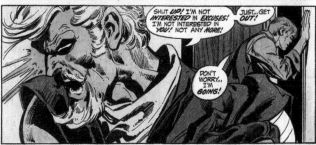
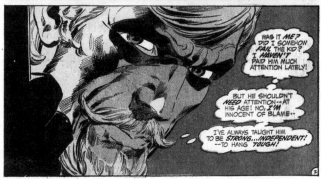

Through the efforts of the National Cartoonists Society and president Jerry Robinson, as well as Adams' vocal support within the comic book industry, the pair successfully regained their credit, along with an annual pension.

"There was no downside to treating them like human beings," Neal says. "They did better, their names got back on the comic book, they got to be feted by DC Comics and Warner Brothers anytime they wanted to do something with Superman, they got introduced and had smiles on their faces because there was money in their pocket. It all worked out very well for everybody."

ABOVE
A pivotal sequence from O'Neil and Adams' second "drug issue", *Green Lantern/Green Arrow* #86, Vol. 2 (Oct.-Nov. 1971). Inks by Dick Giordano. © DC Entertainment.

DENNIS O'NEIL
NYC, 2009

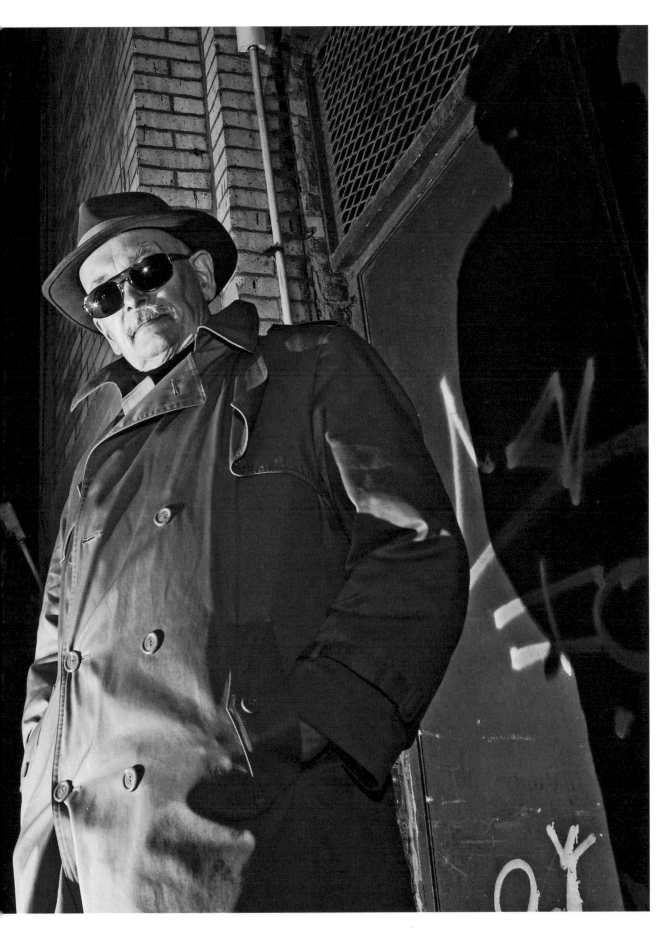

"The Batman that I loved at age six would not have a dozen readers today," Dennis O'Neil admits.

"Sometimes people get stuck, and I'd see it all the time when I was editing *Batman*. The Batman that was their Batman at age fifteen 'is the right Batman, and anything else is blasphemy.' It was right for them at the time, but they have to evolve."

To only credit Dennis "Denny" O'Neil as a writer of superhero comics is an understatement; he took the superhero comic book and, particularly in the '70s, forced it to evolve in ways that no one saw coming. Like the characters he wrote and edited, Denny O'Neil had an evolution of his own.

Denny was different from the other writers of his generation, this breed who started as die-hard fans. O'Neil fell into it at a young age, with just a handful of real world experience, after working for a short time as a journalist.

After six months of working at Marvel in 1966, Denny left Stan Lee's employ and dived into the world of freelance writing. While still doing occasional jobs for Stan, he found his way to Charlton Comics' New York City office, a satellite for the bottom-of-the-barrel Connecticut publisher, who paid only four dollars a page—low even by '60s standards. Only through the ability of their chief editor, Dick Giordano, did Charlton manage to put out any semblance of quality comics.

"No one was thinking about anything except next month," he admits. "I must have been aware that there could have been problems, because I adopted a pseudonym. I worked as Dennis O'Neil doing Westerns and various superheroes at Marvel, and did various things for Charlton as Sergius O'Shaugnessy. I was very grateful. I learned the rock hard basics, one of which was to meet the deadline."

Giordano left Charlton for National Comics in 1968, bringing with him his stable of writers and artists, from Steve Ditko to the young O'Neil. It was a move that would ultimately gave O'Neil his forum for reinventing superhero comics.

When O'Neil was assigned the failing Green Lantern comic book in 1970 by editor Julius Schwartz, and paired with hot shot artist Neal Adams, he paired the space cop with the hippie archer Green Arrow. *Green Lantern/Green Arrow* brought social relevance

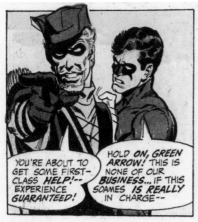
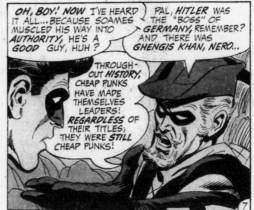

to the pages of superhero comics in a big way.

"We had started doing the so-called 'relevant stories' and then I remember the Comics Code called a meeting, and I got invited as a representative of the freelance community," O'Neil recalls. "It was about Stan's drug issue of *Spider-Man*. What they finally decided was that they could run it without the seal of approval. That, after a while, became a common practice and took this paper tiger—the Code— and made it even less menacing."

Not long after, *GL/GA* revealed Green Arrow's unfortunately-named sidekick Speedy's heroin addiction. Even though Speedy mysteriously recovered by issue's end, it was revolutionary in the cover alone: Speedy was shown with a syringe hovering above his arm, about to shoot up, while Green Lantern and Green Arrow burst in.

Denny O'Neil and Neal Adams reinvigorated Batman in 1970 by returning the character to his original roots as a pulpish detective and crime fighter, introducing characters like Ra's al Ghul, Batman's own personal Moriarty, and al Ghul's daughter Talia, the true love of Batman's life. Along with stints writing (and later editing) *Daredevil* at Marvel, O'Neil landed back at DC Comics by 1986 and became editor of the *Batman* comics, a position he would hold for over a decade.

During O'Neil's tenure, Batman was revamped in the *Batman: Year One* origin story by Frank Miller and artist David Mazzucchelli, Alan Moore and Brian Bolland's violent *The Killing Joke* graphic novel put a darker twist on his archfoe, and Robin the Boy Wonder was killed off in 1988. O'Neil has impacted Batman more long-term than anyone since the character's co-creator Bill Finger, as both writer and editor.

ABOVE
One of *GL/GA*'s many philosophical battles. Pencils by Neal Adams and inks by Frank Giacoia, from #77, Vol. 2 (Jun. 1970). © 2012 DC Entertainment.

"Look, I had one of the great jobs on the planet, and I enjoyed it thoroughly," Paul Levitz says.

"I wish all well to the people who have taken over the different pieces of the responsibility. I hope they have as much fun as I did, last as long if not longer. Try to leave the thing in a better shape then when you find it. That's what I tried to do. I generally think I pulled it off."

Starting in the '70s, Levitz rose in the ranks of DC Comics from Assistant Editor to President & Publisher. Now, he has successfully returned to writing *The Legion of Super-Heroes*, the series that he reinvented earlier in his career—proof that you can go home again.

Levitz hasn't just *seen* the history, but also *lived* it, coming into comics as part of the wave of fandom entering the industry's ranks from around the late '60s to mid-'70s. An entire generation of professionals rose from their modest fan magazine origins and Levitz was no exception, entering the comics industry at age fourteen after editing fan magazine *The Comic Reader*. It provided his entry point into DC Comics as editor Joe Orlando's assistant.

• • •

"[Howard] Chaykin has a great line: we came in at the end of the beginning," Levitz smiles. "We got to know the people who had created the business, but we had a lot of room to create change because the seats were becoming open so rapidly."

Where the creatives were seen as "interchangeable" in the early days, that attitude shifted when artist Carmine Infantino ascended to Art Director in 1965, and then Editorial Director shortly after. Infantino also started hiring editors on freelance, such as Mike Sekowsky. Creator credits even began appearing inside of DC Comics in 1965; it was one of the ways writers and artists started to go from being "interchangeable" to becoming appreciated.

Infantino gave DC more of a fighting chance against Marvel Comics, pushing for a visual sophistication across the board. He encouraged and brought in diverse new talent

LEFT
Paul Levitz, NYC, 2011

such as Walter Simonson to give DC a youthful shot in the arm. Infantino rose even further to Publisher in 1971, and President shortly after.

Carmine left in 1976 and was replaced with production man Sol Harrison as President, while a bold choice was made for the new Publisher: 28-year-old Jenette Kahn, who put things in motion that would even further improve conditions for creators at DC Comics and reach out to affect the entire industry. Kahn even officially changed National Comics' name to the long-branded DC Comics.

"As soon as she got there she saw the shape our field was in, which was not our glory days, and she wanted to find ways to change that, both by taking more creative chances with the material itself and the form, and creating a better set of economic deals with the talent that would give them more incentive to do the work for comics…

"She wanted to find ways around that, and a lot of the work we did over the next batch of years was to create things like the first written contracts for the field for all the contributors, the first royalty plan, and things that would hopefully align the creative talent with the publishing business better, and let everyone live together."

1982 saw one of the high points of Levitz's run on *Legion of Super-Heroes*. His "Great Darkness Saga" ran through five issues (#290–#294) and pitted the Legion against an unknown and all-powerful foe. When the revelation of Jack Kirby villain Darkseid is made in the penultimate issue, it instantly folds *Legion* into the bigger picture of the DC Universe's history.

Levitz's *Legion* was clearly as woven into the tapestry of the DC universe as much as the other titles. "Great Darkness" was a precursor to the multi-part story arcs that have been the norm in monthly comics for over a decade, with each issue leading into one another in an organic fashion.

Meanwhile, DC continued to change, thanks in part to the direct market's allowance for more mature comic books, the new regime's opportunities for creators to maintain ownership of their work and to receive better royalties, and Kahn and Levitz's embracing of new formats.

Kahn's ultimate creative coup was in luring cartoonist Frank Miller over from Marvel Comics to produce *Ronin* in 1983. He followed that up with the postmodernist *Batman: The Dark Knight Returns* in 1986, which became DC's first successful trade paperback collection.

RIGHT
Levitz used Kirby's Darkseid as the major villain of the "Great Darkness Saga." Art by Keith Giffen and Larry Mahlstedt, from *Legion of Super-Heroes* #292 (Dec. 1982). © 2012 DC Entertainment.

Writer Alan Moore and artist Dave Gibbons pitched a finite series, titled *Who Killed the Peacemaker?*, using a group of superheroes DC had just inherited from the defunct comic book company Charlton. Managing Editor Giordano, Levitz, and Kahn prompted the British creators to do their own archetypal characters, and *Watchmen* was born—grabbing a coveted Hugo Award and becoming one of the best selling trade paperbacks of all time.

"The better opportunity for it seemed to be in doing it as an original, because that way the characters could wrap at the end of it, which is what Alan and Dave wanted to do," Levitz recalls. "They could also get a better financial deal because they'd be dealing with something that was a more original piece of property."

Both *Watchmen* and *Dark Knight Returns* have been noted for changing the course of the superhero, sparking a postmodernist slant on the well-trodden men and women in tights genre.

• • •

By the time Levitz concluded with *Legion of Super-Heroes* #63 in 1989 (with artist and co-plotter Keith Giffen), he had spent seven consecutive years crafting DC's future, and around twelve total. Paul Levitz would only sporadically write comics for the next two decades, until his '09 return.

1989 also saw the Time/Warner merger, which garnered Jenette Kahn a promotion to President and Editor-in-Chief, while Levitz was bumped up to Executive Vice-President and Publisher. DC continued to issue experimental books, from the mature-readers Vertigo line to non-superhero imprint Paradox Press. When Levitz inherited the President title from Kahn upon her departure in 2002, he was in charge of a company drastically changed from the one he entered as a teenager, one that he helped craft.

Paul Levitz has seen the ups and downs of the comic book world for 40 years, from both creative and marketing perspectives. While doom and gloom is a common forecast every time sales dip by a percentage, or cover prices go up a buck, Levitz doesn't seem worried. Maybe it's from his ground-level experience, or the optimism of the *Legion of Super-Heroes'* future sticking with him past his keyboard—or maybe it's a combination of both.

"I actually like when comics weren't highly regarded, because they were more subversive," Walter Simonson says.

"There was a time when they were the first thing a kid could buy with his own money, that their parents had no control of. I like that quality." Walter Simonson's trademark goes beyond his beard and glasses and into his distinct mode of storytelling, a blend of Jack Kirby's dynamism and blocky design mixed with a cinematic pacing laced with distinctive sound effects. His style is far from the norm in comics, and his big break was the result of an artist brilliantly unorthodox in his own work, Carmine Infantino—then head cheese at National Comics—who insisted his editors give the budding Simonson work. Simonson started in shorter stories, and soon gained acclaim through the Manhunter stories, written by Archie Goodwin.

"I later worked with Joe Orlando," Walter said of the legendary artist/editor, who had started at EC Comics. "The last time I saw Joe, we'd had dinner that night and he told me was that he felt Carmine saw in me what he would have become had he stayed with it, with the science fiction and design. He saw in me, maybe himself, young and starting out. He was very good to me and, at the time, got me a phenomenal starting rate. Carmine did like the work I had a lot."

Walter eventually worked over at Marvel, who'd had their own tumultuous staff changes. After struggling with a rotating cast of Editor-in-Chiefs, Marvel eventually tapped assistant editor Jim Shooter. Walter's success came under Shooter's time at the top; a tough Editor-in-Chief, criticisms of Shooter involve strict editorial edicts later in his tenure. It was under Shooter's stewardship at Marvel that Simonson took over classic Marvel character Thor, which would become his defining work.

"I couldn't really explain it, but I think that Jim Shooter had something to do with it," Walter observed of the turning point in comics. "He became Editor-in-Chief of Marvel in '77, and there was a while where he was encouraging creativity. He also hired some good editors. Denny O'Neil and others were there as editors, and I think it was a confluence of a lot of talent that crystallized at Marvel at that time, and were given their head. It wouldn't be possible now with editorial direction but, at the time, there was a lot of freedom. And they had some guys who were quite good. In my case with *Thor*, literally, I was hired by Mark Gruenwald, who was the editor at the time.

BELOW
Walter Simonson,
Upstate NY, 2009

"When Mark asked if I wanted to do *Thor*, he gave me carte blanche on it. He gave me a sheet of paper with seven or eight ideas of what to do with *Thor*. He said, 'I don't care if you do these or not, but this is just to show you that I'm serious about doing things different.' The book wasn't selling well. It was a great position to be in because, had it gone down the tubes, I'd still have a lot of room to play. I think that Frank also had a lot of room on *Daredevil*."

Walter's *Thor* run sparked many controversial changes in the Thunder God by introducing alien Thor, Beta Ray Bill, and turning Thor into, of all things, a giant frog. He followed *Thor* up by taking over *X-Factor*, a comic series starring the original five X-Men cast, which he drew and co-wrote with wife Louise. It injected a wealth of new ideas and concepts into the *X-Men* books, including turning the X-Man Angel into the more formidable razor-winged Archangel, and introducing long-standing villain Apocalypse.

In 2000, Simonson again took the reins of a Kirby creation—this one the most pure—when he wrote and drew *Orion*, off of the star character from the *Fourth World* books.

"As far as competing with that material, why bother?" Walter points out. "There's not a chance in hell that any of us could compete with that stuff, so that's not really a question. I had heard that the *Fourth World* was Jack's most personal work in mainstream comics, which I agree with. On that basis, to try to compete with somebody's personal work: you can't do it, it's like apples and oranges."

Although it only ran for two years, *Orion* merged Simonson's penchant for sound effects and design with the power of Kirby's iconic work. To his credit, as with *Thor*, Simonson avoided the route of a slavish fan and placed his own stamp on Kirby's unique world.

"I read where someone was grousing about some story line that was recently run involving some of Jack's characters, because they thought it was 'not what Jack would have done,' and every time you do a story with the New Gods, you have to ask yourself, 'Would Jack have done this?' I think that's probably the wrong way to go about working on this material.

"I certainly did do my damnedest to be as true to Jack's work as possible. At the same time, I can't ask Jack what he thinks about the stuff I'm doing. I knew Jack very casually. I was a huge admirer, and am a huge fan of his. But in the end, the best I can be is a really good Walt Simonson, I can't be a good second-rate Jack Kirby."

MARVEL® COMICS

FOLD COPY TRIM COPY

YELLOW TS

RED TS

COPY TRIM FOLD COPY

TITLE
NO.
MONTH

ARTIST

TRIM COPY

BLACK TS

BLUE TS

COPY TRIM COPY

LEFT
Beta Ray Bill, an alien
version of Thor, is one of
Simonson's breakout stars.
From *The Mighty Thor*
#337 (Nov. 1983). © 2012
Marvel Entertainment.

KIM DEITCH
NYC, 2008

"The secret of my work routine is that I think I've cultivated a relationship with my subconscious mind, so I figured out that it's a different part of your brain," Kim Deitch says.

"For instance, there's the part of your brain that does interviews or other things in your life. One way I get at it is that I take my work to bed with me, especially when I'm creating it. I take a look at what I did in the day and troubleshoot where it's weak and needs improvement. By doing that before I go to sleep, my brain works on it while I'm sleeping. I wake up in the morning and I get working on it as soon as I get a cup of coffee into myself. It's amazing how the little problems start to solve themselves, because even though you don't think you're working on it, something back here is."

The pioneers of the undergrounds, including Crumb and Art Spiegelman, advanced the comics form from the fringes of society, shunning the censorship that had taken the once vibrant medium and set it back from the pinnacle of the EC days of *Tales from the Crypt* and Kurtzman's *MAD*.

Emerging from the underground comix scene of the 1960s, Kim Deitch evolved from a capable cartoonist into a truly unique voice in comics, his work treating a love of forgotten pop culture with a romantic fondness that never devolves into sappy nostalgia. Maybe it's because all of his characters are haunted by personal demons—or by Deitch's favorite subject, a 1930s-era cartoon cat named Waldo who is literally a demon incarnate.

"I'm very much inspired by R. Crumb," Kim admits of his contemporary. "I'd say he's my biggest idol in comics. He was one of my hugest inspirations for getting more involved in all this. While I'd already been involved, he just raised the bar and made the whole level of commitment that much higher.

RIGHT
Kim Deitch's inclusion of himself gives a reality to Waldo the Cat and his absurd animated minions. From *The Search for Smilin' Ed*. © 2012 Kim Deitch.

"I'd like to think that I'm not that much different, in terms of level of commitment, than someone like him. I'm not as good an artist as him, but I don't know who is. I just try to tell good solid stories. I try to make them real enough so that

I'm believing them dramatically when I write them. It's a big deal in my life. I've been doing this for 40-odd years, and I've finally gotten to the point where I like to draw and have trained myself up to reasonably good work habits. I'd be lost without it; it's what I do."

Waldo the Cat started as an exercise for Kim: an anthropomorphic character that could be drawn repeatedly with his developing skills as a beginning cartoonist. Waldo eventually took on a life of his own, and became a figure of torment for various Deitch characters (including Deitch himself), a cross between a trickster god and Felix the Cat. Waldo serves as the catalyst for Deitch's 2002 graphic novel, *The Boulevard of Broken Dreams* (a collaboration with his brother, Simon), which is heavily based on the history of American animation in the early to mid-20th century.

The tragedy behind *The Boulevard of Broken Dreams* lies in the harsh realities dealt the "dreamers" themselves, as they try to survive the decline of animation in the 1930s, as it went from unfettered and into Walt Disney territory.

The basis in history lapsed into Kim's next Waldo project, *Alias the Cat*. With Kim himself as narrator and main character, the reader goes on a historical investigation "supported" by documents dug up by Kim in his quest for the truth behind Waldo the cartoon cat. One chapter features an "interview" with one of the story's characters, told in thirteen pages of prose with corresponding spot illustrations. His next project, *Deitch's Pictorama*, with brothers Seth and Simon, took the prose with graphics approach further.

"It seems like comics are a great delivery system for dishing out words and pictures, but there are times when certain subjective ideas are better expressed in a novel," notes Kim. "So wouldn't it be great if I could get that working better in comics so it wouldn't be so laughable, for instance, if comics get in over their head?"

"One thing that's irritating is that I never thought of what I was making as a 'graphic novel;' It wasn't a phrase in my head," Art Spiegelman says about his Pulitzer-Prize-winning comic book *Maus.*

"I was aware of what Will Eisner had done with *A Contract with God*, or even Harvey Kurtzman's *Jungle Book* (which was something I loved). I was trying to make something different, a structured long work with a beginning, middle, and end—not a collection of short stories. It was an outlined work and (to that degree) novelistic. I wanted it to have the density to withstand, even demand, rereading… I was making a long comic book but I knew I didn't want it to *look* like a comic book. So, I guess it meets the parameters of what is now called a graphic novel."

The story of his parents' survival in the concentration camps of the Second World War, *Maus* is Spiegelman's heartfelt and honest chronicle of a Holocaust survivor—and what it means to be the child of one. One of *Maus*' greatest strengths isn't just in his parents' story, but in the story of Art's dysfunctional relationship with his neurotic father, giving the reader a framing sequence that provokes a personal investment in Art's own plight living with a Holocaust survivor. The irony of *Maus*' success is that it has burned Spiegelman out on his deeply personal story. After being the subject of numerous articles and academic treatises, he feels the work has been completely "talked out."

Art grew up in Queens, New York, around the homogenized post-Comics Code comics, the sugary sweet and bland era of National Comics and Dell Comics, where the stories were "harmless" and vanilla. An encounter with *MAD Magazine* at age seven, and a subsequent introduction to old EC crime and horror books, energized him. On top of that, the young Art was researching old comic strips at the local library on his own.

It was into the experimental world of the underground comix that Art Spiegelman dropped out of art school and launched himself years later. His most intense early work, "Prisoner on the Hell Planet," recalls his mother Anja's suicide in 1968. Arguably his most significant early autobiographical piece, "Hell Planet" was far from being his last.

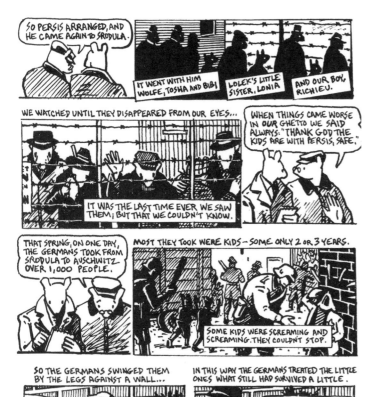

"I remember very early in the '70s thinking that comics needed to strike a Faustian deal with the culture, now that they were no longer a mass medium," Art says. "They were part of what happens in the detritus of the culture, but they weren't the likely place to look for things to develop anymore. Newspaper strips were already shutting down rather than opening up, and the comic book industry was rapidly becoming tedious. Even the underground comics were beginning to shut down as the paraphernalia shops closed…

"Anyway I figured that museums, libraries, granting institutions, schools, and bookstores had to be colonized so that comics might have a place in the late twentieth and now early 21st century."

As the undergrounds were shutting down, Will Eisner was opening up to the newfound potential of comics, on display in the underground scene. In 1971, Eisner was invited to a comic convention by organizer Phil Seuling. It was here that Eisner had his first exposure to the underground comix, comics that were experimental in ways Will never would have dreamed of.

Eisner once again dedicated himself to comics, beginning work on *A Contract with God*, widely considered the first ever "graphic novel" upon publication in 1978. Set in a Bronx tenement during the Great Depression, Contract features four stories, each one following the human drama of a tenant. Rather than a shoddy paperback collection of juvenilia, *Contract* was an adult novel in the graphic language of a comic book, and entirely self-contained. Will also eschewed typical panel borders for loose, dreamy bubbles with characters on a stage, rather than actors in a frozen film still. Where the focus on his earlier work was viewed through the environment,

his later work zeroed in on the characters trapped in that environment.

That same year, Spiegelman took his first step to widespread legitimacy with *Breakdowns*, a collection of his various experiments in form and style. Reprinted there was his first *Maus* story, kind of an audition for what would become his longer work; a grandfather mouse tells his grandson of the Holocaust as a bedtime story, touching on the high and low points of Vladek's experiences.

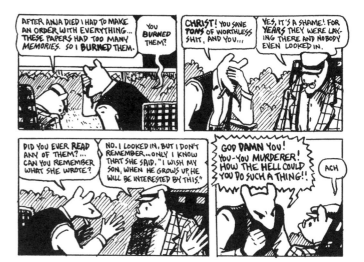

Two years later, Art and wife Françoise Mouly began the self-published *RAW*, an adult comix anthology that showcased established and up-and-coming underground talent, and also featured *Maus'* serialization.

Spiegelman engineered comics that raised the bar of legitimacy for the form, from the disarming sophistication of *Maus* to the grab bag of literary comics in *RAW*. *Maus* inadvertently took the term "graphic novel" and set it on its way to becoming a buzzword.

"If I was just coming of age now would I get interested in making comics?" Art posits. "I'm not sure that I would. A lot of it has to do with this private ownership of [comics as] a completely neglected haunted house that is caving in and that you could go to and nobody else knew about. That was part of the reason it became such a sanctuary for me; it didn't feel so overpopulated…No one else was living in it, so it was very stimulating and a great place to look around. Now, I get confused easily: there are people who really love stuff that [when I look at it] I only wonder why it would be worth ten minutes of anybody's time, and there's stuff that I'm in awe of because it's amazing how great the abilities are of the people doing comics.

"This cultural-striving I was interested in was playing with fire," Art admits later. "As soon as everything is categorized, colonized, and labeled, things begin to feel as shut down and forbidding as the culture was when it led me to escape into that aforementioned haunted house full of old comic books."

LEFT AND ABOVE
Maus presented the reality of the Holocaust through the lens of an anthropomorphic cast.
© 2012 Art Spiegelman.

"When you live in Cleveland, it's hard to transcend," Harvey Pekar admitted of his hometown.

Part of the appeal behind his autobio comics are that they do take place in one of the most uneventful cities in existence, where mundane, everyday occurrences are the pinnacle of excitement—and all there is to write about. By reading about the late Harvey Pekar, the everyman file clerk, and his neuroses, it's easy for us to relate through the boredom of our own everyday lives.

In 1972, Pekar's friend, former neighbor, and fellow jazz fanatic, underground cartoonist Robert Crumb, encouraged Harvey to tell his stories in comics form. Conceived as stick figures scrawled out on paper, Harvey's first story "Crazy Ed" metamorphosed into a comic book story in Crumb's *The People's Comics.* By 1976, Harvey was writing his life story, illustrated by an assortment of artists, for his self-published comic *American Splendor.*

"What I do is start with a story or a biographical sketch or something like that, and I'll just think about the things from beginning to end," Harvey explained. "Maybe everybody does it like this: I dictate it to myself and write it down as I think of it. That's the way I do it. I guess it's kind of unusual because I use a storyboard technique. What I do is divide the page up into panels and I just put the stick figures in there, plus balloons for speech and thought. Then maybe instructions to the artist on what I would like to see in the panel, but I don't get strict about it and say, 'I want to see how this guy followed directions' and go back and check to see if they did it. I think it's because I've worked with pretty good people, and I always say 'If you think you can do something better, you know what you can do and how you like to draw. Go ahead and do that.'"

American Splendor came out sporadically over the years, garnering Harvey an American Book Award in 1987. Harvey started the '90s with a near life-ending experience: lymphatic cancer. Harvey and his wife, Joyce Brabner, chronicled Harvey's bout with cancer in the 1994 *American Splendor* graphic novel, *Our Cancer Year*, drawn by Frank Stack.

Recovering from his illness, Harvey brought *American Splendor* back through a couple of different publishers. Along the way, he picked up more contributors,

LEFT
Harvey Pekar, NYC, 2009

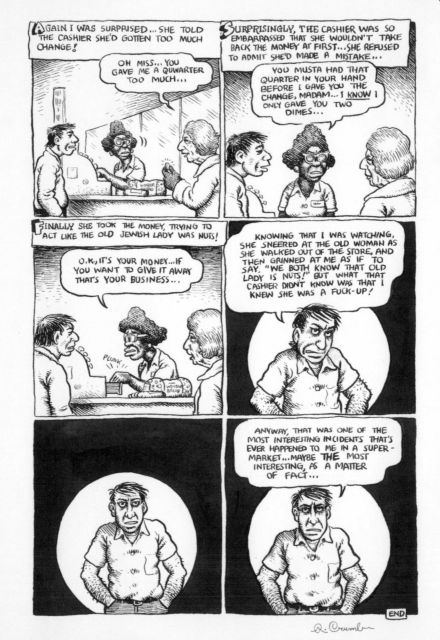

such as Josh Neufeld and, in particular, Dean Haspiel. His association with Dean was the catalyst for the *American Splendor* biopic film in 2003, as Dean got Harvey in touch with the film's producer, Ted Hope. The *Splendor* film not only featured video snippets from Harvey's flipping out live on David Letterman's late night show in the '80s, but also had segments of the real Harvey and Joyce opposite their actor counterparts (Paul Giamatti and Hope Davis).

Harvey also teamed up with Haspiel to produce *The Quitter*, the story of his formative years. Dean's slick ink line and bold design elements illustrated Harvey's trials and tribulations as he picked fights, got canned from jobs, and endured the heartbreaks every young person does—but in the inimitable and poignant way that only Harvey Pekar can. While *Splendor* was Harvey Pekar in the now, *The Quitter* lifted the curtain to show Harvey's coming of age, as he was both held back and pushed even further by his failures to finish college, play on the football team, or stay in the Navy.

Dean's art renders Harvey's story in possibly the most dynamic manner it's ever been told, infusing a bit of Jack Kirby into Harvey's memoirs, whether it's in Harvey's lofty position as neighborhood street fighter, or amongst the stacks of files in the V.A. hospital.

Harvey tried his hand at different comics projects after *The Quitter*, including an online comic strip *The Pekar Project*. It was his last published work before his death on July 12, 2010.

FAR LEFT
Pekar's use of dialect meshed perfectly with Robert Crumb's classic cartooning. From *American Splendor* #3 (1978). © Estate of Harvey Pekar.

LEFT
Much of Pekar's charm as a writer came from his espousing of the everyday. Art by Joseph Remnant, from *Harvey Pekar's Cleveland* (2011). © Estate of Harvey Pekar.

"The thing is, once you've chosen comics, you're really locked into it, whether you like it or not," **Peter Bagge** says. "I experience a moment, almost every single day, where I wish I wasn't a cartoonist, that I wish I was doing something else—*anything* else, depending on the mood I'm in!"

Inspired by the underground comix of the '60s, Bagge paved the way for the alternative movement of the late '70s through the mid-'80s. His art is still considered weird 30 years later.

"I loved Crumb the best, and the first one of his I bought was his *Hytone Comix*. He took the traditional comic book format but broke through everything from cover to cover. There was no crap in it. I always loved the look and feel of comics, but more often than not, I was disappointed in the content," Pete laughs.

Crumb's world of 1930s' cartoon visuals crossbred with no-holds-barred absurdist porn, a subversive and daring package straight from the cartoonist's pop culture-saturated mind, led Bagge to decide what to be when he grew up.

"Once I saw that format, I decided that I definitely wanted to be a cartoonist, and then no one considered comics an art form," Pete notes. "It was shit, the dregs, and people would always be horrified if you said you wanted to be a cartoonist, so I had cold feet about it. With the Crumb comic, it wasn't just that I wanted to be a cartoonist, but I wanted to be *this* type of cartoonist."

While the underground cartoonists hadn't entirely gone away, their cultural movement had grown up, giving rise to the punk movement—a hard-hitting anti-establishment lifestyle that scoffed at the "make love, not war" sentiment of the generation that first bred the undergrounds.

The underground artists continued, including Crumb's comix anthology *Weirdo*.

LEFT
Peter Bagge, NYC, 2011

Bagge saw *Weirdo* as a chance to do work beyond drawing for porno magazines or writing *Bazooka Joe* comic strips. He contacted Crumb through the mail, and the two maintained a correspondence that led to Bagge's inclusion in *Weirdo*, and an offer to edit the magazine in 1983.

"I remember telling him, 'I have some story ideas, using fictional characters that are stand-ins for me, and I'm remembering things that are embarrassing and hard to write about. Even though I'm hiding behind a fictional character, I'm nervous talking about embarrassing events from my past. I'm a little bit afraid. He said, 'Those are exactly the stories you need to tell, especially if it won't go away, and are always in the back of your head.'"

"The way he described it was, 'Stop sticking your toe in the water. Just dive right in.' He said, 'That's the type of work that's going to get the most and best response. People might make fun of you at first, but it'll have an impact.' He was 100% correct, of course."

In 1985, Bagge was offered a regular comic book with publisher Fantagraphics, and had to give *Weirdo* up to focus on his new book, *Neat Stuff*. It would serve as the springboard for his defining work: the '90s magnum opus *Hate*.

Hate was the '90s spin-off of Bagge's semi-autobiographical strip "The Bradleys" from *Neat Stuff*. When Pete decided to launch a new title, the semi-autobiographical teenager Buddy Bradley was a natural subject.

Buddy's a slacker who drinks too much, smokes, and works part-time at a used book store. He was the classic Gen Xer, modeled off of the life of a man then in his 30s, a way for Peter Bagge to look back with a more objective and detached eye.

"Around the time I started *Hate*, I had been married for a while. We had owned a house for a couple of years, and I was finally making a livable wage off of my comics. Being

in that situation, I suddenly was able to look at my previous existence more objectively, from the moment I left my parents' house and the ten years or so following. That part of my life was all over…That was all behind me, and I wasn't in my twenties anymore. So things that used to not be so funny because I was still stuck in the middle of it were now hilarious, like always being broke and having to lug laundry to the laundromat and stuff like that. Now that I was personally distanced from it, it suddenly all seemed hilarious, so it was very easy for me to take all of it and turn it into stories."

Pete has always said that he separated himself and Buddy Bradley by a decade: it was only natural, then, that Buddy mature, going beyond the 100% certified slacker of the Seattle years, and take on the responsibilities he'd spent his first fifteen issues avoiding.

"A problem with *Hate*, if you can call it a 'problem,' is that it's not like *The Simpsons*, where Bart is ten years old forever and everything is stuck in time. Instead I took the *Gasoline Alley* route and had everybody age and change and either evolve or devolve."

LEFT AND ABOVE
Bagge's work is deceptively complex, each page the result of several stages of pre-planning. From *Hate* #28 (Jul. 1997).
© Peter Bagge.

After 30 issues, Bagge retired *Hate*, continuing the series in not-quite annual annuals. "I suppose I could have kept *Hate* going forever," Bagge said, leaning back reflectively, "but the idea behind *Hate Annual* was to just simply keep the Buddy character alive. It's kind of like he's dog paddling (or that *I'm* dog paddling) just to see if suddenly he can take off again, creatively or otherwise."

"I set my own rules and knock down old ones. Maybe I should work more on knocking down my old ones," Jaime Hernandez says with a shrug.

"That's how *Love and Rockets* started: we were just cocky and didn't know we could fail. We went ahead and published the first one ourselves and didn't care what the outcome would be, we just wanted to be printed. Hopefully we could sell it and make money, but there was no one to tell us not to. That was the punk part of it. The more we got good response, the more we kept doing it."

By 1981, Jaime and his brothers Gilbert and Mario had been contributing art to the comics fan scene, and the Hernandez brothers also became immersed in the exploding punk rock scene. At Mario's urging, he, Jaime, and Gilbert self-published the first issue of their black and white comic *Love and Rockets,* in a meager print run of 800 copies.

In his section, Jaime introduced adorable girl-mechanic Maggie and her best friend Hopey, who live in a sci-fi world attributed with jetcar-like mopeds, girl wrestlers, and a man with horns. The Locas stories (as they're collectively referred to) combine old school b-movies with cheesecake comics. Even in that first issue, Jaime's appreciation and understanding of the nuances that make women lovely is in effect.

"I would say it's more collaborative, but in the way that we never worked on each other's work," Jaime says of *Love and Rockets*. "I never got in the way of what Gilbert was doing because I knew he had his plan, and I knew he could pull it off. I never had to step in and say, 'I think you drew that badly,' or something like that. And I wouldn't, because he's an older brother," Jaime laughs.

"I guess it was just the energy that we were doing comics and it was just really inspiring. It was, 'Oh, boy, we're doing this, and we're going to conquer the world,' even if we weren't going to conquer the world. We went in with that attitude, and it kept us going."

Gary Groth, publisher of comics interview and criticism magazine *The Comics Journal* gave *Love and Rockets* #1 a positive review and, before much longer, had agreed to publish *Love and Rockets* through his publishing company Fantagraphics. Los Bros.

LEFT
Jaime Hernandez, NYC, 2010

Hernandez expanded on the original *Love and Rockets* #1, providing a new color cover by Jaime for the 1982 relaunch.

Five women stand in a police line-up: a Jack Kirby-ish amazon takes a drag from a cigarette, while a superhero in a tattered costume looks on complacently, a woman in bathrobe and hair curlers shies away from the camera angrily, an Asian warrior woman and pink-hued spacewoman look on curiously; a spotlight adds drama to the scene, along with two red splatters on the ruled wall behind them. It mixes the commonplace with the amazing, and encapsulates the punk rock *Love and Rockets* mentality found inside.

As much as the misadventures of Hopey and Maggie changed from sci-fi romantic comedy to slice-of-life living during the punk rock scene of the '80s (all wrapped in the Hispanic experience), so too did Jaime's style and stories. Over the years, Jamie began to present the adult antics of Penny Century (dream girl and flake extreme), or the neighborhood kids in Wigwam Bam (which combined his more traditional and realistic style with a stylized "cartoony" style for the children of the strip), and to show his wide range as a cartoonist.

Throughout *Love and Rockets*' run, with the exception of a brief hiatus from 1996 to 2001, both Jaime and Gilbert have aged their characters naturally, matching their readers. That doesn't keep them from jumping about in time, a device that builds backstory and also reminds the readers of the characters' evolutions. The most famous of Jaime's character evolutions has been in Maggie, who has grown into a more Rubenesque build. "As I started to do it, I started to realize, 'Hey, these characters are getting older, and you can look at an old issue and they're just babies,'" Jaime reflects. "It was all remembering who they were while looking at who they were now. Aging them helped the stories and emotional part of it, and just made the stories seem more worthwhile to follow, because it has a past."

SOMEWHERE ABOUT TWO THOUSAND MILES FROM HOME...

"I came to New York with very little technical ability," Peter Kuper admits. "I barely drew, but I was really interested in comics and had been a real big fan of the medium.

"I met Howard Chaykin when I was twelve, at a comic convention, and he was a nineteen-year-old fan artist. When I moved to New York and bumped into him again, he happened to need an assistant and gave me a shot. I needed to get my technical chops together and working for Chaykin at the Upstart studio was a pressure-cooker chance to do that."

While learning the craft and discipline of comics at Upstart, Kuper formed his own tastes outside of the studio. The fact that Upstart was experimenting within the form of superhero comics and that Chaykin was, according to Kuper, "always doing something in the mainstream that was, relatively speaking, alternative," probably made it easier for the budding artist to transition to alternative comics.

"Towards the end of art school though, I discovered a whole new set of artists that interested me, particularly Saul Steinberg, German Expressionism, Ralph Steadman—and rejected most of the styles I had grown up reading in mainstream comics. Already for a long time the underground comics, especially Crumb, had been what appealed to me anyway, both stylistically and in their subject matter.

"Though working at Upstart I was immersed in the mainstream field, I was moving away from those kinds of comics…Even as I rejected superheroes as something I might want to draw I still enjoyed many aspects of what Chaykin, Simonson, and Frank Miller were doing with the form."

The artist that emerged from Upstart and four years at Pratt Institute was an underground cartoonist who employed thick lines and even linoleum block prints for his illustrations. In 1980, Peter

LEFT

RIGHT

Kuper and his collaborator Seth Tobocman founded the magazine *World War 3 Illustrated*, their vehicle for underground political cartoons and commentary.

Almost thirty years from that first issue rolling off the presses, Peter has gained a perspective on his place in the grand scheme of comics:

"When I started in comics I thought what a rip-off it was that there was the beat generation, the hippie movement with the underground comix scene, but they were gone by the time my generation showed up. I'm finding in retrospect that what we've done with *World War 3* was to create a group like that of our own. As an artist, you're mostly isolated and *World War 3* was a way of breaking through some of that isolation, so that even before the piece went to print, you had other artists giving feedback on your work."

• • •

Peter Kuper isn't a traditional cartoonist: he's a mixed-media maniac, often passing up traditional pen and ink for illustrative techniques that involve everything from scratchboard to linoleum prints to spray-painted stencils.

"It was a leap from doing them as illustrations," Peter says of the stencils. "My lifelong pal, Seth turned me on to them. I was looking at an illustration he did this way and it rang my bell. It was apparently a very loud bell, because that was in 1988 and here, to this day, I'm still doing stencils. At this point, I feel like I want to move away from spray paint because of its toxic nature. The irony of doing pieces on degrading environment using aerosol sprays is too much."

Peter next applied his stencil style to an iconic strip: *Spy vs. Spy* for *MAD Magazine*. Started by Cuban refugee Antonio Prohías in 1961, the strip follows a black and white spy wordlessly killing one another through unlikely and ingenious ways. Imagine Rube Goldberg machines in the hands of the world superpowers' top agents, mixed in with *Looney Tunes* slapstick.

"I did it in stencils when they asked me to try out for the job figuring they wouldn't go for it," Kuper says of the 1996 try-out. "I didn't want to try to mimic the style of Prohías, I thought that, 'If I'm going to do this, I'll do something that's different.' I thought they'd thank me for my kooky approach, bid me adieu, and I'd go on my merry way. When they said, 'You got the job,' I thought I'd probably just do it for a year. I'm in my [fourteenth] year of *Spy vs. Spy*."

LEFT
From pencils to final, a look at Kuper's autobio *Stop Forgetting to Remember* (2007). © 2012 Peter Kuper.

"One thing is that when you grow up in a place, you don't come at it with the romance that people who relocate there do," Bob Fingerman admits.

"I think that I do romanticize New York in my own ugly, grungy way, because I do love this city. I've always lived here and haven't left. It's not like *Escape from New York*: it isn't a prison."

Fingerman is one of the more diverse (and underrated) cartoonists in comics today. He got his start in the '80s with *MAD* competitor *Cracked*, and then went on to draw everything from porn comics (*Screw*) to kiddy books (*Teenage Mutant Ninja Turtles*). Bob Fingerman emerged as a self-deprecating, honest, and semi-autobiographical cartoonist through his Fantagraphics series *Minimum Wage*, which has since been collected and revised as the graphic novel *Beg the Question*.

Fingerman's art has evolved greatly since his *Minimum Wage/Beg the Question* days: where his style was initially black-and-white line work, he has reinvented his style as more painterly and more heavily exaggerated.

But one thing has remained the same: like a stand-up comedian, Bob Fingerman isn't scared to deal in stereotyped characters, and to speak what everyone else is afraid to say. Black, white, Asian, mentally retarded…no demographic or minority is given an excuse or an ounce of political correctness in Fingerman's work. His latest project, *From the Ashes*, a "speculative memoir," follows him and his wife surviving in a post-apocalyptic New York City.

"The whole thing is a satire of memoirs," Bob admits. "The whole point of featuring my wife and I as the protagonists, was to call it a 'speculative memoir,' which I thought was funny. But, yeah, it takes place in post-apocalyptic New York. It couldn't be anywhere else, because it involves a new religion rising from the ashes of Fox News headquarters. Even with the buildings in ruins, they're still New York buildings.

"I just can't get away from New York."

LEFT
Bob Fingerman,
NYC, 2008

BELOW
Bob and his wife
flee for their lives,
in *From the Ashes*.
© 2012 Bob Fingerman.

"I didn't really develop a sense of who I was, professionally, until the late 1970s, and that was only by putting myself in the position of publicly humiliating myself unless I could deliver what I promised," **Howard Chaykin** says.

"I took on jobs I didn't think I could do, so I put myself in the position of either doing them or fucking up and dying."

Howard Chaykin's work is all over the place, with dynamic design glossed over by an art deco veneer. Whether sword and sorcery or his pulp characters, Chaykin's work shines the most when it's subject matter he's most passionate about.

In 1983, he hooked up with indie publisher First Comics and became a staple of the indie craze with his adult series *American Flagg!*

Flagg! follows former porn star Reuben Flagg, whose career is cut short when he's replaced by a computer simulation. He becomes a future-cop Plexus Ranger and is stationed on a shopping mall base on Earth. Flagg's a smart-ass Jew (who, in one memorable scene, feels self-loathing for having angry sex with a Nazi) who is forced to reinvent himself while finding a new direction in his life.

"I simply created a kitchen sink strip, which reflected everything I wanted to have in a comic book," Chaykin says. But *Flagg!* was more than that: it was an eerily prescient strip that first showed the fully realized Howard Chaykin to the world. *Flagg!* possesses its own distinctive brand of pacing and sound effects, and was a mature and sophisticated (though occasionally disjointed) melding of satire, humor, and action.

When *Flagg!* wrapped up in 1985, Chaykin relocated to LA. He found that to his own benefit, you could take the man out of New York, but you could never take New York out of the man.

LEFT
Howard Chaykin, NYC, 2008

"There is something to be said about coming to California with low expectations. If you bring an East Coast sensibility, you know what weather is like, and you know how to work your ass off. I came out to LA for a week in 1980, to work on the *Heavy Metal* movie. They installed me in a hotel room and gave me a lapboard, light box, and other tools, and had me draw. They'd been trying to squeeze artwork out of a local artist in six weeks, and they hadn't gotten anything. I finished what they considered a day's workload, before lunch. I didn't let them know that…It was a very profitable trip, and I became aware of the fact that bringing a sense of professionalism and timeliness to my job has served me well."

After working as a TV writer in the early '90s, Chaykin flirted in and out of comics, making a comeback in the late '90s, oftentimes with the same mold of the arrogant hero with a rapier wit. He still lives in LA, but remains a New Yorker at heart, with the coolness to prove it.

"I've reinvented myself about a dozen times over the years," he notes. "If I'm going to continue to work in this field, I'm going to have to be competitive. A lot of my colleagues still behave as if it's 1984. I've been around, and have had a career that was much more satisfying, more longer lived, and much more anxiety and stress-filled than I anticipated when I started. I had no idea what to expect. One thing it has taught me is to step away from expectation, to shun it completely, and accept things as they come, but not necessarily happily."

FAR LEFT
Chaykin addresses the over-saturation of media in *American Flagg!* From #1 (Oct. 1983).

LEFT
Chaykin's *Flagg!* employed sound effects as their own language.
© 2012 Howard Chaykin.

"When I arrived as Editor-in-Chief, I'd been trained in the business by Mort [Weisinger], trained creatively in general at DC, and had two years of Stan [Lee]'s coaching," **Jim Shooter** says.

A boy wonder who broke into comics as a writer for National Comics in the '60s at the age of fourteen, fate brought Shooter back into comics in the '70s, where he started as an Assistant Editor at Marvel Comics. After a succession of Editor-in-Chiefs, Shooter took the sheriff's star in the late '70s, and began a pivotal tenure that is rife with both quality and controversy.

"We had so many good people, and they were doing such good stuff," he notes, "I tried to use common sense—if it was someone like a Bill Sienkiewicz or a Walt Simonson—to keep the hell out of their way and let them do their thing."

Creatively and financially, Jim's tenure at Marvel is one of the more successful eras in the company's history. But typical in business, when a company begins to over perform, the upper brass get anxious to unload it for a profit.

"After that was when Marvel was going on the auction block. When the people upstairs were trying to sell the company, what it means is that someone in my position was the highest-ranking guy other than the owners. So either I would become an accomplice and help them sell everybody down the river, or I become a labor leader.

"They did a good job, and got rid of me. I was blackballed, literally blackballed. Am I the worst writer in the world? Could it be that *nobody* could use me? My phone would never ring, because *nobody* wanted me."

In his own words, Jim Shooter casually notes, "No one would hire me, so I had to hire myself." With the creation of his new start-up company, VALIANT, Jim Shooter experienced his second success as Editor-in-Chief through the early 1990s. VALIANT was an unexpected success that lasted just a few short years for Shooter. Resilient, Shooter maintains a presence in comics as a writer and editor. Doubtless, Shooter still has more swings at the bat than he ever expected and has proven resilient through the ups and downs of his career in comics.

LEFT
Jim Shooter, NYC, 2010

BELOW
Shooter made occasional appearances in the comics, such as the 1984 ad below. © 2012 Marvel Entertainment.

CHRIS CLAREMONT
Brooklyn, NY, 2011

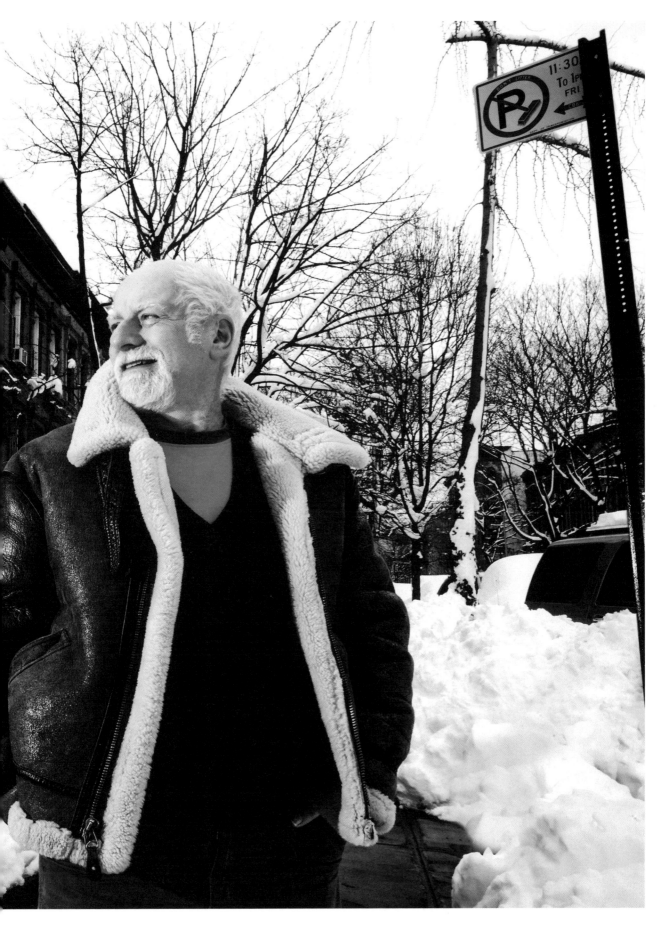

"You may have noticed (as a parenthetical aside)," Chris Claremont says in the middle of a thought, "I talk as I write, which is by the word."

Claremont is synonymous with his blockbuster comic book work as writer of the *X-Men* for near two decades. But Claremont's influential career didn't start with *X-Men*: it started with asking *MAD Magazine* mastermind (and family friend) Al Jaffee about an internship.

"He said, 'I'm friends with Stan Lee. Would you be willing to work for Marvel?' And I said, 'Hell, yes.'"

The Marvel books were creatively in their heyday in 1968, but still a small company with a small staff of about 20 people. Claremont joined Marvel as the second generation was coming into play.

After college, Chris returned to Marvel as Assistant Editor of the black-and-white magazines during a hectic time, as Marvel held onto the same editorial structure that had worked for Stan years earlier, but with several more titles each month.

 In 1975, writer Len Wein and artist Dave Cockrum introduced the "All New, All Different" X-Men in *Giant-Size X-Men* #1. Claremont followed the departing Wein and ventured into one of the most influential runs had by any writer on a comic book. The book became a runaway success, as the team took the mutants into new territory, with the stories' heavy focus on characterization.

"When you commit to your project and your characters, they're the center of your creative focus and universe," Chris notes. "Your vision is the right one and you don't want anyone mucking about with it."

And this is where it becomes apparently clear: Chris Claremont is *still* the X-Men's biggest fan, often going into asides and talking about the mutant superheroes as if they were real people. For someone who defined them, directed their lives with rotating artists, and lived with them for close to two decades—they are real.

RIGHT
Chris Claremont and John Byrne's "Dark Phoenix Saga" elevated the superhero book. Inks by Terry Austin, from *Uncanny X-Men* #132 (top) and #135 (bottom). © 2012 Marvel Entertainment.

• • •

"I'd been doing the book for seventeen years, and had made it the most successful comic in modern comics history," Chris says of *Uncanny X-Men*. "We were scoring numbers that were very breathtaking. I figured that I had earned a level of stature and respect, and I was wrong."

As 1991 approached, Claremont had been masterminding *X-Men* for a record run, and the book consistently sold in high numbers as Marvel touted *X-Men* superstar artist Jim Lee.

Despite Claremont's keeping *X-Men* a long-running success for Marvel, and despite the first story line of the new *X-Men* book setting the Guinness World Record for highest single-issue comic book sales to this day (clocking in at 8.1 million copies), Claremont left the X-Men behind.

"Jim and I did our story with #1, and it blew the lid off of things and created a world record," Claremont notes. "I walked because what was happening was [editor] Bob Harras and Jim were the point men on getting the book back to basics. They wanted Magneto back as a villain. I think Jim wanted a chance to draw the stuff he'd bonded with as a kid, and I was saying, 'Been there, done that, at least three times. Let's do something new.'"

Claremont ultimately came back to Marvel and X-Men, serving as an editorial resource and writing offshoot titles like *X-Treme X-Men* and *X-Men Forever*.

But no matter what else he does, or how many other writers take on the main X-Men titles, Claremont is still as synonymous with the X-Men as the term "mutant."

"I don't call myself an artist: that's an appellation, and not a job title. [I consider myself] a drawer," **Larry Hama** laughs.

"It's like people who call themselves poets who are possibly a little presumptuous. 'Writer' is so innocuous a term that I don't really think of myself as a writer. I'm still the guy who draws the stuff, but I just draw it in my head now and describe the pictures with words."

Shortly after working as an assistant to EC Comics legend Wally Wood, Larry moved to Neal Adams' famous Continuity Associates.

"[One of the] most important things ever told to me about the comics process was from Neal Adams. He was looking at something I was drawing…He'd just stand behind you and look at what you do, and then suck crumbs out from between his teeth. One day he said, 'You're settling for that.'

"I said, 'What do you mean?'

"'You're drawing something you've drawn a hundred times, because you know that you can do it. For this particular thing that you're trying to draw, you can probably see this thing in your head that's probably a thousand times better and more dynamic, more dramatic, or more whatever. But there's something inside of you saying, 'I don't think I can get away with that,' or, 'If I do it, it's going to suck.' So you settle, and every time you settle, you push your dial back one notch. Each time you try to do that thing that's the next thing you've never done, it might suck, but then it might not, or at least you'll know not to do it that way. If you're not always pushing it that way, then all you're doing is just tracing stencils.'

"[G.I. Joe] was despised. It sold really well, and the company loved it," Larry points out with a laugh. "Marvel loved it, Hasbro loved it, and it made lots of bucks for everybody. Everybody was happy with the checks and numbers for a long time. But critically? It was considered garbage, because it was toy book prejudice. There was that weird pretentious elitism that says, 'If it sells a lot, it can't be any good.'

"At the same time, I was making inroads at creating this underground fan base that would outnumber those people."

LEFT
Larry Hama, NYC, 2010

When toy company Hasbro brought their soldier doll back as a series of *Star Wars*-sized action figures in 1982, they approached Marvel Comics to develop the characters and story lines. Jim Shooter approached Larry, who had developed a spy pitch called *Fury Force*, to retool his pitch to fit the developing action figure line they'd just licensed. The result: an entire series of action figures developed by Larry and given life in a new comic book and animated series. Marvel did all of the character and creative development for this new line of action figures, and Hasbro offered cross advertising with Marvel.

With pencils by longtime Marvel Comics staff artist Herb Trimpe and inks by Bob McLeod, *G.I. Joe* #1 came out in June of 1982. The series was also advertised in animated TV commercials, a corresponding cartoon, and the release of the small line of action figures in toy stores the nation over. Thanks to the multimedia ad campaign, *G.I. Joe* got a lot of kids who wouldn't normally buy comics but loved the toys and cartoons to follow it each issue.

"After I plotted the first *Joe*, I remembered sitting there thinking, 'What the heck am I going to do now?'" Larry confesses. "It was one of those moments of panic, but I'd have those moments of panic every month. The whole thing is to push them over the cliff right at the beginning, and have a situation to get it rolling, and then follow that snowball down the hill. The action is secondary. The action and the plot are there as a framework to support the characters. The characters are the only thing to make people come back. This is primary, and something that publishers and editors don't seem to understand. They don't get it."

In an attempt to keep readers guessing, Larry kept himself guessing as well. Writing on the fly? Possibly, but it was a formula that grabbed the interest of new readers and kept them coming back. "I didn't know what was going to happen," Larry admits. "Knowing what the end was and then intricately plotting out towards that end never really worked for me. It doesn't work for me when I'm reading it in other people's stuff, either. If I get to page three and can figure out what's going to happen, it doesn't work for me."

Hama also, due to a deadline issue, wrote and drew a "silent" issue; the wordless (save for sound effects) story not only became recurring in *Joe*, but also promoted a cinematic, image-based form of storytelling.

Despite *G.I. Joe*'s longevity and success, though, it was still considered a substandard comic:

"You had to understand that, the entire time I did *G.I. Joe*, I never got a single review or write-up," Larry points out. "None exists, because it was considered below serious critical radar, because it was a toy book. I was never a fan favorite, and I wasn't taken seriously as any kind of creator. It gave me a lot of freedom. I never got invited to a

convention, and never even made it to B status. Toy books are C status."

Joe ran for over a decade, with Larry writing most every issue. It was a phenomenon that began in 1982 and died a gradual death well into the next decade.

Throughout his run on *G.I. Joe*, Hama also wrote *Wolverine* and the short-lived *Nth Man*. Perhaps his greatest contribution as an editor is the critically-acclaimed series *The 'Nam*, initially drawn by Michael Golden and written by fellow Vietnam vet Doug Murray. *The 'Nam* showed the Vietnam War through the eyes of the average American soldier, and was a sharp contrast to the bright comic book action of *G.I. Joe*. Larry returned to *Joe* years later, picking up the old numbering of the book that helped him raise a new army of comics readers.

"In doing this stuff, you always bear that in mind about what is really important, and then you don't get bogged down in inconsequentialities and these weird tangents that nobody cares about.

"It's all about the character, what the character feels, or how the character relates to other characters."

"I just looked him up in the phone book and he was there. That was back when artists were much more accessible," Frank Miller recalls as he lights another cigarette.

The subject is Neal Adams. "He was my hero and I found his name in the phone book."

It's 1976, and Frank has just arrived in New York, armed with a portfolio Frankensteined together out of polyester, cardboard, and bailing twine.

"I had a big portfolio of artwork that I wanted to show him. I almost broke his nose with it when I opened it up. He looked over my artwork and said, 'You're from where?' I said, 'Vermont.' 'You should go back there and pump gas. You're never going to be good.'" For Adams, it's a way to find out just how serious an aspiring artist really is: if they want to work in comics that badly, then they'll overcome their ego and *actually* become better.

"The women in my life would tell you, I'm very persistent," Miller says with a smile. "I kept coming back until finally Neal, at one point, said, 'He knows he can't draw. I already told him that, but the storytelling is ballsy,' and he got me my first job."

Frank would soon go on to the bigger pasture of DC Comics before making the move to Marvel. Frank Miller, young and lanky and determined, was about to hit his first defining moment as a cartoonist.

"I had done a couple issues of *Spectacular Spider-Man* and I looked at Daredevil, [who] was blind. All of a sudden I realized that I could do all my crime stories through this character," Frank states.

Daredevil had been the poor man's Spider-Man, but when Miller eventually took over the writing chores on *Daredevil* as well, he pitted the minor league superhero against major league villains like Kingpin and Bullseye. New York City itself, in Miller's *Daredevil*, became as much a character as the shadowy crime fighter—the stories often taking place on the rooftop level. The bold inks of Klaus Janson complemented Miller's style, giving *Daredevil* that final noir look.

Miller infused crime fiction with ninja action, throwing Matt Murdock/Daredevil's *femme fatale*

LEFT
Frank Miller, NYC, 2010

Elektra into the mix. At the end of his first year, Miller had Kingpin's assassin Bullseye viciously run Elektra through with her own sai—an unprecedented, unexpected death of a major character.

By the time Miller wrapped up his first run on *Daredevil*, with 1983's #191, the character had gone from a predictable superhero archetype to a tortured (and very human) hero struggling to stay on the side of the angels. What Miller created in Daredevil wasn't necessarily an antihero, but a hero who was never too far from becoming a villain himself.

While working on the Elektra saga, Miller was invited to join Upstart Studio in the Garment District of New York, working alongside other cartoonists including Howard Chaykin and Walter Simonson, where Frank was exposed to new influences that took a firm hold of him for his next project.

"Both Walt Simonson, and particularly Howard Chaykin, introduced me to the European comics. Then, through a girlfriend, Laurie Sutton, I discovered the Japanese comics," Frank reveals. "That all gave birth to *Ronin*."

Miller's 1983 futuristic tale merges samurai adventure with cybernetics, corporate America, and social dystopia. *Ronin* starts off looking like the *Daredevil* Frank Miller with a slightly different inking style, and organically merges different European and Japanese storytelling and inking techniques as it goes.

Miller got reacquainted with Daredevil in 1986's *Born Again*, this time with artist David Mazzuchelli, and turned the hero's life even more upside down. *Born Again* follows the hero's complete nervous breakdown and subsequent rebuilding, a postmodernist deconstruction and *re*construction from ground up. By literally stripping the superhero of his identity, Miller deconstructs Murdock/Daredevil and forces a narrative redefining of the character.

Miller helped define "postmodernism" in comics with 1986's *The Dark Knight Returns*. With story and pencils by Frank, inks by Klaus Janson, and watercolors by Lynn Varley, *Dark Knight* takes place in a future world, where Batman is considered nothing more than an urban myth whispered amongst the cracked pavement and foundations of Gotham

City. Pushed back to the edge, Batman rises up again and fights enemies new and old, while suffering the strains of middle age and the media-riddled social climate.

By finally facing his mortality, this Batman becomes seemingly immortal and more true to the urban myth whispered about on the news and the streets of this future world. *The Dark Knight Returns* doesn't just distill Batman to his primal elements; it also encapsulates the 1980s political climate and the waning days of the Cold War.

The next year, Frank looked to the other end of Batman's timeline with *Batman: Year One*, a new origin story, again with Mazzuchelli on art. Just as he redefined Daredevil's New York years earlier, Miller makes Gotham City a cracked metropolis, dangerous and downtrodden enough to justify the need for a Caped Crusader. Mazzuchelli brings an urban modernity to a classic style, as heavy shadows dramatically wrap themselves around the characters, and long shadows are cast upon buildings.

Miller then came back with the graphic novel *Elektra Lives Again*, his final word on the Greek assassin. *Elektra Lives Again* isn't a Daredevil story, rather a noir one focusing on a grieving Matt Murdock. When he stands in a trench coat, bandages pasted across his face at the end, it's a taste of things to come in Frank's next iconic, creator-driven work.

"I just said, 'I don't give a damn. I'm going to do exactly the comic that I want to do,'" Frank admits. "I didn't care whether it succeeded or not, and it succeeded way beyond my expectations."

And so began crime comic *Sin City*. When it starts, it feels like the old Frank, with some of the same line work, but with heavier blacks and longer shadows. When the antisocial Marv jumps out of a window, he resembles Batman, substituting a long trench coat for a cape.

As *Sin City* progresses—it seems like it should be printed on crappy paper between cheap card stock covers. Miller clearly loves seeing how much he can get away with each story, and we love it for being so damn dirty and subversive. Where *The Dark Knight Returns* launched a wave of violent superhero comics, *Sin City* brought crime back as a formidable genre.

ABOVE
Miller's Batman and Robin don't swing like mortals—but soar like demigods. Inks by Klaus Janson, from *Dark Knight* #3 (1986). ©DC Entertainment.

Sin City made it to movie screens on April 1, 2005, directed by both Miller and cult filmmaker Robert Rodriguez. With a motley cast—boasting Bruce Willis, Clive Owen, Jessica Alba, Mickey Rourke, Brittany Murphy, Rosario Dawson, and Benicio Del Toro—a handful of the *Sin City* stories were brought to celluloid life. *Sin City* the film showed us Miller's absurdist, noir tendencies in motion, while making the creator-owned comic book a household name. It also gave Miller the last laugh, placing him in the director's chair on his own terms.

• • •

How does Miller himself define a hero?

"Got a week? It's somebody who is defined by his virtue. He might be tortured, might hate himself, but he always does the right thing."

Frank celebrated the hero in his retelling of *The 300 Spartans* in the aptly named *300*, a panoramic graphic novel with lush watercolors by Lynn Varley. The style was still distinctly Frank's, but enhanced with Varley's watercolors, grounding his art in a muted and faded reality. *300* was easily Frank Miller's most ambitious work to date, and spawned its own Zack Snyder-directed blockbuster film in 2006.

The Dark Knight Strikes Again, the 2002 sequel to *The Dark Knight Returns*, was jarring when it came out. It's entirely different in tone and flavor than the predecessor, trading grim seriousness for pastiche. For Miller, it wasn't just a celebration of the superhero, but a reaction to the gritted teeth and gun-toting knockoffs that *Returns* inspired.

"I wanted to go back to what was really fun about these things," Frank admits.

The irony of *The Dark Knight Strikes Again* is that it's arguably *more* postmodern than the first one, with more narrative fragmentation and a tendency for more pastiche of old comic books and the current state of the "media." Miller's art style was more pared down, with a thicker contour line on his figures, simpler backgrounds, and more bold shapes in the design.

"I wanted to recapture the feeling of DC Comics from when I was growing up. I deliberately did a very crude line and did my best to capture that," Frank admits.

• • •

When Will Eisner died in 2005, it was a blow to comics, but especially one to Miller, who was given the chance to honor Will's legacy in a film version of *The Spirit*.

"With Will, I couldn't ignore the sacred trust," Frank says, clearly affected. "He was my mentor, and meant the most in the world to me. I took it, and I looked at it, and said, 'This isn't a movie, but this needs to be changed to be turned into a movie, and I want to put his spirit into it.'"

The end result was a film that was a hybrid of Miller's sensibilities with Eisner's own, using the green screen techniques of *Sin City* to create a world atmospherically linked to Eisner's newsprint one through Miller's high contrast lens. *The Spirit* clearly isn't meant to be a straight action or crime film—not even a superhero one—but something aware of its own absurdity. Given *The Spirit*'s blend of pastiche with unapologetic comic-book action, it has the underpinnings of a cult classic.

The most striking thing about Frank Miller's career choices are that he hasn't hit a level of developmental stagnation. Frank has reinvented his style at least three or four times and still refuses to keep doing the same schtick each project.

ABOVE
Miho's thin ink line emits lightness and grace against the heaviness of *Sin City*'s world. From *Family Values* (1997).
© 2012 Frank Miller.

"My cartoon avatar is definitely separate from me," Scott McCloud reflects.

"I know it's unnerving for people to meet me. I can tell there's always that adjustment period, like when I go to speak at a university that they obviously have to admit, 'This guy isn't what I was expecting.' Then they have to go, 'Who was I expecting? This guy with blank eyes and black hair and line drawing?' The fact that I've made my cartoon character a little heavier and given him the graying temples doesn't matter, because I'm still very different than the character."

In 1993, McCloud authored *Understanding Comics*, a graphic novel that presented his theories and analysis of the mechanics of storytelling and comic book language. The first theorist working in comics, McCloud narrated *Understanding* with his avatar, illustrating his examples in the format he was dissecting.

Understanding Comics came at the right time: graphic novels and comics of the 1980s, like *Maus* and *Watchmen*, raised the medium's profile, while colleges and universities slowly embraced the sequential arts. Comics were finally starting to gain their long-overdue legitimacy.

After concluding his groundbreaking science fiction comic book *Zot!*, Scott started work on *Understanding Comics*. *Understanding Comics*, in many ways, further legitimized comics by being the first accessible and unpretentious study of the form. Within a decade, the term graphic novel would become even more synonymous with comic book, mostly as a means to grant a once-juvenile medium a modicum of adulthood. McCloud followed *Understanding* with two more books, *Reinventing Comics* and *Making Comics*.

"When Will Eisner first started using the term graphic novel, he was on the phone trying to sell *A Contract with God* to a potential publisher. He pulled it out of his ass because he had to have something to call it to get it through the door. In a way, that phone conversation is the iconic and embryonic version over what happened during the last 20-something years: we had a term that helped get us through a door, and that was that. Each medium has its different terms. You can go to a 'movie' but then you can write about it as a 'film,' and then put on your tuxedo and go to an awards ceremony at the Academy of 'Motion Pictures.'

"Any medium worth having a real footprint in our culture is worth having a few different modes of presentation: there's the formal mode, the critical mode, and the ceremonial mode. You can have an Academy of Sequential Art, and when people are done working there they go home and read some comics. There's nothing wrong with that, it's okay."

LEFT
Scott McCloud,
Brooklyn, NY, 2010

BELOW
Unlike his comic book
avatar, the real Scott
McCloud has pupils. ©
2012 Scott McCloud.

"I wanted to produce books I was proud of, and I think that's the thing that has carried me through my career from day one," **Jim Lee** notes.

Jim Lee's art debuted in the late '80s at Marvel Comics; it was slick, heavily rendered, dynamic, and dramatic—with just the right infusion of both American and Japanese influences. When Lee started on the art chores on *Uncanny X-Men* in 1989, with inker and studio mate Scott Williams, he quickly became one of the new breed of hot, young, "rock star" artists at Marvel. These new artists were sometimes (and arguably) eclipsing the respective writers on their titles—particularly Todd McFarlane's weird hyper-detailed work on *The Amazing Spider-Man* and Rob Liefeld's crude art on *The New Mutants*.

The superstardom the three had achieved at Marvel wasn't enough when compared to a lack of autonomy and ownership, or a lack of compensation for merchandise brandishing their art, and—adding cartoonists Jim Valentino, Erik Larsen, and Whilce Portacio to their ranks—they united to strike out on their own and start their own comic book publisher: Image Comics.

"I definitely didn't want to do something foolish and fail," Lee admits. "I think I was more scared of failure rather than, 'Oh, I'll leave this really cushy thing behind and what if I can't get it again?' I don't think that was an issue. It was more like, if I was going to make this big move, I wanted it to be successful, and that meant having the right people involved."

Image quickly became infamous for thin writing, over-the-top visuals, and late books; all things the fledging company struggled with in their first few years.

"I think people did read and enjoy the books, but that group was in the minority," Lee says. "The majority of people buying Image comics were speculators that were basically looking to buy them and sell them at a profit in a short period of time."

Marvel Comics was in dire straits by 1996, left creatively and financially bankrupt through a string of bad decisions and a collapsing market. They approached Lee and Rob Liefeld's respective studios to relaunch four of their main titles: Lee on *Fantastic*

LEFT
Jim Lee, NYC, 2009

Four and *Iron Man*, and Liefeld on *Captain America* and *The Avengers*. Dubbed "Heroes Reborn," the year-long experiment was Marvel's way of trying to reinject some of the early '90s mojo into the company line. With Liefeld bowing out half a year in, Lee and his Wildstorm studios took over Liefeld's two titles to produce all four.

"I think it was Marvel, after 'Heroes Reborn,'" Jim recalls, "that was interested in purchasing us to then run their whole editorial line…When that fell through, there were other parties that were interested, a couple of media companies in Hollywood. And we were friendly with Paul Levitz at DC and met with him a couple times prior to us basically asking them if they were interested in purchasing Wildstorm."

DC Comics' 1998 purchase of Wildstorm as an imprint freed Lee up to focus on drawing comics again. When Lee and his inker Scott Williams took over *Batman* for

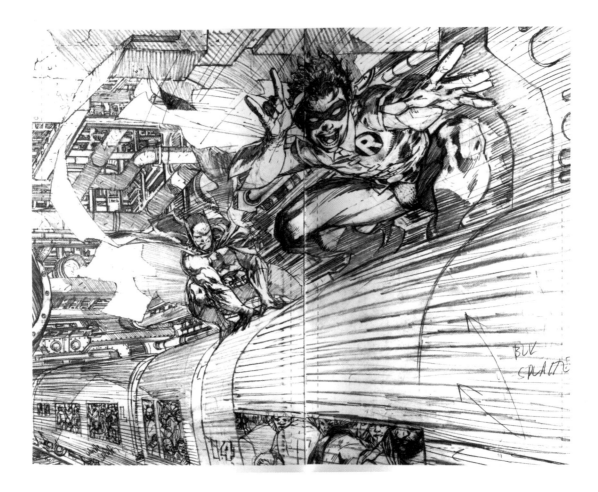

a year-long story line with writer Jeph Loeb in 2003, it catapulted him back to the stratosphere of his *X-Men* days. 2005 saw Lee back on Batman, drawing *All-Star Batman and Robin, the Boy Wonder* with the legendary Frank Miller.

When DC Comics restructured themselves as DC Entertainment in 2010, they pegged Lee as Copublisher with Dan DiDio, giving the artist the reins of an in-development digital realm. Part of that digital initiative, kicking off the next year, involved Lee's redesigning several classic DC Comics characters for a relaunch of the entire company line for both digital platforms and print comic books.

All interview quotes appear courtesy of writer George Khoury, from his book *Image Comics: The Road to Independence* (2007, TwoMorrows Publishing).

ABOVE
In *All-Star Batman*, Lee made it abundantly clear that his work had only improved since his Marvel days. © 2012 DC Entertainment.

GRANT MORRISON
NYC, 2011

"Back then we brought influences from outside comics, from music and cinema, poetry and theater," Grant Morrison remembers.

"American comics had become formulized, but we had grown up loving the stuff [from before] and we just wanted to get our hands on it to apply all the influences that we had—like the punk stuff. American comics were given a little bit of a jolt, because we loved this material and we were able to come up with a different angle on it. We revitalized the scene, for at least a few years. American creators learned from that, and their comics became just as good. Right now, I think comics across the board are better than they've ever been, and there are a lot more great writers coming in."

With a career writing British comic books like *Doctor Who* and his own *Zenith* under his belt, Scot-born Grant Morrison first made his mark in American comics with the trippy, adult-aimed *Animal Man* in 1988, followed by the freakish *Doom Patrol*. Writer Alan Moore had been the advance guard for an infusion of British talent, primarily with *Watchmen* and *Swamp Thing*, while Neil Gaiman made waves with *Black Orchid* and his literary fantasy series *Sandman*. Where Moore celebrated the superhero in the comic book version of the real world and Gaiman focused on other worlds, Morrison's work balanced between the two—placing unlikely and quirky superheroes in absurdist, fantasy versions of the real world.

In 1989, he and surrealist painter Dave McKean presented the Batman graphic novel *Arkham Asylum*. While Frank Miller had re-established the Dark Knight's darkness, Morrison and McKean pushed it further to question the roots of that darkness, and the state of Batman's own sanity in this trippy head rush of a graphic novel. Even after starting his mind-bending and oddly autobiographical Vertigo title *The Invisibles*, Morrison was well-respected as a cutting edge writer of unconventional superhero tales featuring arguably "postmodern" heroes.

When he relaunched *Justice League of America* with artist Howard Porter in 1997, he brought a classic vibe back to the once mediocre superhero team, reuniting DC Comics' seven most powerful superheroes in a run that smacked of a brightness reminiscent of writer Mark Waid's celebration of the classic superhero sensibility in *The Flash*, but was coupled with Morrison's unique brand of high concept.

"*Animal Man* was still a case of trying to do something maybe more realistic and polemical, but then I got the opportunity to write *JLA* and there I went for an approach that was more expansive and Jungian, like the bible or the Greek myths."

Morrison took the seven major DC stars—Batman, Superman, Wonder Woman, Green Lantern, Flash, Martian Manhunter, and Aquaman—and treated them as the Greek gods of the DC universe. Positioned on the moon in their Olympus-like base the Watchtower, Morrison once again made *JLA* the book where big things happen.

"Getting the Justice League was like handling the American Constitution," Grant admits. "I wanted to do it *justice*, quite literally, and to not drag it down but to go into that big world that was very mythological. Superman was a pure essence, and Batman was a pure symbol.

"We didn't have too many problems, but the strangest problem of all was that nobody wanted me to do those seven central characters. This is the Justice League, with the seven most recognizable characters, and they *should* be in the same comic together. That was the thing that there was resistance to most of all…

"For me, it was about putting the imagination back in. I wasn't dictated by anything, except to have plot-driven stories that didn't rely on having Superman weeping," Grant jokes. "I gave it big ideas and had the characters deal with it."

Those big ideas came into play when Morrison wrote *All-Star Superman* in 2005, a twelve-issue series drawn by Frank Quitely, that presents an iconic Superman reminiscent of the 1950s version as he grapples with his imminent death.

"In my head, there was always that quintessential Superman," Grant admits. "I thought it was a nice ending to what I was doing with *All-Star Superman*, where you see the moment where he left us all to live in the sun and to save everyone he built an engine in the heart of the sun. I liked the idea of tying it all together."

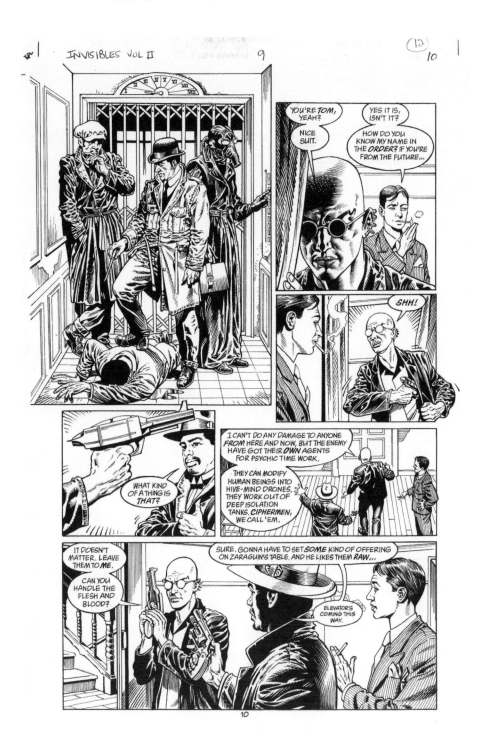

When Mort Weisinger took over editing *Superman* from the '50s through '60s, he built an entire mythological world around the classic superhero and his supporting cast. First and foremost, the Weisinger era stories were fun, which Morrison and Quitely embraced.

"I went back to that because, honestly, I thought that the most universal version of Superman was where he was the least like us," Morrison admits. "Because there were so many other costumed superhero characters, to try to separate Superman away from it, you have to go back to something where he represented something a lot bigger and talked to a more mainstream audience. That's why I chose that era, because that Superman was at his peak there."

"People are always saying, 'If he's too powerful, then he's unrelatable,'" Grant adds later. "In *All-Star Superman* I wrote the most powerful Superman I could, but tried to show how he could be emotionally wounded and is vulnerable."

Right now, Morrison is gearing up to revisit the Man of Steel, this time reimagining him from the ground up, as part of DC Comics' relaunch of their entire comics line. *Action Comics*, with art by Rags Morales, is Grant's shot at giving us a new classic Superman, starting from day one. In Grant's *Action*, Superman starts his career in jeans, a t-shirt, and work boots, smacking of the laboring class—a blue collar take similar to his 1938 origins as an activist.

"With *Action Comics*, I wanted to go back to that original Superman, who can only jump (he can almost fly), he can be hurt by a bursting shell; it's the basic idea getting back to a Superman who can be hurt, so that he gets that relatability and humanity back. He doesn't even wear his traditional costume at first."

By embracing the traditional aspects of long-running superhero comics and merging them with the punk rock experimentation and edginess of the British comics culture, Grant Morrison continues to put a new spin on old material. Reading *Supergods*, his essential manifesto on the superhero genre that combines his observations with history and autobiography, you are taken on a long ramble that fluidly and imperceptibly shifts from subject to subject. Much like a Grant Morrison comic book, where Batman encounters cavemen, a satanic cult, and alien technology within a handful of issues—it all comes together beautifully in the end.

Perhaps that's the secret we can pull out of comics' own narrative alchemist—a way to blend the best of all worlds (no matter how prominent or esoteric) into an unapologetically off-beat masterpiece.

LEFT
Grant Morrison became hyper-real as a character in his title *The Invisibles*. Art by Phil Jimenez and Chris Weston. From *The Invisibles*, Volume 2, No. 9. © 2012 DC Entertainment.

"When I was growing up, I wanted to write comics and I remember reading some letters page in a DC Comic," the soft-spoken **Neil Gaiman** says. "Someone asked the question 'How do you get into writing comics?'

"The replier, who I think was [editor] Denny O'Neil, said 'Most of our writers are writers— some of our guys come from journalism and some from other places. You don't just start out writing comics.' I became a journalist, because the idea of writing comics seemed impossible. I was a kid in England, and no one in England wrote American comics. Then I saw Alan Moore's work; he was from *Warrior* and [was then] writing *Swamp Thing*."

Neil Gaiman is comics' first rock star, a member of the British invasion that energized American comics, primarily with his landmark fantasy/horror series *Sandman*. But when Neil Gaiman was just an opening act—it was to no less than writer Alan Moore who showed him the nuts and bolts of Comic Writing 101.

And write Neil did, his work gracing a series of British graphic novels with multi-media artist (sculptor/painter/photographer) Dave McKean and occasional issues at DC Comics. He and McKean teamed up in 1988 for the three-issue miniseries *Black Orchid*, which reinvented a '70s superhero for an adult audience. The collaboration prompted Gaiman's writing a monthly series for DC Comics, and *Sandman* was born.

"With *Black Orchid*, I was trying to change the world and do something big and important and say big, important things, about ecology and pacifism," Neil reflects. "*Sandman*, I was just trying to write a monthly comic, every month."

Sandman was a character that had gone through a series of iterations, from a gas masked pulp hero to a superhero, and then a helmeted dreamland protector (via Jack Kirby and Joe Simon). When Gaiman took the name, he reinvented him not as another muscular hero-type, but as tall and gangly dream god Morpheus who had otherworldly pale skin, jet black hair, and piercing eyes. With art by Sam Kieth and inker Mike Dringenberg, *The Sandman* #1 came out in 1989. The first seven issues had the title character emerging out of a decades-long entrapment to put his kingdom back in order. The comic book itself would affect not only the perceptions of the

LEFT
Neil Gaiman, NYC, 2008

comic book, but eventually the format of comic book storytelling.

"My plan with the first seven issues was basically to try and do each issue as a different kind of horror," Neil reveals. "They were absolutely horror comics and stories, and the first in my head was a Dennis Wheatley-esque/English/M.R. James-ey horror story; two, I was doing EC comics and old DC horror comics; three, I wanted to do something more like Clive Barker; four was sort of *Unknown Worlds*/1940s magical horror. By eight, I'd done that initial agenda of doing a bunch of different horror stories.

"I think I'd learned what this thing was and who these characters were. It really did feel like me, it didn't feel like me trying to do anybody."

Neil fully emerged with the eighth issue of *Sandman*, "The Sound of Her Wings," which introduces Morpheus' sister Death, who is the Grim Reaper recast as a perky goth girl (and the series' breakout supporting character). As *Sandman* progressed, Gaiman introduced Dream's other siblings, the Endless, each a different facet of the human experience: Destruction, Desire, Destiny, Delirium, and Despair.

Early into *Sandman*'s run, Gaiman's tendency to write in story lines that ran several issues helped define a new format for comics, one then just saved for special projects like *Watchmen* or *The Dark Knight Returns*: the trade paperback. Media notice for *Sandman* in *Rolling Stone* urged DC's marketing person Bruce Bristow to package *Sandman* for the mass market.

"We were up to issue fourteen and a half at that point, and got a note to collect *Doll's House,* which hadn't even come out yet. *The Doll's House* trade paperback was thrown together within a week, and came on sale as issue #16 came on sale. It came into existence simply in order to be advertised in *Rolling Stone*...He'd created *Sandman* trade paperbacks, and it was the first time someone had started doing trade paperbacks of an ongoing series."

More than anything, *Sandman* was ultimately about stories—Shakespeare performs

ABOVE
Gaiman's Morpheus elaborates on his personal evolution, from *Sandman* #67 (February 1995). Art by Marc Hempel.

A Midsummer Night's Dream for the actual faeries it's about; a writer who rapes a muse is deluged with too many brilliant ideas; visitors at a cross-dimensional tavern exchange yarns *Canterbury Tales* style—stories mixing myth and folklore with contemporary fantasy, told through rotating creative teams every arc. It allowed for Gaiman to constantly experiment through the series' run, providing a variety of narrative flavor in a breakout book that snagged the cool kids into reading comics. The trade paperback presence in mainstream bookstores, as well as Dave McKean's illustrative, fine art covers, made *Sandman* a hybrid book that combined the tenets of folklore and literature in an adult comic book.

Sandman wrapped up with #81, a premeditated end by Gaiman, as Morpheus sacrificed himself in payment for crimes committed through his earlier acts of hubris, while another aspect of him is resurrected in a new form (the pale white-haired Dream). Just as a new chapter is set up for the world of *Sandman* and his world of the Dreaming, Gaiman closed the back cover and left his audience wanting more.

Gaiman spent his first decade in the comic book industry elevating the medium to that of classic fantasy literature, and creating a series that reached out beyond the established tried-and-true comic book fans. In a time when the industry wasn't widely friendly to non-superhero fans or even females, *Sandman* extended a pale and welcoming hand to that overlooked demographic.

Neil comes back to comics every once in a while, whether to revisit *Sandman*, take on Jack Kirby's *The Eternals*, or even to write the ultimate, final *Batman* story. No matter how many novels or screenplays Gaiman writes, he always comes back to his first storytelling medium.

ABOVE

The introduction of Death in *Sandman* #8 (August, 1989) provided the title character more humanity, and gave the series its most popular supporting character. Art by Mike Dringenberg and Malcolm Jones III.

"It's nice that there are nice people in my industry," Jill Thompson notes. "I like to think I'm one of them, and treat anyone who comes up to me as a friend. If you're nice enough to come up and like my work, how could I ever possibly be anything but gracious?"

Thompson remains one of the more outgoing creators, literally and figuratively, her personality a reflection of her bright watercolor palette. Where *Sandman* was her first shining moment as an illustrator, she followed that up with *Scary Godmother*, her successful debut as a sole creator.

"I was working on 'The Parliament of Rooks,' [*Sandman #40*] which was our tryout together, where he was going to see how I interpreted a script that he wrote and what he would have to write for me after that," Jill remembers. "It was an extremely easy process to work with him, and even less than halfway through it, he would fax me scripts—or sometimes it wouldn't be a full script and I'd get a page a day because he was travelling and not able to finish an entire script. I would be done with what he'd given me and then fax him and go, 'I need more script.' He would send me faxes back saying, 'This is exactly what I saw in my head when I was writing it.' It was the highest compliment I could be paid."

Neil and Jill's story line, "Brief Lives," set the siblings Dream (the eponymous Sandman) and his sister Delirium on a road trip to find their brother, the black sheep Destruction. Delirium, a confused god who resembles a teenage girl with insane tendencies, was a perfect match for Thompson's gestural and expressive art style.

"I really understood when he would write that character that she was so vulnerable. It was (pardon the pun) a dream to be able to work with that character because she was all about body language…and Sandman was all about body language in the fact that he was so reserved. He was the perfect straight man for any comedy that there could be, because he was so uptight."

LEFT
Jill Thompson,
Chicago, IL, 2011

"Brief Lives" was originally intended to only be three issues, but Neil and Jill got carried away.

"When that was over, I did not want to stop drawing that comic, ever. I begged him to let me keep drawing it, and he said, 'No, we have other artists,'" Jill remembers, imitating Gaiman's English accent. "I said, 'I don't care about them, just do *Sandman* with me!' It was the easiest job I've had in my entire life.

"I've worked on comics where, no matter what the people have written on the script, you sit there and look at the paper and go, 'Oh, I don't know where to go with this. How do I make this interesting?' *Sandman* was not like that."

"The way I presented it is the only way that I've wanted to tell it—a story that I would enjoy, but just for kids," Jill says of *Scary Godmother*, her first 100% Jill Thompson project. "In fact, there are very few comics for kids nowadays, but there should be more comics for kids. There should be comics that are just G-rated. I don't think G-rated is a bad thing. Maybe what it's become has been a pandering toy commercial. I think that any old black and white movie you find could be considered G-rated, but they can make you cry, and people can die. There can be suspense and horror, and all kinds of stuff. It just isn't done in a gratuitous and pornographic way. I think that's perfectly fine. I want people who read my comics to laugh, to cry and to think. There wasn't much out then that represented that, and I wanted to be one of the people who spends the time to make sure that we have another generation of comic book readers."

Scary Godmother came about during the hard times of the post-bust 1990s comic book industry, as work was scarce and publishers were struggling and shutting down.

"*Scary Godmother* was one of those perfect storm situations," Jill points out. It started when she was without work. "I finished what I was working on, and went to look for more work and couldn't find any. There was a period of time where I was scrambling and doing advertising work, gaming cards, a pin-up here and there, but nothing really steady.

ABOVE
Thompson's flair for nuance made her a perfect fit for the stoic Morpheus. From *Sandman* #44 (Dec. 1992). © DC Entertainment.

"So I had time to draw for fun, and it was also the time that my sister-in-law was pregnant and I was going to become an auntie for the first time. I loved the idea of becoming a godmother…I was lobbying very hard to become the godmother of what would become my first niece, Hannah, but at the time I was still dressing in all black…I was thinking to myself, standing in the back of the Catholic Church, with my giant, big shoes, and my black motorcycle jacket and big hair, that I was a scary godmother.

"Literally, when I said those two words together, the proverbial light bulb went off. I saw this picture in my head of a witch with little bat wings, a black tutu, and little black eyes. And she was teeny tiny, like Tinker Bell. I immediately sketched her out."

That little sketch of this Scary Godmother soon took on a life—and a world—of her own.

"When I started writing it, Scary Godmother had friends right away, and things started writing themselves. I went, 'This is the story, the things I haven't had for so long. People have been telling me to do my own thing, well this is my own thing.' I'd actually gotten more than just a sketch and I decided that, instead of making a book by hand for the baby, I'd try to get the real book made and went looking for a publisher. It was more difficult than I thought. I went outside the comic book community and it was very difficult to get seen if you were without an agent. I'm very impatient and did not want to go through this process all over again."

The first *Scary Godmother* story follows a little girl, Hannah, on an adventurous Halloween spent with her conniving older cousin Jimmy, where she's tricked into entering an apparently haunted house alone. It just turns out that the monsters who live in this house, including Hannah's Scary Godmother (who just happens to look like Jill Thompson, distinctive red hair and all), help Hannah turn the tables on her mean cousin. *Scary Godmother* is a hybrid storybook and comic book, told in lavishly painted illustrations. Jill continued to make *Scary Godmother* in both storybook and comic book form, even picking up two computer-generated television Halloween specials and a stage play. It has, wonderfully enough, become a holiday tradition on cable television.

BELOW
For Thompson's *Scary Godmother*, Halloween is every day.
© 2012 Jill Thompson.

"We're not just supposed to believe things because somebody told us to; we need to think these things through," Mike Allred says.

"With Frank Einstein, he's a clean slate, but had a life before. The more he learns about his previous life, the more he realizes, 'Maybe I don't like who I think I might've been, but what's important is who we are now.'

"That's the lesson I've learned in my life: I may have done horrible things, but that shouldn't affect my future. This day, I can decide to change my behavior, and tomorrow I can be a better person than today, and the next day I can be a better person than I was then. That's who Frank Einstein is—he wants to be the best person he can be."

Allred's seminal creation, the amnesiac Frank Einstein aka Madman of Snap City, is a pop-culture saturated hero running through Technicolor adventures as he explores his own spirituality and sense of self. Mike, like his avatar, spent the '90s questioning faith, religion, life, and identity; his existential questions found their way into Frank's word and thought balloons, as every adventure forced Frank to discover yet another facet of who he was while forging ahead on who he is.

Through *Madman*, Allred developed from a capable cartoonist and into an exceptional one, working in a classic art style that evoked comics and pop art from the '50s and '60s. Briefly a black and white comic with blue tones, his wife, Laura, soon began coloring his work in candy color tones that were straight out of a View-Master reel. *Madman* came out in 1992, at a time when comics were widely dark and depressing. *Madman*'s debut was like Dorothy's stepping from the grays of Depression-era Kansas and into the color world of Oz, and was refreshing during a grim time in comics.

"I had the freedom to do what I wanted," Allred says. "I guess the luck of the draw was counter programming: I think it was because of the era that it was released in, and that it had this feeling of joy. It's all because I was optimistic about what I was doing and about someone actually paying me to make comic books. I think it was because it was this bright chunk of weirdness that it stood out, and there wasn't anything happening beyond that."

Madman's pop-culture laden life continued through a number of publishers as Allred continued to call his own shots and create his own distinctive comic book world. He

even bowed out of *Madman* for a brief time to create *Red Rocket 7*, an experimental mass-media project that encompassed an independent film, an indie rock album, and a seven-issue comic book series.

In 2000, The Allreds took the self-publishing leap with their AAA (Allred Atomic Art) Pop Comics, putting out fifteen issues of *The Atomics* (guest-starring Madman) and then made the unexpected jump to Marvel Comics that year when they joined up with writer Peter Milligan on *X-Force. X-Force* was a postmodernist superhero comic book that was a quirky combination of action, drama, and social parody. It was also a mark in Allred's evolution.

"I played with detail and economy," Mike says of his art on *X-Force*. "Just before *X-Force*, I was trying to be as economic with my line work as possible. In some ways, it was too simple. With *X-Force* I started to get more detail and finer line work, instead of that thick brushstroke, so less bold and more intricate and lush, maybe. Then, also, I was experimenting with efficiency…

"That even goes to, 'Where should I put my pencil down? If I put it here, it'll be easier to reach.' It's something as simple as that. With the *X-Force* stuff, I even experimented with page size, and was working almost printed size. It was faster, but because of the detail I was putting in it, it ended up physically hurting my hand. Again, it was an experiment, and I learned some things from it and realized other things didn't work as well as I would like." In all, Allred enjoyed a three-year run on a mainstream superhero book that forced him to reinvent his way of working, as well as his style.

Allred continues to work on *Madman* in spurts: a series here and there, mixed in with other work like the horror comic *iZombie* for DC/Vertigo, about the adventures of a girl zombie and her ghoulish gang. More than any other cartoonist, Allred manages to bring the nostalgic visuals of old comics from a more innocent era, and successfully marry them to the sentiments of modern ones.

"With any opportunity, I really always want to talk about the potential of comic books in general," Mike says in closing. "Even today, it's so untapped, the power to combine pictures with words. I always want to express to people out there who want to give it a shot: if they do, have fun with it, no matter the skill level. As long as you're having fun, it's good for you. If you have fun with it, you do it more, and if you do it more you get better at it, and if you get better at it it's more fun…and it keeps building on itself. I say that because I'm a fan, and anytime I can get excited about somebody else's work, it gets me excited about my own. The more people who jump into the pool, the more fun the party's going to be. I encourage everybody to pitch in and do stuff that's going to get me excited."

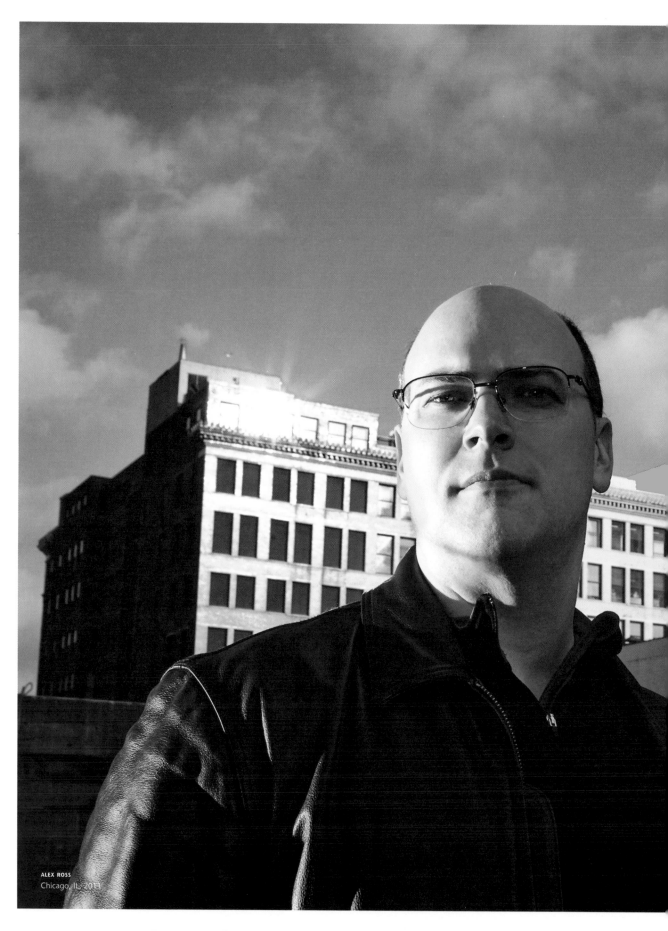

"There's absolute artistic fulfillment that I get from comic books," Alex Ross says. "This is what I've wanted to do since I was four, and I don't have regrets on the career path that I took."

Alex Ross' success is unprecedented in an industry whose painters ignored the superhero, primarily for less fantastic genres. Before the superheroes became movie stars, Ross was making them real on the comic book page.

Ross's first big splash was with *Marvels*, a fully painted, four-issue comic book series with writer Kurt Busiek, about photographer Phil Sheldon, an everyman who witnessed the birth of the Marvel Comics characters from the late '30s through the '70s. In Sheldon, Busiek and Ross created an accessible, fallible, and believable proxy hero for the audience—a man struggling with a constantly threatened and ever-changing world populated by god-like beings. Sheldon is there from the beginning, and Busiek and Ross revisited key events straight from the Marvel Comics canon. Sheldon's own skepticism and love-hate relationship with the "Marvels," combined with Ross' photorealistic art, keeps *Marvels* balanced on the fine line between accessibility and reverence. It was, perhaps, the most sincere and least pretentious of the self-aware superhero comics.

In that first issue, Ross' figures looked like they came straight out of an Edward Hopper painting—stiff and somewhat alien in places, but even more realistic in others. There seemed something almost posed about them, a quality that gave way to a naturalistic and softer look by the second issue, where he began to look like the Alex Ross we know today, combining real people with iconic and classic versions of superheroes. Ross began crafting an even larger project with writer Mark Waid while working on *Marvels*, a futuristic epic that featured all of DC Comics' biggest characters, called *Kingdom Come*.

Kingdom Come's future is one rife with urban warfare between factions of misguided superheroes, a world where collateral damage in America is as common as a war zone. After Superman goes into self-imposed banishment, other heroes follow, allowing a grim and gritty new breed to take over and push the world into chaos. The turning

point of *Kingdom Come* is Superman's return, inspiring other original superheroes to follow his lead, to set the current generation down correct path. By dressing them in costumes similar to their original versions, Ross makes the commentary that the originals are always the better version, with prototypical design elements running on everyone from Superman to the most obscure classic DC character.

While *Marvels* was an unassuming, postmodernist take on the superhero, *Kingdom Come* felt like a postmodern commentary on postmodern comics: the "good guys" could only really function when returned to their visual roots, and the "bad guy" superheroes were based off of the "grim and gritty" superheroes running rampant in 1990s comics. Considering coauthor Mark Waid's love of the classic material, as well as his return to traditional superheroics at a time that comics were "dark," it should come as no surprise. Ross has only wandered out of the superhero realm a few times in his over-20-year career. He doesn't dismiss going into other genres, but plans on sticking with what's fun for him. It's apparent that superheroes are where his heart is; he talks just as much about his love and thoughts on specific characters and comic books as he does the business end of comics.

"I've got to throw a mask or cape in there somewhere, because otherwise it's just a bunch of human beings. A staple of my work is to try to humanize things, but I need a touch of the fantastic to keep it interesting.

"It's all very open to negotiation, but in trying to represent the fantastic combined with the human, I had been holding myself back from doing more of the fantastic, because I feel like I've had to eat my vegetables before enjoying dessert. Now I feel like, 'You know what? I've eaten enough goddamn vegetables. I want all candy.' I've been in more of an all-candy phase," he laughs.

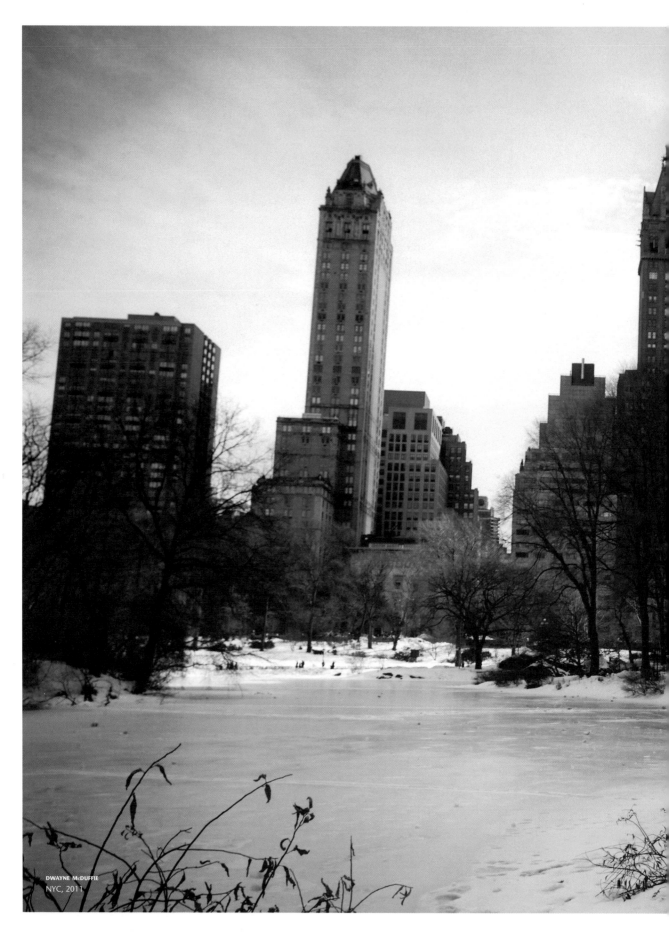

DWAYNE McDUFFIE
NYC, 2011

"I want to write stories about people,"
Dwayne McDuffie said.

"Things happen to people. I think my disappointment with the current superhero comics is that, mostly, they don't have supporting casts; superheroes only interact with other superheroes and supervillians; and they don't seem to have lives outside of their work. It's hard for me to connect, as a reader, to people who go out and save lives every week but don't have lives or have anything in common with me."

The irony of his career is that while comic books chewed him up and spit him out, he kept one foot in that world while distilling the superhero's essence down in several animation projects—something he didn't see coming back in the late '80s, when he entered as an assistant at Marvel Comics and grew into becoming a successful writer, teaming up with artist Denys Cowan.

"There had been a lot of conversations, generally in the industry, about controlling the stories and owning your characters," Dwayne reflected. "Another part of it was Denys and I both had an interest in doing multicultural characters, which was not a priority at Marvel. They didn't care if you did them or not, and wouldn't say no to it. Denys will tell you that, when he was an intern, the older black artists had talked about doing that fifteen years before. It just so happened that there was a window because (one) the industry was exploding and there was a need for more product, and (two) there was this general sense in the air that if you didn't work for Marvel and DC, you could go off and make a living doing your own.

"We got this gigantic royalty check for *Deathlok*, and I was like, 'Denys, I think we can afford to do this.' He called up Michael Davis and Derek Dingle, who is the unsung genius of the thing, because without his business knowledge we wouldn't have lasted more than a few months (like many other groups of artists who got together to come up with their own stuff). Derek's publishing experience comes from *The Wall Street Journal*, *Forbes*, and *Black Enterprise* magazine. He knew how to run a magazine and publication and taught us a bunch of things."

With McDuffie's editorial experience, Cowan's narrative power, Davis' roster of up-and-coming talent cultivated through his Bad Boys Studio, and Dingle's business acumen, Milestone's inaugural titles were *Icon*, about a Superman-like alien hero who landed in America during times of slavery, and was prodded into becoming a symbol by his teenage sidekick; *Hardware*, a man in a suit of armor built at the expense of the crooked

RIGHT

McDuffie's Hardware was, in the end, a frustrated creator like his writer.

Top: Art by J.J. Birch and Jason Minor, from *Hardware* #8 (Oct. 1993).

Bottom: Art by Denys Cowan and Jimmy Palmiotti, from *Hardware* #1 (Apr. 1993).

© 2012 Milestone Media.

employer he was contractually shackled to; and *Static*, a teenager with electrical powers who fought gangs in his schoolyard.

"Denys was a big fan of DC and had a good relationship with them. Jenette Kahn, particularly, wanted to do different kinds of comics. Derek was attracted to DC because they were a Time Warner company, and he saw synergistic possibilities."

Where Dwayne's Marvel work was all well-crafted and competent, it was with Milestone that his distinct voice really developed, his personal investment in characters that weren't being signed off to a major company shone through.

An unexpected collapse of the comic book market in the early '90s brought an end to Milestone, as well as several other smaller publishers, as comic book stores were closing down and the newsstand was diminished.

"Basically, we figured out the month when we would no longer be in profit, and gave the artists and writers that much time to finish up the stories. DC's feelings were hurt, and we turned all those books in and they were never published."

With the last bunch of Milestone issues still unpublished and sitting in a hypothetical desk somewhere, the dream seemed to be over. Or was it? Alan Burnett, a successful animation producer, sold Milestone character Static as a weekly cartoon to Warner Brothers.

Static Shock! already had the involvement of Denys Cowan as producer and it was inevitable that McDuffie come on board as writer. *Static Shock!* was his first foray into animation, after the disappointment of the dying comic book industry. The show not only aired for four years, but Dwayne won a Humanitas Award, and the show received four Emmy nominations (winning one for music). While it ironically didn't result in a job for McDuffie, it did lead him to one with the Cartoon Network's *Justice League* cartoon, a stint that redefined his career as an animation writer.

The vibrant McDuffie died unexpectedly on February 21, 2011 of complications from heart surgery.

"I think people take for granted how much stuff we actually did that started these trends," Jimmy Palmiotti says.

"We were just doing it because we were glorified fans who wanted to see some cool shit. It helped that Joe and I were actually guys who went out, met girls, and got laid. We weren't guys that were introverts or mama's boys, but just fanboys that made comics a little cooler. That helped everybody and comics' image."

Jimmy Palmiotti first made his big splash with his old friend and partner, Joe Quesada, in 1994. The duo had become one of comics' most noted penciller and inker teams, and finally decided to take the leap into self-publishing with their own Event Comics.

"We entered the self-publishing arena because we were frustrated with the lack of quality and care on a lot of the books we were working on," Jimmy recalls. "It wasn't a huge risk since we were doing well at the time, but looking back we could have just stayed with big names doing *Batman* or *Spider-Man*, but we chose a different path. Again, we'd never written a comic, so it's kind of bold that we chose to self-publish and write those books. Looking back, the writing on those titles wasn't great, but there is a unique energy that comes when people create something that they own. The best part of the books was Joe's artwork…very kinetic and beautiful. The guy's brilliant. The whole Event experience was a great learning process for us."

By late 1997, Marvel Comics had declared Chapter 11 bankruptcy, due to a rash of poor business decisions and a failing market. Marvel was in bad shape, and went to Jimmy and Joe for help. The experiment was a bold one on Marvel's part, but one that paid off, when they hired the pair to start their new Marvel Knights imprint. The imprint gave a branding to a handful of Marvel titles, primarily *Daredevil*, where Jimmy and Joe packaged the books into something slicker and (in some cases) darker and more progressive than Marvel had been doing for a while.

"We took over the penthouse on Park Avenue and had constant interaction with the company," Jimmy recalls. "We changed the way the books were being produced the three years we were there. For us, the coloring and production was important, and the stories got a little darker and a little more intense under our banner. At the time when we came in, a lot of the books were getting cancelled, and it wasn't a good time for Marvel. They figured they had nothing to lose with bringing us idiots in.

LEFT
Jimmy Palmiotti,
NYC, 2009

It actually worked out pretty good, as we got a lot of hype for the company, which helped out with the Chapter 11 situation…"

Their biggest coup was in approaching cult filmmaker Kevin Smith about writing a new arc for the relaunched *Daredevil*. With Quesada and Palmiotti on the art chores, Smith's "Guardian Devil" arc revived the noir of Frank Miller's run and married it to a coolness the book hadn't had in a long time. When Daredevil leaves the arch villain to blow his brains out in the last chapter, it was abundantly clear the Marvel Knights line wasn't playing around. "It definitely made us better editors because we always approached things visually," Jimmy says of the Marvel experience. "Even with the writing, we wanted stories to be told on a grander scale and the books to look much better than they have been. I think it has everything to do with us having our own idea of the potential for comics and how we didn't think it was being reached by their titles at the time. We pushed the envelope on just about everything. Whether it worked or not, it's okay, because we were pushing where other people were just gliding.

"Branding the line of books was a priority for us. It had a big effect on the way everything looked; even when we did our books, we had a separate logo and did a brand within the Marvel universe, which had never been done. They stood out and we found that retailers were telling us that if people bought one, they bought them all, because they felt they were getting in on something. We were out there. Joe and I did the commentaries in the back of the books, and went to the shows to talk to the fans. We went out there and

connected. People buying them felt that the people creating the titles were listening to them. It's something that needs to be done more everywhere. Plus, we put our faces and names on everything to show we were committed. Although it seems like an ego thing, we wanted people to identify that we were doing these books, and that they can trust us that they would be good books."

Jimmy and Joe were following Stan Lee's example and putting both their faces and personalities out there for the fans to see. "We did the fan model, because we felt it was right," Jimmy says. "Nobody was making a connection with the fans beyond a page in the back of the book. A lot of the fans, because we were creator-owned, were rooting for us to succeed. They felt, 'These are our guys.'"

The Marvel Knights were the superhero books that indie readers could go to and not feel ashamed of picking up. The use of Smith on *Daredevil* brought mainstream media attention to the book, just a few years before comic book movies increased the visibility of the characters.

Jimmy and Marvel Knights would part ways, and he'd transcend his roles as an inker and editor to carve out a niche as a writer, even making time as editor of new comic book company Kickstart Comics.

"Call it what you will, but in my world, it's been one lucky break after another," Joe Quesada says. "Some people say you make your own luck, whatever it may be, or maybe I was in the right place at the right time, but I have been very, very fortunate."

Now Chief Creative Officer of Marvel, Quesada's ten-year reign as Editor-in-Chief granted him his fair share of credit for renovating the House of Ideas after villainous investors and corporate suits were the landlords through the '90s.

"I use Stan Lee…as my role model, especially his public persona," Joe reflects. "There's a lot known about Stan's era, but I learned so much more from just sitting and talking to Stan and the amazing stories he would tell me.

"Stories about the wild, feverish creativity, publishing by the seat of your pants, and putting the best story possible out there, as well as the openness and inclusion of our readership—when I was reading Marvel comics as a kid, it all felt important. Marvel has the ability (and I think it's where we're unique amongst other entertainment companies) to pull the curtain back and say, 'There's no wizard, and here's the gears, and sometimes they get rusty and break down, but you get to see it. We don't hide behind a curtain, and you get to see more than any other company would feel comfortable in showing you.'"

A breakout artist of the '90s, Joe paired with friend and inker Jimmy Palmiotti and started their own Event Comics, an experiment towards their biggest success as a creative team. The pair took their savvy and experiences as a small publisher and applied it to running a fraction of one of the two largest comics publishers when Marvel Comics gave them their own imprint to edit:

"When Marvel gave us the imprint of Marvel Knights, we started running it like a small independent company," Joe notes. "What was happening, and I think this is very true with both companies, Marvel and DC: what money editors were spending on the artists' and writers' salaries on the books, *vis a vis* to what the sales on that book were, didn't come into play towards how they cast or marketed the book. They just did it."

LEFT
Joe Quesada, NYC, 2009

Tapping cult figure Kevin Smith for the writing chores on *Daredevil* was a revolutionary move that elicited media attention then unusual for comics.

"I keep thinking that if someday they ever decide to name this particular comics age, what would be the book that put the flag in the sand and say this is where it started? I honestly think it was *Daredevil* #1, and not because I was involved with it, but speaking from the moment the industry changed," Joe says. "I think Kevin Smith's coming into the world of comic books changed everything. There had been people in Hollywood who'd dabbled in it before. Kevin was making these small movies, but had such a huge public persona. He was on the net with fans long before others embraced it, and was a groundbreaker in so many ways, love him or hate him (and, frankly, I love him to death). It was revolutionary; with his coming to comics, it changed so much and opened people's eyes during a time that you could argue was pretty dull in the industry and everyone was looking for the one bright spot.

"So, to me, I think Kevin Smith saved the comics industry, I really do, and from that point on, other people picked up the baton."

In 2000, Joe Quesada was promoted from Marvel Knights to Editor-in-Chief of Marvel. Bill Jemas was named new President of Marvel at roughly the same time, and the pair rebuilt the company after turning the comics industry upside down, starting with dropping out of the Comics Code in exchange for Marvel's own rating system. A decade later, DC Comics and other publishers finally followed suit, killing the paper tiger that had burdened the comics industry for half a century.

As the 21st century kicked in, so did Marvel's cinematic presence, as a string of movies based on their characters performed gangbusters in the box office. With their production company in California, the Marvel movies featured mostly loyal representations of their characters and were the catalyst for Marvel truly becoming a multi-media entertainment company.

"Kevin Feige in our West Coast office [is] so respectful of the comic books and what we do," he states later. "He looks at us and goes, 'You guys are the source, you're the top of the creative pyramid. If you look at the financial pyramid, the movies are at the top, but if you look at the creative pyramid, the comics are on top. It starts there, and then trickles down.' That's what enables them to make the movies that they make.

"They do look at the comics, and the thrill and challenge for us with the Marvel movies, is making sure that the person who goes to see the movie, when they walk out of the movie theater, has had the Marvel experience."

Marvel's cinematic presence also caught the attention of Disney, who bought the comics company in 2009. Long rebranded as Marvel Entertainment, Marvel continues to work autonomously with their independent film and television divisions operating alongside publishing.

"Disney has told us that we are the shepherds of our own content and that's all-important," Joe points out. "They said, 'We like the comics you publish, we like the movies you produce, as well as the animation you're starting to create. We want you guys to do all that stuff and maintain your autonomy. Let us figure out how to expose this to a wider audience. Let us help you market it and utilize the Mouse's muscle.'"

The merger brought about a series of promotions at Marvel, including Quesada's rise to Chief Creative Officer, where he works across the ever-expanding divisions.

"The fact that we have so much going on is part of what led to my becoming Chief Creative Officer of Marvel," Joe says. "With so many irons in the fire and plates spinning, I spend a considerable amount of time creating and working on story and design ideas as well as being an intermediary between our studios, publishing division, animation division to make sure that all things Marvel remain all things Marvel. In truth, that's one of the things that speak to Disney's desire for us to retain our autonomy.

"Part of my job is synergy. While it's the go-to, all-too-often-used buzzword in business these days, it's really the only way I can describe it…A very large and considerable part of my job is that I am responsible for drumming up as many ideas and concepts as humanly possible for all divisions."

But at the end of the day, it all comes back to comics for Joe Quesada:

"The fun for me right now is that we're building business, reminiscent of when I took over as Editor-in-Chief: back in 2000, we were rebuilding the publishing division and recreating it in a more modern sense. This whole new landscape feels eerily similar. We're building a bigger, better Marvel that will hopefully expand the comics medium, expand the art form, and expand the characters for decades to come."

ABOVE

Quesada and Palmiotti's *Daredevil* brought a new dynamism to the old character. From Vol. 2, #11 (May 2000). © 2012 Marvel Entertainment.

"Any time I'm doing any kind of story or book, I think of myself as a storyteller first," David Mack says.

"Really, when doing a comic book, I think of myself as a writer first, and the art is another arsenal in the toolbox of writing. If you're not completely identified to a certain style or medium, it gives you that liberty as a writer to ask yourself of each individual project, 'What's the best way to communicate this particular story?'"

Mack jokes that he'd consider himself a Renaissance man, but it's not an unrealistic tag: he's not only worked in comics as a writer and artist, but has also written and illustrated a children's book, and established himself as a fine mixed-media artist. Working on so many levels was, apparently, something that only comic books let him pursue:

"In the graphic novel format, you can do anything, and hit it in an incredible way. It's completely open to your imagination.

"Comics allow that. They're the rock 'n' roll of literature, where they're not necessarily given a certain amount of respect, but they're this fascinating and exciting hybrid media. Rock 'n' roll isn't exactly one thing. It combined rockabilly and jazz and gospel—all this—and anytime it copies off of itself it becomes boring and stale, but anytime it pulls from outside itself, and absorbs that into what it's doing, it's conceptually vital. I look at storytelling in comics in the same way. When people are copying off of something already there and trying to make it look like that, it's not as interesting to me, but when someone is taking that interesting grammar that's already there and standing on the shoulders of those giants who have taken it there, but adding something new, it's taking it to the next step and adding a new and interesting vocabulary to the medium. That's when it's exciting to me."

Mack's comic book *Kabuki* started in 1994 as an Orwellian sci-fi comic, about a Japanese woman, Ukiko, who is also a costumed assassin fighting against the criminal syndicate she worked for. The story takes place amidst a society driven by its popular culture and media influences, and combines Mack's developing traditional comic art style with tinges of action and social commentary.

David wasn't planning on drawing the book at first, working with other artists to develop it, but he eventually took the plunge and drew it himself:

LEFT
David Mack, NYC, 2009

"I was so focused on the story part of it, and I felt other people could draw it better than me," David admits. "That story in the first volume, that ended up being very black and white, wasn't the type of work I was doing at the time. I was doing more mixed media and fine art type work, and there was a level of detail in there that I didn't think I'd be comfortable doing. I thought it'd make more sense if I just ended up writing it and being a part of a team with another person that could do great work. Even though the artists were all really good, it wasn't fully integrated to me. It felt like there was a difference between the story and art, and maybe it was a failure of mine to communicate it exactly through the script, but I just felt that something was missing. I started doing it myself, chapter by chapter, and it became its own thing, and the words and storytelling became indistinguishable."

In Mack's second *Kabuki* volume, *Dreams*, Ukiko is on death's door, collapsed and bleeding on her mother's tombstone. The stories are all Ukiko's thoughts, as she reflects on life and, especially, her late mother, a Kabuki performer. Mostly told in captions that are all written poetry, creating beats and rhythms of Ukiko's fractured thoughts. The artwork, rather than pen and ink, is mixed media that combines everything from watercolor painting to photography and even more collage, and is reminiscent of the experimental spirit of Mack's friend and mentor Bill Sienkiewicz.

Through the next two volumes, *Kabuki* undergoes its own narrative change. Captions aren't used as regularly, swapped out for thoughts written out in spirals and other shapes, behind or around characters. No longer illustrated in a myriad of techniques, *Kabuki* was now designed in a way that blurred the divide between conventional speech and thought devices (word, thought balloons, and captions), and the artwork.

As Joe Quesada was gearing up for Marvel Knights with Jimmy Palmiotti, he called Mack with the offer of drawing any of the Marvel Knights titles he wanted.

"I had just started a new *Kabuki* series at Image Comics that I was writing and drawing," David recalls. "For *Kabuki*, it takes two months an issue to do it. I was in the middle of that and said, 'First off, it's a dream to get this kind of call, but there's no way I could write and draw another story at the same time as drawing this. I have to fulfill this obligation first.'

"Joe said, 'What about if you just wrote?' I said, 'Perfect!' He gave me a call later and said Kevin Smith is writing *Daredevil* and Joe would be drawing it, and I

would follow Kevin Smith on *Daredevil* as the next writer with Joe."

The story, "Parts of a Hole," featured Mack's knack for descriptive first-person captions, something that fit with a character with heightened senses; the art by Quesada has an approach reminiscent of Mack's own. Mack and Quesada also collaborated on the painted covers, the fruits of which would be Marvel's gaining a new star writer in Mack's friend and cohort Brian Michael Bendis.

"I would send a layout and Joe would pencil it, Palmiotti would ink it, and then I'd paint on top of it. I would send them Fed Ex packages of painted covers back and forth. In one of those packages, I included a couple of Brian's *Torso* comics. Joe called me and said, 'Hey, Dave, what's this?'

"'It's my friend Brian's, and I wanted you to see some of his crime comics.'

"At the time, my way of saying it is that he didn't think Brian's art was right for Marvel, but he could write his ass off. 'Let's get this guy writing something immediately.' That's how that *Daredevil* started. It was Bendis' first script. He did that script, and it got him the offer for *Ultimate Spider-Man*, which was published first, because *Daredevil* was a little bit late when that project came out.

"It was amazing to be able to work with Brian, because this was '99 or 2000; we'd worked on a whole bunch of stuff together in '93 and '94, but it wasn't stuff we would tell you to go get," David laughs. "We were finally doing a project that we felt was worthy of our friendship."

BELOW
Mack employs a mix of media and styles in his work.
© 2012 David Mack.

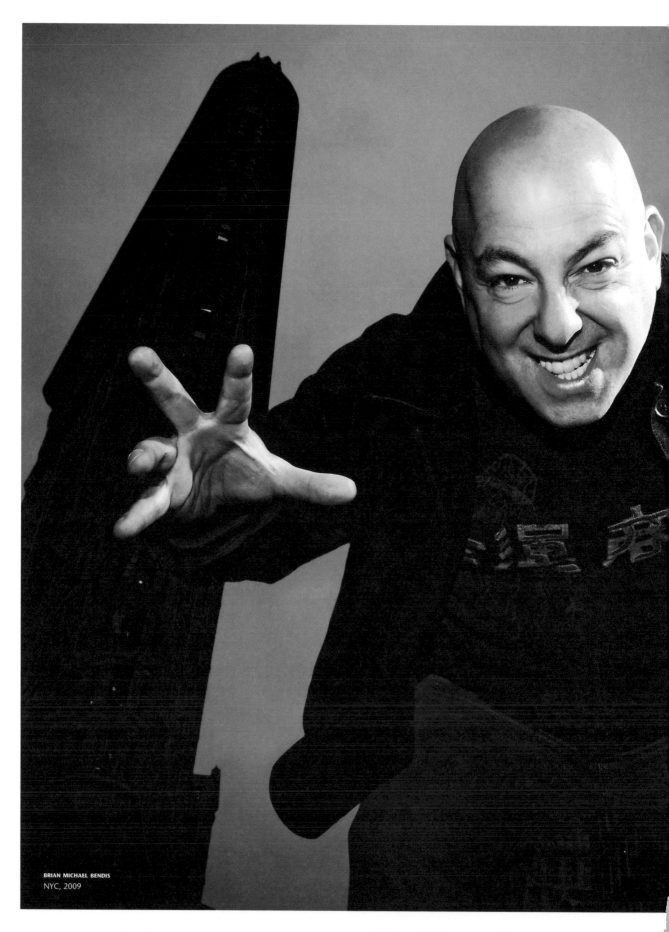

BRIAN MICHAEL BENDIS
NYC, 2009

"I asked myself, 'What do I have to add?' I like plays and I like when characters seem to be talking at each other rather than to each other because of a monologue," Brian Michael Bendis says.

"I don't like exposition-heavy dialogue, or if it's exposition, it's because one of the people in the room doesn't know what they're being told (which doesn't make it exposition anymore). It's very, very important to me.

"Could it be applied to *Spider-Man* and *Daredevil*? It may slow down the action elements of the story a bit, but that doesn't mean nothing's happening, because something just as vicious could be said.

"When you find things superheroes haven't done or seen before, or interactions or friendships you haven't seen before, that's gold, man."

Under Bendis' tenure, the Marvel comics have become more noir, as heroes question their own missions and clash over beliefs, and—every once in a while—the bad guys win. Bendis' stories are also smattered with chatty dialogue and a lack of third person captions; considering what a talkative and personable guy Bendis is in real life, it's not surprising. Much of his personal accessibility was inspired by his meeting his hero in comics at a convention—Walter Simonson—when Brian was only twelve. The affable Simonson continued to encourage and mentor Bendis through correspondence.

Bendis did grow up into a career in the comic book industry, cutting his teeth as a writer and artist at defunct black-and-white comics company Caliber on crime books like *Fire* and the more successful *Jinx*. In 1999, Bendis won the comics industry's Eisner Award for Talent Deserving of Wider Recognition, and decided to express his gratitude to the catalyst for his success:

"I walked up to [Walter] and told him what he did for me, and now I'd won an Eisner," Bendis reminisces. "I was waiting for the moment when I'd done something and could come up to him and say, 'You did this, you made this

RIGHT
Confrontations between Bendis characters even get violent verbally. Art by Alex Maleev, from *Daredevil* #50, Vol. 2 (Oct. 2003). © 2012 Marvel Entertainment.

happen. You changed my life.' I got him a little misty, and I'm very happy about that.

"He looked at me and went, 'You're not young, and you were twelve. Shit, I'm old!' We became friends. My whole life has been wanting to be Walt Simonson. I don't do a lot of [conventions], and with the Internet, I try to 'be Walt Simonson' on the Internet."

As Bendis cut his teeth as a writer on smaller press comics, he established an online connection with his fans, making him one of the earliest professionals to use the Internet as a forum for self-promotion.

His crime comic book *Torso* was shown to Marvel Comics' Editor Joe Quesada by artist David Mack, and Bendis was given two issues of *Daredevil* to write for Marvel, which led to a bigger and more defining job.

"Joe calls me up and goes, 'Hey, do you like Spider-Man?'" Brian continues. Marvel, hoping to gain new and younger readers, were ousting 40 years of backstory for a fresh and separate approach to their comics. Originally called Ground Zero comics, this new line was soon rechristened the Ultimate line, with *Ultimate Spider-Man* leading the charge, written by Bendis.

"With great power comes great responsibility' is ultimately the story that you're telling," Bendis reflects. "It wasn't broken, so you didn't have to fix it. I went about telling the story how we would do stories today: Uncle Ben originally died on panel sixteen because Stan and Steve only had about eleven pages to tell the story. When you read it, it's like a *Cliff's Notes* of this other story. I said, 'I'll write that other story, and not the *Cliff's Notes* version.'

"It's not enough to say, 'Uncle Ben's dead, let's be sad.' Let's make you feel it."

In the summer of 2000, the Ultimate line premiered with *Ultimate Spider-Man* #1 to much acclaim. *Ultimate Spider-Man* also established Bendis and artist Mark Bagley as a long-running creative team, clocking in at a full 111 issues together, eclipsing Stan Lee and Jack Kirby's legendary 102-issue run on *Fantastic Four* in the 1960s. The Ultimate comics line was an unexpected success, and continues to run today.

"We did everything we were supposed to do originally and got everyone off their ass," Brian notes. "Most of these weren't my idea: the recap letters page and the way the Internet was being used for the audience. There weren't the recap pages before,

that happened and then the writers could go ahead without having to worry about exposition. It absolutely changed the language of comics, without question."

While crafting *Ultimate Spider-Man*, Bendis was also becoming more firmly entrenched in *Daredevil*, eventually inheriting the title fully.

Bendis' run on *Daredevil* is indicative of a new breed of comic book storytelling: a long form structure where several issues are not only formulated as a larger story, but that larger story then feeds into another larger story—one that ultimately climaxes as the conclusion of an even bigger, overarching direction, perfect for the collected edition. While working on his 55 issue run on *Daredevil*, Bendis also inherited the superhero team book *The Avengers*, starting his run on the book by killing a team member and changing the book's status quo.

"There was no difference between what I did and a little kid coming up on the playground, coming up to a toy, and stepping on it. I did exactly the same thing: you don't know who I am, and I came up to you and popped your balloon with a pin. I kept doing it, for five straight months, and then I ended it. I had a great idea that I would direct my *Avengers* so that every reader is an Avenger. If you were sitting at the table with them, you were the one at the table, and were an Avenger. If I made you an Avenger, then I could sit you down at the table and blow your world up. It wasn't the nicest first thing to do to you as a reader."

But Bendis' cruel narrative act snowballed into steering the course of Marvel's line, cementing him as one of Marvel's main story architects.

ABOVE
As story architect at Marvel, Bendis devised *Secret Invasion*, which pushed the heroes into further moral gray area. Art by Lienel Yu, from #6 (Sep. 2008). © 2012 Marvel Entertainment.

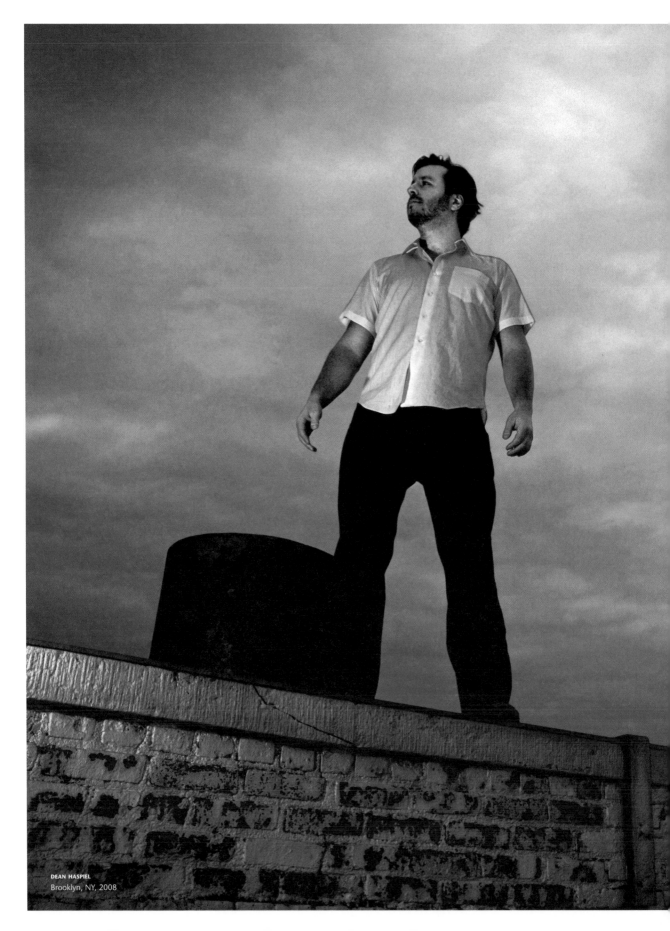

DEAN HASPIEL
Brooklyn, NY, 2008

"If I can explore who I am through a character, yet have that filtered and separated so that you can also hop aboard and think about yourself, it makes it the best type of story," Dean Haspiel observes.

"It's not about solutions, it's all about questions, and I think it's better to have more questions than answers."

Dean Haspiel creates beautifully oddball characters in his comics, whether fictitious, beatnik powerhouses or direct ciphers of himself. Truth isn't far from fiction in his work, because Haspiel, himself, is just as much a character as those he immortalizes on paper. Dean's work combines a modern sensibility with the established visceral power of Jack Kirby, and a dash of Will Eisner, along with a smidgen from his early mentors at Upstart Studios.

"I had a stellar 1985, hopping a subway after school to Upstart Studios in the Garment District on 29th Street," Dean recalls. "I walked into a studio that housed the talents of Howard Chaykin, Walter Simonson, James Sherman, and (at other times, before I entered), Frank Miller, Jim Starlin, and Alan Weiss."

"Pretty soon, I was working for Howard on *American Flagg!,* and doing some stuff for Walt Simonson on *Thor.* It was really cool to be working on stuff like that and then on my own comics at home."

After college, Dean and childhood pal Josh Neufeld teamed up for their black-and-white indie comic *Keyhole,* an anthology that featured autobio by both cartoonists, a genre they both excelled in.

"I think what was happening is that I was failing Marvel and DC Comics miserably, and deciding, 'Let me try to do something new on my own,'" Dean admits. "Josh and I were fans of *Eightball, Love and Rockets, Yummy Fur, American Splendor, Optic Nerve*—and we figured, 'If they can do it, we can do it.'"

An underground newspaper from the East Village, *The New York Hangover,* featured the

1995 debut of Dean's character Billy Dogma, a football-jersey-wearing bruiser with a swank girlfriend. Billy stood on the fringes, noble yet not bound by the rules or laws of society. His own experiences were stylized versions of Dean's own, as the overly verbose Billy expounded philosophy in a cross between jive talk and Beat slang. Billy had a good life in print, and made the crossover to the digital realm in the early 21st century, as Dean saw the potential in digital distribution early on in the life of the Internet.

Meanwhile, Dean joined up with Harvey Pekar, drawing stories in the *American Splendor* comic book, and also took the artistic reins of Pekar's autobiographical origin story, *The Quitter*.

"It's a daunting task to take Harvey Pekar's origin and turn it into a comic, especially because the guy basically writes a comics rant with stick figures," Dean admits. "I've got this page of scribbles, and thinking, 'Oh, my God, I have to turn this into a comic book. How do I preserve the integrity of his story?' What I told Pekar is that, 'I have to make the story mine, so that I can make it yours.'"

Harvey's story of his childhood in Cleveland, and his proclivity for old-fashioned street fighting is given the Haspiel touch… but a more advanced and sophisticated Haspiel touch, less flashy and more subdued than his earlier work, with maybe a bit more of an Eisner influence than a Kirby one.

"Harvey's the king of the mundane," Dean says of his collaborator. "He's doing the antithesis of the superhero by celebrating the common man. However, the more you read about Harvey, and the older he gets, the more unique and bizarre he actually *is* to the common man. He was one of the first guys to just say, 'I'm going to do a comic book about my everyday life.'"

The Quitter also put Dean more on the collective radar, allowing him to break out beyond the independent comics world, as his work started to crossover in the superhero one as well, for both Marvel and DC Comics, while he continues to flex his creative freedom as a cartoonist in the growing digital realm.

"I've been working to broaden my horizons and do some other work," Ben Templesmith says.

"I'm hopefully coming up with my own voice. I want to be known for the work I do, and mature into a career, rather than what I did that was made into a movie. The movie got me a career, and helped with name recognition, but you make your own luck."

The Australian-born Templesmith made his first waves as the artist on vampire comic *30 Days of Night* in 2002. *30 Days of Night* led into a feature film produced by Sam Raimi and countless spin-off minis, mostly engineered by writer Steve Niles. The pair's comic was the first for publisher IDW, and launched them into becoming one of the major contenders in the present-day comic book industry.

Ben hit his stride as a writer/artist with his smart-ass, supernatural *Wormwood: Gentleman Corpse.* Wormwood is, literally, a worm that possesses corpses and hangs out in a strip club run by Medusa when not battling an array of monsters. Wormwood doesn't go after monsters: they just have a nasty habit of finding him.

"*Wormwood* is all about having fun as much as anything, and I also like to take the piss out of the whole monster hunter genre if I can. I wanted to make it even more different and add my particularly quirky voice to it…and lampoon much of what others try to do legitimately! I wanted *Wormwood* to be the anti-monster hunter: he'd rather sit in a pub and drink a beer, but the trouble finds him instead of him having some goal. He doesn't say, 'I'm going to save them,' or some such shit."

Wormwood couldn't work if not for Ben's anarchistic writing tendencies, marrying the macabre with the absurd and creating a comic so wrong it comes right around to being right. Templesmith's art is deceivingly layered and intricate, his loose line work placing a focus on his sense of design, while gray tones are merged with transparent layers. The process is a marriage between traditional pen and ink techniques and modern-day Photoshop.

Ben Templesmith has had a great ride of a career so far, successfully adapting a distinctive style into various genres and approaches. And, with the emerging digital venue of comics and his involvement with selling his comics digitally, he has more up his sleeve.

LEFT
Ben Templesmith, NYC, 2010

BELOW
Templesmith's art benefits from both a glow and grit. From *Wormwood.* © 2012 Ben Templesmith.

"When you're telling something controversial and everybody embraces it, then you must've taken some shortcuts or made some mistakes along the way," Dan DiDio says.

"But if you try to expand it out so that you have so much reaction and they can't wait to see what happens next, then you've accomplished your job. The last thing we want in anything we do is apathy, and the last thing we want to see is that nobody cares. That's the easiest way to lose an audience, and not something we want to do."

Dan DiDio first made a splash in 2002, when he became Vice-President of Editorial at DC Comics, and ushered in long-form comic book series that redefined the status quo of the entire comics line.

"One thing that I tried to do when I first came in here was what we used to call the uber-story, or the big story: something that could underlay and bring the cohesiveness of the universe together and then move the entire universe together as a whole," DiDio reveals. "What I saw during my days in soaps is to try and build soap opera aspects—the highs and lows, interlocking characters, and then using them to tell the social sensibilities of the world and being able to use a set of different characters and putting the problems of the world on them, so you could see it through their eyes and get the scope of what people are feeling at the time."

Since his rise to editorial power at DC, Dan DiDio has managed to create a more cohesive comics universe, with intersecting characters and story elements, moving beyond the simple model of the trade paperback-geared monthly comic.

In 2009, DC Comics' parent company Time Warner AOL restructured the comic book company into DC Entertainment, in an attempt to bring digital and film aspects into a cohesive new company. DiDio was promoted to Vice President and Copublisher of Publishing, which is still the nucleus of the company.

LEFT
Dan DiDio, NYC, 2011

BELOW
DiDio has engineered the "uber-story," where story lines link together to create an overarching theme. © 2012 DC Entertainment.

"I feel that a book influences, and has as much of a contributing effect, on the story as the drawings, ink, colors, and paper," Chris Ware observes.

"To me, a book is a fairly obvious metaphor for a human body: aside from the fact that it has a spine, it's also bigger on the inside than it is on the outside, and it can harbor secrets. One can either be put off or invited into it depending on how it's structured and what's offered as the point of entry. It can affect how the whole story is felt. I like books. They're my life."

Ware is one of those rare people who pulls something deeper from the world around him, which makes him perfectly suited to cartooning and telling stories of human conflict.

"I don't think I really read superhero comics that much as a kid," Chris admits. "What I really remember was reading *Peanuts,* and laughing at *Peanuts,* and really loving *Peanuts*—essentially feeling a real connection to the characters. When I got into college, I started looking at turn of the century comics more closely."

While still a student at the University of Texas, Chris Ware received a call from *RAW* editor and *Maus* cartoonist Art Spiegelman, a call that came with an invite to publish in the pages of the cartoonist's lauded magazine.

"To suddenly pick up the phone and have him there on the other end of it was, well, shocking and flattering," Ware admits. "And most amazingly, 20-some years later—more than half my life—we still talk regularly and he's always very encouraging. Back then I'd send him recent work and he'd write back or call me and talk to me about it directly, though now we're more likely to talk about how hard it is to focus at the drawing table, our personal lives, and other young cartoonists whose work we find interesting. He's one of my closest friends and I owe him my life. The same goes for Françoise; I don't think cartoonists appreciate how much she and Art have done to legitimize what they do, and to go out of their ways to tell publishers and other writers about work they find interesting."

Spiegelman's influence was not only vital to the development of Ware as a cartoonist, but helped cement a personal and cartooning philosophy.

"I learned how to structure a page and how to think about comics in a language and

LEFT
Chris Ware,
Chicago, IL, 2011

not as a genre. I learned how to listen to what was important inside me and to think creatively, but not pretentiously—or even worse, too theoretically. Early on, as a kid, I thought comics were only either for telling adventure stories or telling jokes, but from reading *RAW* and *Maus* and his experimental work and via various things that he said or wrote about comics he changed my thinking, from the inside out."

Ware's breakout signature work, *Jimmy Corrigan: The Smartest Kid on Earth*, is a narrative exercise in memory, imagination, and how they intersect or conflict with real life. Jimmy started as a weekly strip for Chicago's *Newcity* and soon evolved into serialized form in Ware's series *Acme Novelty Library*. Taking five years to complete, *Corrigan* follows friendless loser Jimmy's quest to meet the deadbeat father (also named Jimmy, after *his* father) who'd abandoned him years before. Ware employs parallel timelines, weaved throughout the narratives as the memories and experiences of the Jimmies culminate in the meeting of the three. Dreams play as important a part, with sudden dream sequences offering glimpses into the characters' inner desires and torments. In *Corrigan*, Ware creates a sympathetic (and pathetic) protagonist, a well-meaning man-child dealing with a domineering mother and in need of a hero/father figure—be it Superman or his own father.

"I do believe that cartooning, a very memory-based art, has something fundamental to do with a constant sort of revision of ourselves and our lives, the same sort of resorting and refiling that goes on when we're dreaming."

Chris Ware's quest for perfection in his art is obvious: his ink line is mechanical, the lines of buildings and backgrounds painstakingly laid out by hand, the lettering still done directly on the art boards. The color palette of every Ware story is just as thoughtful and decisive a part of the story as the plot and the drawn aspects—all of it coming together into Ware's narrative music or language.

Jimmy Corrigan's collected form gave Ware a higher profile as it raked up the awards—ranging from industry awards like the Eisner and Harvey, to the American Book Award to being named one of *Time*'s "Ten Top Graphic Novels."

As Ware progresses with every new *Acme Novelty Library*, they've become more grand in scope, each one practically an individual interlocking graphic novel. "I think readers are already beginning to forget that what started as alternative or underground comics were just an imitation of the shoddy newsstand pamphlets but with different content and some timid format changes, if any. I was tired of that format and didn't want to work within it; I also wanted to set a precedent for other cartoonists to do whatever they wanted. Strangely, it made a lot of cartoonists angry, as if I was trying to ruin comics, or something. Some thanks!"

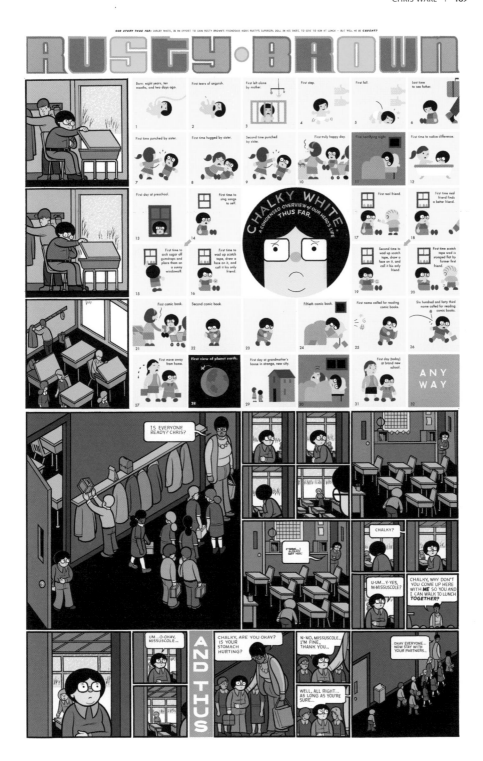

"For me, comics are uncertain territory, and that's why I feel I have to reach beyond comics to find my audience," Michael Kupperman says.

"People who appreciate my comics aren't just into comics, but more into comedy. A lot of the attention I've been getting in the past years has been outside of comics."

Kupperman's slick art, on display in *Tales Designed to Thrizzle*, has the polish and stiffness of old advertising art, creating a posed disconnect that adds a layer of absurdism to his offbeat stories.

"Ultimately, I'm trying to bring the joke," Kupperman admits. "So the art is not about trying to win awards, or for it to be attractive on its own merit: it's about making the jokes clear."

The off-brand and spontaneous humor was earlier cartooned on the fly, but Kupperman found it a "real hit or miss way to work," and switched to a tighter narrative plan with occasional improv. *Tales Designed to Thrizzle* colors pop culture with shades of naughtiness: there's little wonder that some people might not know what to make of it.

"I don't think it fits the model of what the people in publishing necessarily want to [see] happen," Kupperman admits. "The people publishing and editing comics in the past two decades have tried to equate comics with literature, which I think is a flawed approach: comics have their own strengths, and to try to make them the same as other art forms weakens them."

LEFT
Michael Kupperman, Brooklyn, NY, 2009

BELOW
Kupperman's *Tales Designed to Thrizzle* revels in the absurd. © 2012 Michael Kupperman.

PAUL POPE
NYC, 2008

"I feel like production is considered low on the totem pole, which is amazing to me," Paul Pope says.

"All this plastic and Styrofoam, people tend to undervalue objects. But it's so wonderful to make things. In that sense, I'm very old-fashioned. I like to physically make things, hands-on. I'm interested in craft and technique."

Emerging in 1993 with his self-published graphic novel *Sin Titulo*, Pope's comics ranged from an escape artist's dealing with death (*Escapo*) to the adventures of a teenage girl in a science fiction world (*THB*). Pope's art is a blend of styles and inspirations, with an unmistakable air of rock 'n' roll about them.

"I fundamentally did not believe I was a professional artist at that time, and didn't think I could get a job in the mainstream," Paul admits. "I was going to art school studying studio art and art history, and was really turned off by galleries and the pecking order of the art scene and publishing scene, but I was interested in materials and publishing.

"I picked up the rule, 'Publish a book about whatever you know, whatever you're good at.' What I'm best at is drawing, coming up with ideas, structuring an exciting visual story, and putting in the twelve-hour days to get the stuff done."

Those long shifts of cartooning paid off, as Pope honed his style through his own work like *THB*, or the cutie girl manga *Super Trouble* for Japanese publisher Kodansha (much of this work, oddly, never saw print). The infusions of different styles created an influence cocktail that included everything from comic books to literature. While working for Dark Horse Comics, in 1995, Paul's editor Bob Schreck put him in touch with another influence—this one becoming a personal one—Frank Miller.

RIGHT, TOP
Cover to *100%* trade collection.

RIGHT, BOTTOM
The oversaturation of sound effects and close camera shots bring the reader into the ring. From *100%* (2002). © 2012 Paul Pope.

"It's cool now, thinking about it, that we've been close friends for around a decade," Paul admits. "He's like a big brother, in a lot of ways he's like a mentor. One time, when we got lunch with Bob, those guys were talking about *Daredevil* and the work Frank did on it in the '80s, and it occurred to me, 'Oh shit, wait a minute. I'm friends with Frank Miller!' It's the only time I've ever felt a sense of being star struck by the guy. Normally, he's super articulate, he's funny, he's a very generous guy, and he's cool. We have a lot in common on different levels, and have a lot to talk about that isn't about the industry or future projects. That was an interesting moment of perspective.

"Frank has directed, and will probably direct again. He's a hybrid storyteller in a visual medium who can seamlessly go from paper to digital celluloid. Whereas me, I feel like I've gone back to the roots: I think a lot about Moebius, and Kirby, Guido Crepax, and Roy Crane.

"I'm a little more interested in being isolated and solo. To me, art is like spelunking in a cave, going down, and finding something undiscovered but familiar, and then bringing it back: that's what I want to do."

Kirby's brought back in Pope's work frequently, whether he's telling stories with Kirby characters like OMAC, or simply embracing his influence. Pope himself conveys "rock star" in a genuinely cool manner, so it's not surprising he places a music analogy on Kirby.

"To me, Kirby in a visual sense is like the blues scale," Paul reflects. "If you get into blues, there are a lot of different types of blues that you can play. In that sense, Kirby is like a blues blueprint, if you look at the components of comics as being like a musical scale. So you look at Kirby, and there are certain types of ideas you can convey using Kirby-isms, because he's done so much work and it's now very ubiquitous that if you reference a Kirby crackle and put it in a page, and even if you don't recognize that it's Kirby, you still at least recognize it for what it is. It's the language of comics, in the same way that if you play a certain blues riff it makes it like a blues song. That's the way I see him and that's how I use him."

If comics are music, then Kirby provides bass—present, but subdued on stage—in Paul's upcoming graphic novel series *Battling Boy*. Where *New Gods* was a mark of Kirby's creative maturity, *Battling Boy* is the same for the young but experienced Paul Pope.

"In a sense, it has that classic hero's journey, where there's a young god discovering his powers in a corrupt world," Paul says. "It's a very personal story, and is told using a rhetoric that is very familiar to people who read comics, with a lot of Kirby in it, a lot of Moebius, and a lot of the staging is Manga.

I wouldn't say that there's satire or camp so much as a humor in it—I'm not quite sure what the humor is, but there's something funny to me about a kid fighting adult monsters. That was my thought when I started this thing: Let me conjure a new superhero in an alchemical sense, and take personal experience and a love of comics, with drawing ability being the anvil, and let me try to forge something new here."

Battling Boy is coming of age in a time where comic books are frequently making the leap to movie screens, and is gestating between both storytelling mediums simultaneously, forcing Paul to spin both plates at the same time, while still stepping out to pursue poster art for rock bands, or even fashion design.

Regardless of the quality of artwork he produces, he has pushed the boundaries of being just a cartoonist of comic books and graphic novels…to being a blend of cartoonist, pop artist, and fashion designer. What Pope proposes is to eliminate the appropriation aspect to create full-blown popular art that happens to exist in a narrative manner.

"I think that the great thing with comics is that we haven't found our Jackson Pollock or our Hendrix yet. Or our James Joyce. When I was younger, I was interested in writing and performing music. But I feel like it would be difficult to do that: there's so much competition, and there has also been so much done in the field already. Comics haven't yet that level hit…For me; action painting is the final challenge for painting, when the demonstration is literally the paint being thrown on…

"I don't think we've hit that with comics yet, because it's such a craft-oriented art form, with at least pretty pictures or poetic words. I don't know about other cartoonists, but I feel very willing to keep away from the people who want to take comics into action painting, or all the people who just want to make money off comics."

ABOVE
Pope's limited silk screen print, *Napoleon*.
© 2012 Paul Pope.

ABOVE
Pope melded influences in the *Strange Adventures* strip in DC Comics' experimental *Wednesday Comics*.
© 2012 DC Entertainment.

BRIAN AZZARELLO
Chicago, IL, 2011

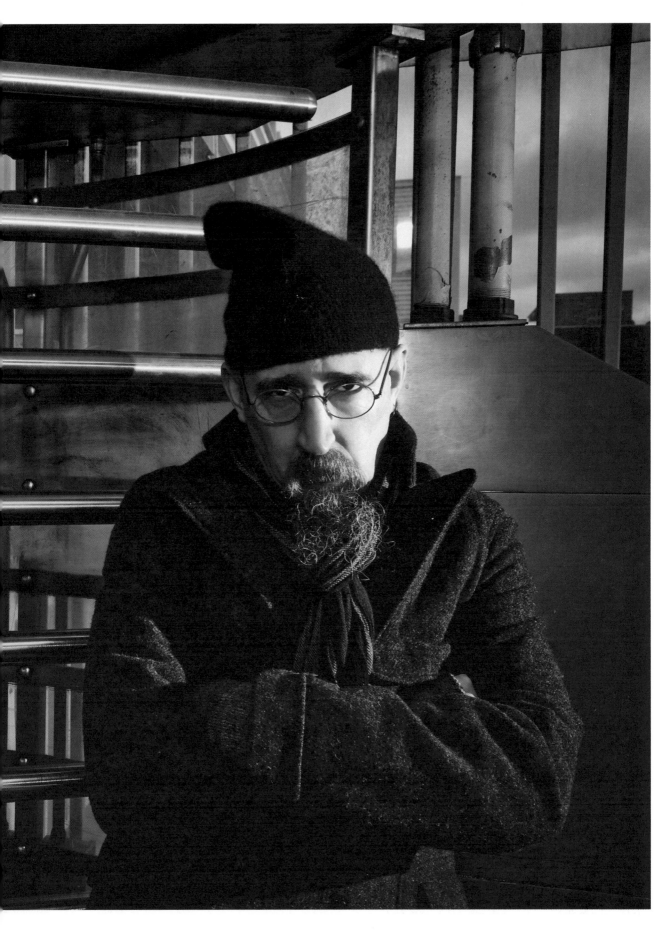

"I don't change my approach to anything, and I approach everything the same way," Brian Azzarello says. "To come up with a story that, hopefully, is different than what you expect."

Brian Azzarello is not just a crime writer, or a noir writer, or even a postmodernist superhero writer with deconstructionist tendencies: he doesn't like to be labeled, and just focuses on telling a good story.

"What makes a good noir story?" Brian posits. "Let me answer that for you: it's a great mistake." Keeping in the damnable crime/noir motif, for a minute, if Azzarello were in the interrogation chair with a light in his face, his short answers would frustrate the most patient cop. However, it becomes abundantly clear in a short amount of time—Brian Azzarello has thought out his work, and the craft of writing, so much that he's boiled it down to points. In short, he ain't talking much, but what he has to say is brilliant.

When he first pitched his crime comic *100 Bullets*, he left out the cobweb-like relationships between characters, and instead focused on the high concept: "I figured pitching what it really was was not a good idea, because it became a very complicated story," Brian confesses.

"But pitching the high concept? People can get their minds around that easily! A guy gives you an attaché filled with one hundred bullets, a picture of a guy who did an egregious wrong that ruined your life, and the ability to enact revenge. It's easy for people to relate, because everybody's had murder in their heart at some point." That's the basic premise of *100 Bullets*, a narrative slow boil that starts whistling loudly as early as its first year. Random characters are approached with a briefcase by the mysterious Mr. Graves, and they don't always succeed in getting their man (or woman). Like everything that's too good to be true, there are strings attached and conditions that come back and bite them in the ass. Running from 1999 to 2009, *100 Bullets* came in during the crime and noir craze, and redefined DC Comics' imprint Vertigo from focusing primarily on horror and fantasy to include crime and espionage. It also placed Azzarello amongst the ranks of Vertigo's second generation of writers, following Neil Gaiman and Alan Moore.

RIGHT
Eduardo Risso's art sets the perfect noir mood for Azzarello's subtle dialogue and pacing. From *100 Bullets* #13 (Aug. 2000). © 2012 DC Entertainment.

Argentine artist Eduardo Risso's thin ink line and liquid shadows give a distinctive noir look that makes *100 Bullets* a unique world visually as well as narratively. The artist worked on all 100 issues of the book with a translator on Brian's scripts and the two have become a rare thing—a long-running creative team.

"You know what separates Eduardo from a lot of guys working in comics, is the fact that he designs a page," Brian points out. "He looks at the whole page, rather than panel to panel."

Brian's plot for the issues of *100 Bullets* was planned out from the get-go, creating a cohesive narrative as Risso's panels come together to create a solid instance of storytelling. "I think that it holds together, because we were working towards a point where we knew where we were going," he says. "We'd reference these things early on in the series that would come back, and that made it more compelling."

"With historical fiction I can still sink my teeth into any emotional and spiritual themes I'm currently wrestling with, but can also have some proper distance," James Sturm says.

"I also like the challenge of making another era seem vital and real." After a stint self-publishing his comics in the late 1980s, working for Art Spiegelman on *RAW* in 1990, and co-founding Seattle's weekly paper *The Stranger*, Sturm emerged in the '90s as not only a brilliant cartoonist, but also a ground-breaking educator of comic book art.

The Golem's Mighty Swing cemented Sturm as a historical dramatist: the book garnered mainstream media praise that included Best Graphic Novel of 2000 by *Time*. *Golem* follows the Zion Lions, a Jewish baseball team of the early 20th century who perform under the pressures of anti-Semitism as they travel from town to town in a broken-down bus. *The Golem's Mighty Swing* uncovers a little-known period of old time baseball; watching the game on paper creates as riveting a dramatic experience as the most suspenseful crime comic.

"Coming from my background in comics, I was really inspired by the underground cartoonists and alternative cartoonists," he continues. "If you wanted to get published you make your comic and publish it, so I just took this mind-set to education and said, 'Why not just start a school?'"

The Center for Cartoon Studies, located in an old department store, boasts a modest student body of around 100. The small size is more a result of intentional design than limitation, especially when considering the streamlined curriculum that focuses more on "cartooning" than "drawing comics."

"One of the main philosophies at CCS is, from the first assignment, to have students create finished work. If I give a one-page assignment, the finished product will be 20 copies that are handed out for critique. If you want to be a cartoonist, you have to do the work: you can't just talk about your characters and plot, and research endlessly. You actually have to make finished pages and finish your comics. The assignments get more and more ambitious, and there's more and more room for them to explore their own personal obsessions and interests."

LEFT
James Sturm, NYC, 2010

BELOW
Sturm's pencils for a pivotal sequence in *The Golem's Mighty Swing*.
© 2012 James Sturm.

"The best way to grow as an artist is to do the things that are really difficult for you," Jessica Abel says.

"If you're doing things that are easy, you're improving those things but you won't be growing much as an artist. There are always going to be things that you're avoiding, and they'll become bigger holes in what you're able to do as time goes on."

Jessica has emerged in the past decade as a unique voice in comic book art education (with her husband, Matt Madden), and as one of the premiere female voices in comics. She started in the 1990s, when women became a growing and much-needed demographic in the ranks of professional cartoonists. It all started with a date, actually—a date with one of Pete Bagge's comic book characters from *Hate*.

"In his letters page, Pete Bagge ran this contest," Jessica reveals. "You could win a 'date,' drawn in the pages of *Hate* with his disgusting character Stinky by writing in. I wrote an exuberant letter about how much I loved *Hate* and I won the contest. Pete was coming to the Chicago Comic Con, and said, 'Let's meet up so I can draw you into the comic.' I was really excited about that, of course, and I met him at the Comic Con. "I was bartending at a café/bar and there was a jam comics night there once a week. I think Pete must have come to the bar at some point. I was being an obnoxious 22-year-old bartender, and that interaction of my being a bartender is what made it into the strip. At some point I was defending [the band] Babes in Toyland to Pete because he was running them down and I was planning to go see them, I think," Jessica laughs. "Not ready to defend them to the death, mind you."

The "date" appeared as a one-page strip in 1992's *Hate* #10, where Jessica picks up the obnoxious Stinky at the bar she works at, after arguing with him over the value of Babes in Toyland. Not only did the "date" result in Jessica's coming to comic book life via Pete's pen, but it also served as the catalyst for her to organize her first self-published comic book, *Artbabe*.

"I actually self-published the first issue *because* of it, because I knew I'd meet Pete," Jessica says. "I needed something to show for myself at the Comic Con, and I also knew that if I had something, he'd plug my comics in *Hate*. That's why I did the first issue and brought it with me to the Comic Con. I made fifty copies."

LEFT
Jessica Abel, Brooklyn, NY, 2011

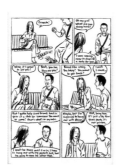

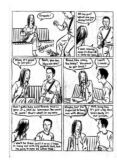
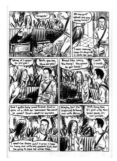

And *Artbabe* was born, Jessica's photocopied comic that graduated to professionally published with the fifth issue, the recipient of the Xeric Grant for up-and-coming cartoonists. *Artbabe* was picked up by Fantagraphics, publishers of Bagge's *Hate*. *Artbabe* continued through 1999, giving way to Jessica's landmark comic book turned graphic novel *La Perdida*.

"I'd wanted to do a longer and more ambitious, graphic-novel-length story," Jessica admits. "When I first started doing *La Perdida*, I thought of it as *Artbabe* Volume 3. In fact, it was solicited as *Artbabe: La Perdida*, although even then I knew I would collect it sometime, probably under its own name…But before I actually published *La Perdida*, I decided that I wanted to do a different format and title, and make a separation from *Artbabe*. Frankly, the title 'Artbabe' wouldn't really work on a book like *La Perdida*. It's too silly and snarky for a serious, dark book."

La Perdida was, in part, inspired by Jessica and Matt's two-year residency in Mexico, and follows the misadventures of American expat Carla, as she struggles to find a place as an American in Mexico. *La Perdida* starts off as a drama about a dysfunctional young 20-something, but quickly turns into something far more suspenseful and unexpected. *La Perdida* presents Jessica Abel as a more developed cartoonist, as she prefaced work on the book by painstakingly reinventing her style through exercises suggested by her husband Matt.

"I couldn't have done *La Perdida* without having done the stories in *Artbabe*," Abel says. "Each issue had one to four or five complete short stories in it, and that repetition, of narrative after narrative, building in length, was crucial to my development as a crafter of narrative. I'm proud of them still and am happy with how they turned out. But then, you can't learn about making a longer narrative without making one: you have to do it. *La Perdida* was my first long book."

But it isn't just Abel's art that makes *La Perdida* work: it's the underlying sense of pacing and composition in every panel.

"My main concern is telling a clear story, and I'm interested in complex characters with complicated and intriguing interpersonal relationships," she observes. "That the action that happens, grows out of character, is my main concern. As a visual artist, meaning when I'm drawing as well (which I'm not at the moment) my specialty is to draw non-verbal communication really clearly—facial expressions, body postures, and spacial proximity tell the story of the relationships non-verbally."

Abel and Madden have both firmly established themselves as distinct voices in the teaching of comic book art, as teachers at New York's School of Visual Arts. According to Jessica, it's SVA's dedication that makes it possible for them to inspire and direct the rising generation of cartoonists.

"The thing about SVA that's great for us as teachers and for the students is that it's a *comics program*," Jessica elaborates. "The teaching gets broken up into chunks, and each subject can be treated more at length, where elsewhere there might be just a single semester of comics available…It's a combination of technical teaching (we go over layout and lettering and basic technical skills) and this technical-minded thinking about structuring narrative, and testing out various approaches."

LEFT AND BELOW
Abel's process, from her graphic novel *La Perdida*. © 2012 Jessica Abel.

The pair have published the definitive textbook on comic book art—*Drawing Words and Writing Pictures*—and are following it up with a second volume. The couple also edits the annual hardcover collection *The Best American Comics,* where they work with a guest editor to select highlights from the comic book industry that year, and bolster the presence of comics in mainstream outlets.

"It's a book that has a wide appeal outside of the comics community," Jessica notes. "It's prestigious; this is a well-known series that has been around for close to a hundred years, so it's good for the artists to have that feather in their caps. I think it's important, too, for comics because people outside of aficionados will pick it up; it gets assigned in classes and ordered by libraries. It's a platform that we didn't have before, which is valuable."

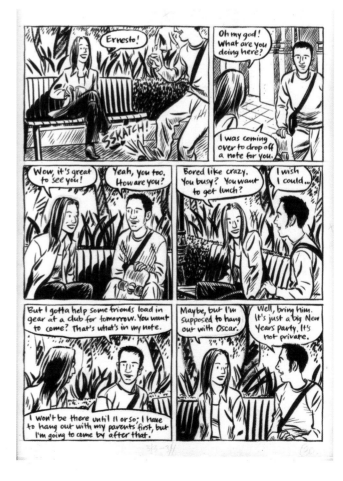

BRIAN WOOD
NYC, 2008

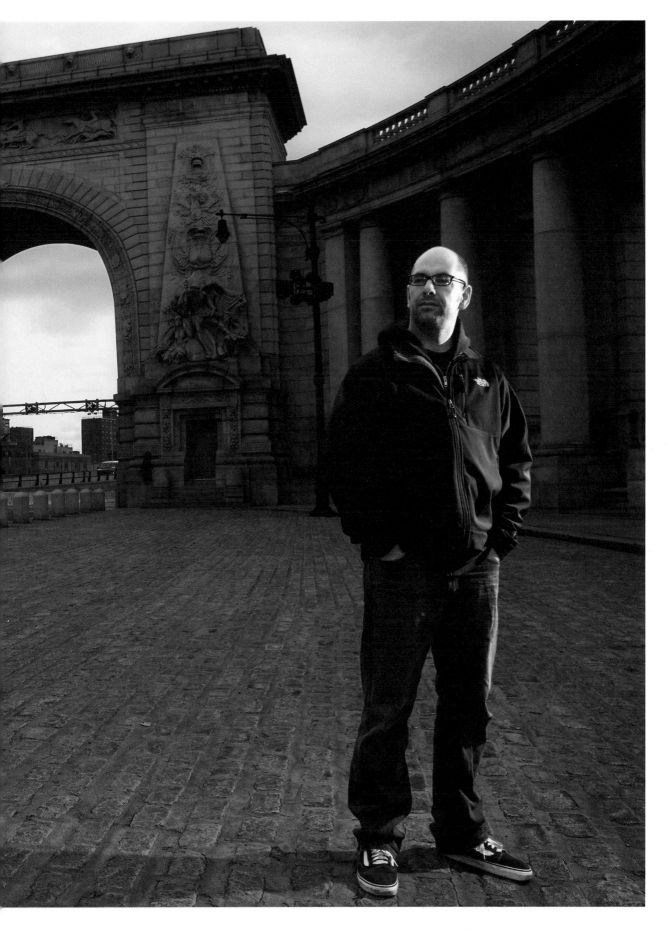

"*Demo* was when I was doing indie comics and not making any money at all," Brian Wood reminisces. "I knew that I wanted comics to be my job, my only job."

Brian Wood is guilty of being one of the most diverse comic book writers today: his characters firmly grounded in very real and human motivations.

With artist Becky Cloonan, Wood's 2003 anthology *Demo* is where his potential was unleashed in a flurry of twelve self-contained issues.

"*Demo* was born out of a marketing idea; I really wanted to remove all excuses I could think of for someone to not read the book. I'm talking format, here. With single issue stories, ones that are completely unconnected to the ones preceding or following it, a reader can 'jump in' at any point."

Each issue of *Demo* follows a different person with an odd ability. Starting out as a super-powered teenager book, *Demo* soon followed non-super-powered characters in a blend of everything from horror to humor to human interest.

"*Demo* was really where I punched above my weight," he states. "I think that in terms of my craft, and the risks taken, it's where it really paid off; I think that was where my career really changed and advanced in a big way."

Another of Wood's signature books is *DMZ*, a comic book thriller set against the landscape of a hypothetical future world with undercurrents of our own.

"*DMZ* is definitely meant to entertain more than inform, or rather, to use the tools of action-adventure entertainment to communicate its message," Wood reveals. "I want *DMZ* to be a book with mass appeal, and I truly feel that if someone is reading the book for the action and is choosing to ignore the allegory, that's totally fine with me."

The protagonist of *DMZ*, photo intern Matthew Roth, is stuck in the middle of America's second Civil War in the demilitarized zone that Manhattan has

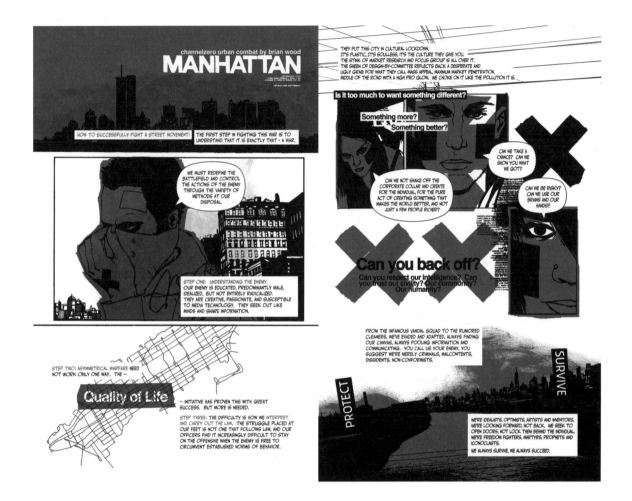

become. Left for dead by his network, Roth quickly learns the media and government's ulterior motives in selectively revealing and often misreporting the news.

"From day one, my editor and I didn't want *DMZ* to be preachy. I didn't want to present anything as 100% right or wrong or who's on the right or wrong side of the conflict in the story. I didn't want to favor any one side, but really highlight the fact that both sides do horrible things in war, and here it is, and leave the judgment up to the reader."

"I wasn't sure what I was going to do in college," Becky Cloonan admits.

"I thought I was going to be an animator, but then I dropped out. I started making mini-comics and bringing them to conventions. One of the first people I gave a mini to was David Mack. He read it, and thanked me for it. I was floored, here was a professional creator who I looked up to, and who thought my comic was worthwhile even though it was photocopied. It was great to feel like you're part of a community where everyone is pretty cool."

Cloonan has since gone beyond being just a Xeroxed ashcan cartoonist, and proven her diverse artistic chops with the successful 2003 comic book miniseries *Demo*. The series showcases Becky's special ability to mimic different stylistic approaches each issue, giving the impression of a different artist each story.

"I think the styles are the same, but the techniques that I use are different," she modestly says. "When we first talked about *Demo*, I knew it was twelve issues, and I knew there wasn't any way I could draw 300 pages consistently, so I went with different approaches to each story. I think Brian wrote each story with a different sensibility, so I approached the stories individually, as well."

The stories range from horror to drama to humor, and Cloonan's diverse hand works well with Wood's varying narrative voices.

Where some comic book artists tend to come across as one-trick ponies who are slaves to their set style, Cloonan has an arsenal of styles that come out per project. Her mini-comics may have started as a chance to get her work out there in the closeness of the comics community; as she started to gain work, however, she continued to do them as an exercise in form and sequential storytelling—for comics' sake.

Another noticeable thing about Cloonan is her natural cartooning ability. While many train themselves to illustrate comics, her work is intuitive and natural, with her focus on the narrative and directorial approach. Every year, she continues to explore new techniques and approaches in her mini-comics, despite the heavy workload of comics coming her way.

LEFT
Becky Cloonan, Brooklyn, NY, 2008

BELOW
A page from Cloonan's self-published *Wolves* (2011). © 2012 Becky Cloonan.

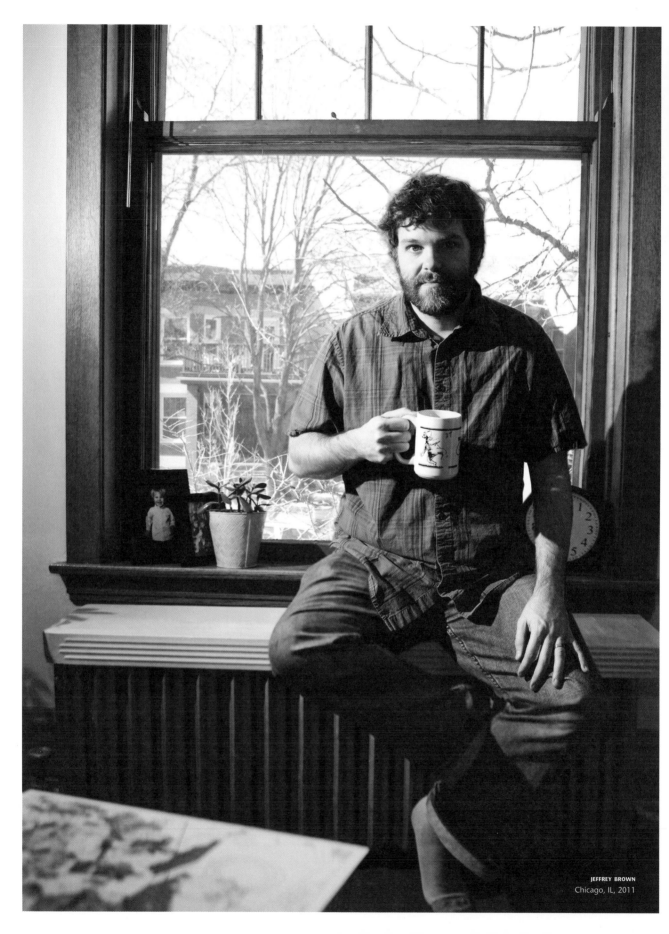

"At this point, the biggest factor in what I reveal now is in being aware of how many people are reading things," Jeffrey Brown says.

"My wariness of that is so much more heightened that I don't have any more ways to trick myself left. Before, I was doing it for myself and then happening to publish it. Now, I can't get that kind of distance. When I'm drawing it, I'm hyper-aware that at some point someone is going to see it."

Jeffrey Brown is deceptively talented: his comics work possesses the charm of a high schooler doodling his life experiences (or robot battles) in a ruled notebook, but he has a strong foundation in the fine arts. The pacing and foundation of his autobiographical or humorous comics are disarming in their seeming innocence.

"What it came out of was just being at art school and having all this build-up of everything I've learned and everything everyone else was doing—this whole big world was starting to weigh down on the actual making of art. Art wasn't fun anymore, and the most fun art was from when I was drawing comics as a kid. I was trying to get back to that," he says of his autobio work.

An encounter with fellow Chicago cartoonist Chris Ware at a book signing gave him the artistic direction he needed. Ware, particularly through his work in his own *Acme Novelty Library*, was redefining comic book storytelling, and developing a linguistic graphic connection between both words and pictures.

"He was looking at my paintings and looking at my sketchbook, and seeing things in my sketchbook and pointing out things that I was doing (that I knew I was doing) from a different perspective," Jeffrey says. "I think he saw, even though I wasn't drawing comics per se in my sketchbooks, that there was all that influence there. The things he was responding to in my sketchbook, I realized 'Oh, that's the type of stuff I love doing.'"

Brown's first autobiographical graphic novel, *Clumsy*, details a former long-distance relationship in snippets and vignettes, while his follow-up, *Unlikely*, details his first serious relationship. The originals are literally drawn freehand in small journals, possessing a spontaneity and energy that the most overworked artist can't achieve.

"The first few stories were in my head and I wrote them as I went," Brown says. "Then I started scripting the stories. I'd settled on the six-panel-a-page format, and I would write numbers out one through six, and then what was in each panel, and then draw the stories. Then I would do the next set. It was just straight ink, and no penciling or thumb-nailing beforehand."

Brown portrays himself as sensitive and anxious for the approval and acceptance of his girlfriend. It's all sincere, funny, and lacking drama in portraying the drama of a relationship. Brown followed it up with *Unlikely* or *How I Lost My Virginity*, which details his first serious relationship. Neither of those, or the third book *AEIOU or Any Easy Intimacy*, are told in chronological order, but synchronically in scenes short and long from his recollections.

"If I remember a moment that, on the surface seems insignificant, why am I remembering that very specific moment and not something else?" Brown says. "If I am remembering it, then there's some importance, even from the context of being in the relationship still, or having been in the relationship. I don't have the perspective to understand how relevant that moment is, or what it meant. I tried to pick those moments and put them in a context where, when you step back and look at everything, then you can see what the meaning there was, or why that moment is significant."

Where his mentor Ware produces his comics as a finished gallery piece of a book, Brown works in reverse, making each book as a singular work of art within a sketchbook and then reverse-engineering it into a mass-printed book. Despite his fine art background, he's jettisoning as much of that as he can to bring himself back to the sincere amateur artist, unknowing his critical training while letting his developmental do the work.

"On the one hand, it's trying to consciously discard all of those things that I've learned," he says of his comics work. "But on the other hand all that stuff ends up being there in ways that I don't realize. I feel like, as I make more comics, that there's a better synergy between those, but at the same time something is lost, where with drawing *Clumsy* and even *Unlikely*, I was so much less self-conscious about the actual process. I wasn't overthinking things, which I sometimes do now."

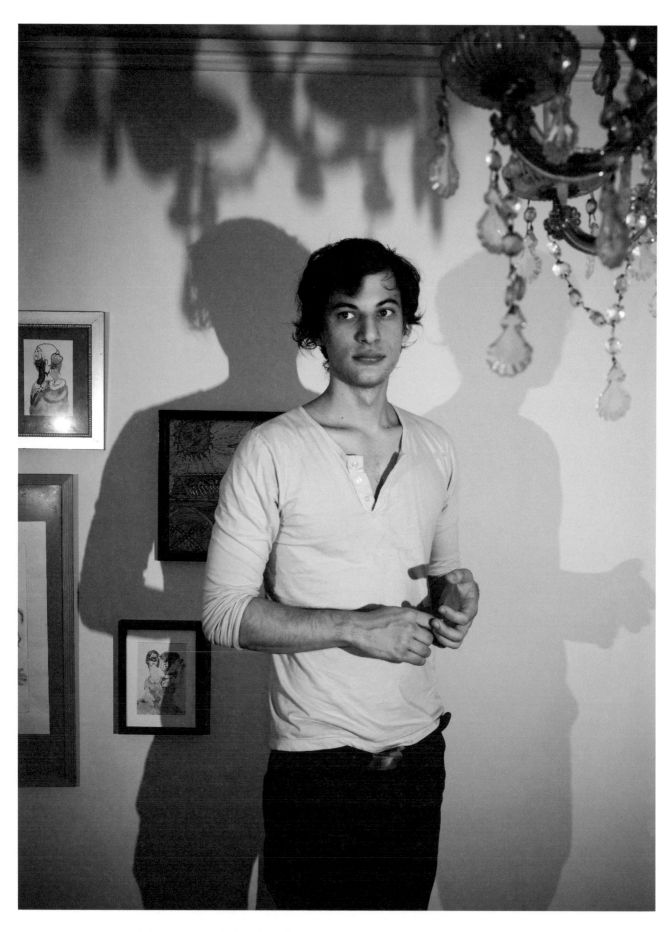

"I don't really like cities," Dash Shaw admits.

"When I draw comics, I try to transport myself to a place that's different from where I am. *Bottomless Belly Button* is a beach house area, and my webcomic *Body World* is in the woods, in a remote, experimental town where everything is built around parks. I don't like doing city-based stories, and don't really like being in the city.

"But," he admits, "I do like that New York has a lot of visual culture and different kinds of people. You walk down the street in New York, you see all different kinds of faces."

Having done a number of anthology collections, and graphic novels for small publishers, Shaw struck out in 2008 with *Bottomless Belly Button*, a brick-sized, 720-page graphic novel through Fantagraphics.

Dash went to SVA for sequential arts ("If I didn't get into SVA, I probably wouldn't have gone to college…" he noted) to learn the ropes. He left New York upon graduating in 2005, and made his way back a few years later in time to benefit from the release of *Bottomless*.

"It's not a long time, considering that was what I did every day. If you think about what you're doing between ages 22 and 24, that's when a lot of things happen to people. I just worked on that book, so that portion of life got a little looked over."

Bottomless Belly Button follows the reunion of a family on the eve of their elderly parents getting a divorce: while the older siblings have a hard time dealing, their sexually repressed brother loses himself in a doomed summer romance. The younger brother is arguably the focal point of the narrative: at the very least, he's the most relatable. The protagonist of Shaw's futuristic tale, *Body World,* is another conflicted outcast: Professor Panther, who finds himself castigated from a public school where he has been performing research…and becomes embroiled in relationships with both a teacher and a student.

"I did *Body World* more like a serialized story, and *Bottomless Belly Button* was written, then edited into sections, and was more of an intuitive writing process. And with *Body World*, I don't really edit, but complete section by section. What I'm hoping to do after *Body World,* is something I pencil all the way through, and then ink all the way through. I'm trying different ways of working that fits whatever I try to do. What would it be like to do a year of layouts, then a year of penciling; rather than doing it scene-by-scene? I'm trying different things."

LEFT
Dash Shaw, Brooklyn, NY, 2008

BELOW
Dash Shaw uses the tier layout to narrative effect, from his webstrip/graphic novel *BodyWorld* (2008). © 2012 Dash Shaw.

The Internet's rise to power in the 1990s is on par with the creation of the printing press by Johannes Gutenberg in the 15th century, both causing a widespread change in society and how we communicate.

As the Internet evolved, the comic book industry started to collapse; the two are unrelated, but would come to a head in the late '90s as cartoonists viewed the World Wide Web as a new and untapped means for distributing their comics, free of the shackles of censorship or expense of printing costs.

As we move into the second decade of the 21st century, comics still hasn't entirely figured it out. Chances are it will be an enterprising creator like the ones following, be they an established professional or a rising star.

"I was such a hard-ass about that when I started making them, back in the mid to late '90s, I actually drew them at 72 dots per inch, for the reason that I didn't want to be tempted to think of them in print terms," Scott McCloud says of webcomics.

"I wanted them to be able to work on the screen and the screen only. Now the screen's got a lot more resolution and some of those early comics are too small. Of course all my friends yelled at me about it, and I was like, 'No, damn it, this is just for the screen. This isn't a brochure for the printed comic.' I was very militant almost about wanting to not repurpose, and saying, 'If this thing is in one format, it will be designed for that format.'"

In 1998, Scott McCloud was one of the first cartoonists to openly embrace the Internet as a new distribution system for comics, as well as a platform for unlimited experimentation. McCloud regarded the Internet as an "infinite canvas" on which to experiment. Comic book panels didn't have to be structured in the same way as a page, and could technically go on for miles' worth of screen.

McCloud included a section on webcomics in his book *Reinventing Comics*, a follow-up to *Understanding Comics*. Released in 2000, it didn't take long for parts of *Reinventing* itself to become obsolete.

LEFT
One of McCloud's "old" webcomic ideas, from his personal website (www.scottmccloud. com) on June 2000. © 2012 Scott McCloud.

"I think the knock on the book would be that it's irrelevant or history has gone a different direction or left it behind," McCloud says. "But at the time it was really weird, radical, and confusing stuff. There were people in the business who'd thought I'd lost my mind."

But McCloud hadn't lost his mind. While not everything theorized and lobbied by Scott came to pass, he was prescient, as the Internet and digital distribution quickly grew.

"I've always been very egalitarian," Tom Hart says.

"I want people to make things and for that stuff to be seen. When the Internet started, I realized there was a whole distribution network that can exist, and anybody can get something out there. I always wanted to be an editor, or an aggregator. So I wanted to find talent, and find people who would want to have their work out there."

In 2000, Hart and a group of other cartoonists that included Nick Bertozzi, launched one of the first web comics forums in Serializer.net. Hart's social satire *Hutch Owen* developed on computer screens while most other cartoonists were limiting themselves to print.

"With every project I take on, I've wanted to learn something," Nick Bertozzi reflects.

"I've always had this idea of where I wanted to go with comics and that the comics I've wanted to make have been the ones I've wanted to read—they're intricate, complex, moving, they're funny, they're human, but they also ask a lot of odd questions, and also have quirky moments. With every project I've taken on, I've given myself a new goal, a new little chip off this giant block of comics."

Bertozzi has become one of the most thoughtful creators of the past decade; after doing too many comics admittedly aimed towards an audience, he discovered his holistic voice at the prodding of his roommate in the late '90s—cartoonist Dean Haspiel —and has continued through a series of unique and acclaimed projects since.

"He had quite a profound effect on my cartooning," Nick says. "Dean said to me, 'Stop drawing comics for an audience, start drawing comics you would like to see'…I started making comics that weren't filtered through what I thought an audience would want, but instead comics that tried to be a direct communication from me to an audience."

Nick's 2007 graphic novel, *The Salon*, started as a webstrip on Serializer.net, and was transformed into print soon after. *The Salon* combines a fantastic murder mystery with art history, permeating the wide-screen panels with Bertozzi's distinctive philosophies on art.

"I wanted readers to come to *The Salon* and even if they didn't like the content, they'd find the format would be pleasing to the eye. If they saw a page of a naked Picasso assaulting Georges Braque, they might be disgusted by that but think, 'Well, at least the page-layout is pleasing.' I put a little bit of thought in it but just that much."

LEFT, TOP
Tom Hart, Brooklyn, NY, 2009

LEFT, INSET
Tom Hart's Hutch Owen.
© 2012 Tom Hart.

LEFT, BOTTOM
Nick Bertozzi, NYC, 2008

ABOVE
A page from Bertozzi's *The Salon*, featuring a nude Picasso.
© 2012 Nick Bertozzi.

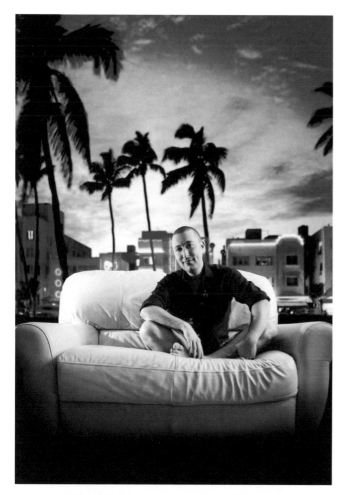

"I don't think digital comics replace books whatsoever," Dan Goldman notes.

"But all it does do, is allow the tentacle of the octopus to reach out to far more people that will come back and buy books when they're available. The opportunity to publish on both paper and digitally, exponentially extends the reach of your work."

After self-publishing within the tumultuous direct market, Dan Goldman teamed up with Dean Haspiel and an assemblage of other Brooklyn cartoonists to create ACT-I-VATE in 2006. This web portal viewed the Internet primarily as a promotional tool and launchpad for a published draft of their webcomics.

"Comics are well represented in a publishing industry that is failing; everything's going to have to change, and this is part of it," Goldman says. "We just got our literary credibility at the right time because, had it been a year or two more, the publishing industry wouldn't have had the strength to hard sell the media on comics being 'legit' as literature. That happened to us two or three years ago, for real. Now that the House of Usher is shaking down, we're all going down together. As digital and electronic solutions happen, we're in it together. We're not on a dinghy being dragged behind the ship, but we're on that ship, too. I think that's really significant and exactly how it's supposed to happen: whatever coming mutations publishing is going to go through, when it all comes out the other side, comics will be there, too.

"And that's all that matters."

"**What's really great about ACT-I-VATE,**" Dean Haspiel says, "is that I have a place where I can do whatever I want without editorial influence, where my work is being seen worldwide.

"As I'm making the comic every week, and until it's finished, I have a support system with not only my peers, but also with honest and immediate fan reaction. It's almost like a focus group for your comics."

After a healthy run in black-and-white indie comics, Dean took his bruiser character *Billy Dogma* off the printed page and onto color computer screens, merging the action-based tenets with personal, autobiographical ones. Dogma was no longer just Dean's flagship character, but his interpersonal mouthpiece, as well.

In 2007, DC Comics launched their own webcomics site, Zuda Comics. The strips on Zuda were formatted in a 4:3 ratio—a horizontal layout that fit the boundaries of a computer screen, as well as an iPhone—one that was more accommodating towards the new e-readers. Dean revisited semi-autobio with *Street Code*, his Zuda comic strip. *Street Code* follows Dean look-alike Jack Mack and his exploits and misadventures.

"The hard and fast rule to good semi-autobio is to impart real experiences as lived and observed," Dean notes. "The other thing about semi-autobio (and why I call it semi-autobio) is that my version of the truth and your version of the truth are both true, meaning we could go away and a week from now, could write about tonight, and it would be pretty close to my version, but different as filtered by your version because of how you saw things and how you experienced them."

In between *Street Code* and other projects, Dean remains an advocate of the webcomic, as he revisits *Billy Dogma* for further electronic adventures.

LEFT, TOP
Dan Goldman, Brooklyn, NY, 2009

LEFT, BOTTOM
Dan Goldman's webcomic *Red Light Properties*. © 2012 Dan Goldman.

ABOVE
Billy Dogma's digital life took him into new territory. From *Billy Dogma in Sex Planet*. © 2012 Dean Haspiel.

RIGHT
Telgemeier's charming
sense of pacing in *Smile*.
Scholastic Inc./Graphix.
Copyright © 2010 by Raina
Telgemeier. Reprinted
by permission.

BELOW
Raina Telgemeier,
Brooklyn, NY

FAR RIGHT, TOP
Kevin Colden, NYC, 2008

FAR RIGHT, BOTTOM
Colden's *Fishtown* cast a
sodium-like lighting over
its troubled subjects.
© 2012 Kevin Colden.

"I started putting a page a week up," Raina Telgemeier says of her webcomic *Smile*. "I had the first 20 pages or so mapped out and, in my head could say, 'Wow, maybe it'll be a whole hundred pages long. That's crazy!'

"Then it spiraled into a bigger thing than I thought it would be. It got to be more fun to write, because people were chiming in each week, and I realized I was creating something that actually resonated with some people. Readers were finding it because they'd been searching for 'braces,' 'dentists,' or 'orthodontics.' They were responding, too, and were saying things like, 'I had something similar happen to me, and it's great to read your story.' I realized there was actually a market for this."

Telgemeier's autobiographical comic was soon picked up as a graphic novel for publisher Scholastic, a publisher who reaches into the academic and young adult markets through book fairs and mainstream bookstores.

"It morphed from a day-to-day comic strip format into a graphic novel," Raina notes. "It flustered me for a little while, as to whether the format of *Smile* would work as a graphic novel, because there were beats and punch lines on every page."

Raina smoothed the beats out to create one of 2010's most engaging graphic novels, a coming-of-age story that is both sincere and heartfelt.

"I'd been talking to Dean Haspiel and Dan Goldman about *Fishtown* for ACT-I-VATE and also sent the Xeric application in, not thinking I'd win," Kevin Colden recalls.

His graphic novel *Fishtown* started as a webcomic, and was awarded the prestigious Xeric Award and grant for an up-and-coming cartoonist to self-publish. Webcomics were still a relatively new thing, and the Xeric Foundation saw them differently than traditional print.

"I had the chance with ACT-I-VATE to put it up, and it actually went up the day after I received the [award] letter from the Xeric Foundation. I went back and forth to find out if I could keep it online and print the first issue of the comic…I chose to go the online route because, at the time, I could sense that webcomics were starting to take off and that was where we were going into the future, as far as serializing comics goes."

"I told the Xeric Foundation, 'Thank you, but I need to go online.' And they said, 'You can still call yourself a Xeric winner.'" The Xeric Foundation soon changed their requirements, and later awarded the 2009 award to cartoonist Nathan Schreiber, for his webcomic *Power Out*, published on ACT-I-VATE.

Fishtown did see print in 2008, and Colden launched a new webcomic, *I Rule the Night*, through DC's Zuda Comics. The comic, a dark take on the Batman and Robin superhero and sidekick relationship, continued as a digital comic sold off of DC's digital comics application when DC canceled Zuda.

"I don't think the format's important," Michel Fiffe reflects.

"I'm personally married to the idea of newsprint comics, but it doesn't matter. Comics are the perfect vehicle for pure expression, because it's just you and an empty canvas, and a comic you can roll up and take anywhere and lend out is appealing, but if they go, they go.

"I think the only thing that will save comics are the ideas and content, not the specific formats, not the specific brushes you used, not the revisionist update of old lame characters, not the screenwriters from Hollywood. Comics are thematically infinite, and exploiting that potential will save comics."

Julia Wertz launched her autobio comic *The Fart Party* (recently renamed *Museum of Mistakes*) in 2006.

Unlike many of her online contemporaries, though, Wertz only posts a small percentage of her work online.

"What I keep in mind when I'm working on a project is the printed version," Julia notes. "I'll do about three to four pages a day (and I work every single day) and then I'll post maybe two comics a week online. Sometimes those comics have nothing to do with the book I'm working on, but I'll put them up. That's not fully representative of what I want my work to be: it's a way to keep online and keep in touch with people, and then put my effort into the printed books."

"It's impossible for me to imagine doing it [all at once] because I'd never taken on a project that was this long before," Josh Neufeld says.

The subject is his graphic novel *A.D.: New Orleans After the Deluge*. "I don't think I was capable of conceiving and writing what was essentially a novel, and draw it, in two years. Even though doing it online and serializing it that way was difficult, it made me produce, since every month I had to have a chapter done. I was building towards something."

The true story of a group of Hurricane Katrina survivors, *A.D.* was originally serialized for online magazine *SMITH*, and has since been reformatted for a hardcover format. Neufeld, whose career has mostly consisted of short stories and anthology contributions, found the discipline of a webcomic refreshing.

"When I put the book together, the book was structured slightly differently: it's in four segments rather than fourteen. I had to rejigger things a bit, and added a few more things to the story."

Like any storyteller, Neufeld focused on the narrative and dramatic beats of the piece. In *A.D.*'s case, it was in taking the effectiveness of an online comics experience, and refiguring it for print.

"I was able to structure things in a way that added emotional beats that weren't in the online version," Josh says. "Once I did that, it was a matter of looking through the book and seeing what parts of the characters' stories I wasn't able to tell earlier, because of time or because it wasn't appropriate at that moment. That new material would then go into the new skeleton I created for the book. Because there's 25% new material, and because its been reformatted, that in essence changed the emotional and dramatic beats in the original."

LEFT, TOP
Michel Fiffe, NYC, 2008

LEFT, CENTER
Julia Wertz, Brooklyn, NY, 2011

LEFT, BOTTOM
Josh Neufeld, Brooklyn, NY, 2009

ABOVE, LEFT
Like his mentor Steve Ditko, Fiffe embraces the weird. From *Zegas* © 2012 Michel Fiffe.

ABOVE, CENTER
Julia Wertz's cartoon avatar from her 2012 autobiographical graphic novel. © 2012 Julia Wertz

ABOVE, RIGHT
Neufeld's *The Vagabonds* chronicled his and his wife's travels around the world. © 2012 Josh Neufeld.

"I'm very interested in structure," Jason Little admits.

"There are some cartoonists for whom character is their main motivator, and they want to make characters that are real. The nuts and bolts of comics is what gets me excited."

The webcomic *Bee* has been the vehicle with which Jason has evolved, not just visually, but in his much-loved sense of structure. While several webcomics cartoonists might embrace the amount of site visits and other stats, and celebrate the instant feedback from their readership, Jason's more focused on the process of creating a graphic novel in weekly installments on www.beecomix.com.

"I'd said *Bee* is going to be flat coloring without any rendering, not much in the way of solid blacks, no shading, it's going to be four tiers per page (like *Tintin*), but split into a spread when put into a book. It's going to have that weekly strip rhythm where there's a cliffhanger or gag at the end of each episode. I'm feeling that I'm chafing against that, and am more interested in variety and experimentation, and possibilities of bringing in other drawing media. I just want to open it up every way that I can."

"There's a purity to it that really is people bringing their experiments and ideas and really putting them out there, for no other reason than to work out these ideas and create a story," Mike Cavallaro says.

Parade (with fireworks) is a human drama that documents a piece of Mike's family's history in Italy during the rise of Fascism in the 1920s. *Parade* was first posted as a web strip on ACT-I-VATE and eventually collected in the form of two single print issues.

"Increasingly, the model is becoming graphic novels, whereas an artist used to do a monthly comic," Mike says. "Now instead of doing 20 pages, you're doing 120 pages. You're in the trenches for about a year and you vanish, you're off the map. You're holed up in your own studio. Having a side project that comes out online, maybe as a weekly comic, enables you to tell the world you still exist and keeps your name out there. Ultimately, you're laying the groundwork that will help you promote your long-term project as well. It doesn't help for you to disappear for a year."

ABOVE, LEFT
Cavallaro illustrates the troubled narrator's inner thoughts, from *Parade (with fireworks)*. © 2012 Mike Cavallaro.

ABOVE, RIGHT
Mike Cavallaro, Brooklyn, NY, 2008

"I think it would be a great way to draw people in with that sense of old comics as well as emphasize the physicality of these ephemeral, decaying pages," Joe Infurnari says of *The Transmigration of ULTRA-Lad.*

"I also enjoy the fun anachronism of having a new character and comic idea presented to look old and do it on the web. You have a web comic that looks like it was printed years ago."

Joe hopes to bring *ULTRA-Lad* full circle and put it in actual print, aiming for about a 120-page count by its conclusion.

"My approach is to generally prepare them as if they're going to be a book, and then save them out for the Internet," he reveals. "They're all imaginary books that are going on the web, and I just make them as though they are. I also like thinking, 'What would this look like as a book?' I guess I'm kind of old school and perhaps even a little nostalgic to assume print will be the final destination."

"I love how since I'm doing it myself I don't have to make it family friendly or give it a clichéd plot with a love interest and happy ending," Molly Crabapple says of her webcomic *Backstage.*

Her collaboration with writer John Leavitt, is a murder mystery that follows the murder of fire breather Scarlett. Molly's art is a love letter to the turn of the 20th century.

"Years ago, back when Zuda was starting, they came to me and said, 'We would love for you to submit something to us about burlesque,'" Molly recalls. "They didn't end up going for our proposal, but me and John had gotten really attached to the characters and didn't want to throw them out. I loved what Dean Haspiel was doing with ACT-I-VATE, so we decided to submit it there."

"That was my first piece of comics journalism and eventually I'd love to have it in a collection," Sarah Glidden says of her web comic *The Waiting Room*, which documents the plight of Iraqi refugees in Syria.

"This is what I want to do: in between the big projects (and while working on the larger ones), have these smaller pieces of comics journalism that I'll keep doing. They're really, really satisfying to work on. I enjoy them a bit more than working on a book. Maybe eventually I can drop the book thing."

Glidden made her splash with *How to Understand Israel in 60 Days or Less*, her 2010 graphic novel that detailed her personal quest to Israel. Honest, fair, and cleanly drawn in thin line with soft water colors, *Israel* was her first step towards using comics as memoir.

"I think that if you're fascinated with what's going on in the world and with other people and their stories, then journalism is the way to go. I love reading novels and love fiction, but pulling a story out of my head seems almost impossible to me, and there are so many interesting people and stories already in the world that I wanted to find out as much about as possible, and find out how the world works. Using comics to tell those kinds of stories is a dream job."

LEFT, TOP
Joe Infurnari, Brooklyn, NY, 2009

LEFT, CENTER
Molly Crabapple, NYC, 2008

LEFT, BOTTOM
Sarah Glidden, Brooklyn, NY, 2011

ABOVE, LEFT
Infurnari's *ULTRA-Lad* tells an adult story through the lens of old comics nostalgia.
© 2012 Joe Infurnari.

ABOVE, CENTER
© 2012 Molly Crabapple.

ABOVE, RIGHT
From Glidden's 2010 memoir of her cultural journey.
© 2012 Sarah Glidden.

"I think anytime you're working with any kinds of restrictions it is often a benefit, because you become more creative in terms of trying to get across what you want within the confines you're working in. Imagine a boxing match on a dry lake bed?" Leland Purvis laughs.

"It'd end up with one guy 20 feet from another and both walking the same direction. Nothing would happen. You've got to have the confines in order to have anything happen."

"Recently, lines are blurring between what's destined to be online and what's to be print," Matt Madden notes.

"Like with my recent short story *The Others*, more people are probably reading it on iPhones using Panelfly than in print, so does that make it a webcomic? It's ultimately irrelevant as it's legible and works well in the platform."

"Even in the best of circumstances, comics are a slow process, and I think every cartoonist has a backlog of books that they would do if they had the time to sort it out," Madden says. "I am starting to look at each of those ideas and ask if they're anything I can tinker with, where the format would be appropriate to electronics."

"At some point, I might like to do something that only makes sense as a webcomic, and where the fiction of it has to deal with it being a digital reality."

"Because of the way ACT-I-VATE works, you have an audience that responds," Simon Fraser says.

"You get immediate feedback. As an artist you kind of feed on that, if not actually feeding your stomach. What started out as a 48-page graphic novel is now becoming a hundred-page web comic. I think I have something that's much better than what it started out as. I look at the original script, and it's really just a sketch. What started out as a proof-of-concept project turned into a much more personal thing. My own obsessions and worldview came in; traveling, parents, love in its many forms, trust. All the things I feel strongly about."

ABOVE LEFT
Fraser's *Lilly MacKenzie* found print life in British comics magazine *2000 A.D.*
© 2012 Simon Fraser.

ABOVE
Simon Fraser, Queens, NY, 2008

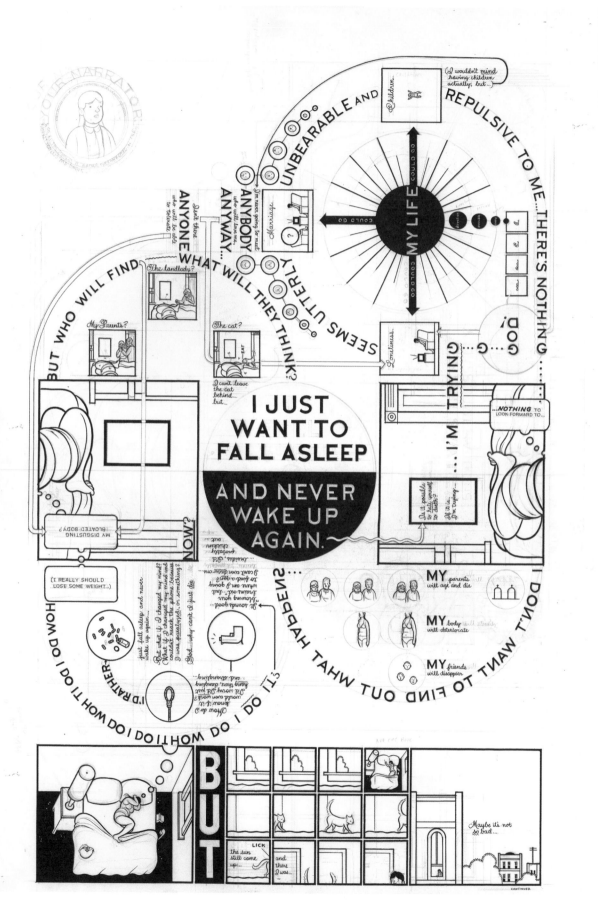

"I think there's a place both for books and for digital content," Chris Ware says.

"I read the news on the computer and the iPad every night; it's the perfect tool for news. I come from generations of editors and I love newspapers, but it's absurd to waste resources on what is essentially the rapid movement of information, especially when that information is changing by the second. If there's another terrorist incident in America, is everyone going to be standing around waiting at the newsstands for the evening edition?"

Ware believes in the book as object, creating an art piece that is the sum of everything from cover to cover (and in between), during a period where digital printing and distribution is quickly on the rise.

"I really admire Apple's design, and feel that the general idea and driving principle behind it, almost since their inception, is to make information tactile. They're finally getting to this point now where one can manipulate information with the hands and the body. As designers, they're also so sensitive in ways that I don't think any other computer makers understand, as their chief designer knows it has to do with very measured, combined subtleties of tactility and weight and gesture and materials. In a way, they're almost a 19th-century company, more sensitive to the world of nature than to technology, or at least respectful of it. I can certainly see reading comics electronically, with the possibilities for inter-penetrability of story and image, but I think comics will have to develop into something completely different before that happens."

"Really, I love paper and I love books, and one of the aspects of comics I find so compelling is the illusion of movement produced by drawings printed on an inert substance—but if the medium isn't inert, the illusion is broken. The disappointment would be akin to going to a movie theater and being forced to sit through a slideshow. In short, what's the point?"

LEFT
Chris Ware's treatment
of comics as a language:
"Building Wake Up" from
Acme Novelty Library.
© 2012 Chris Ware.

Photo by Chris Guzman
(www.cspinfilms.com)

Christopher Irving is a pop culture historian with a concentration in the American comic book. A veteran of comics history and journalism magazines like *Comics Buyers Guide* and multiple Eisner Award-winning *Comic Book Artist* (where he served as Associate Editor), Irving combines new journalism with comics history to create personality essays on comic book creators. *Leaping Tall Buildings* is Irving's fifth book on comic books. Irving currently edits digital comics magazine *The Drawn Word*. **www.thedrawnword.com**

To my father, Elliott Irving: You were there for the beginning and I know that, somehow, you're here for the end, holding a copy in your heavenly hands. To my mother, Janet Breton: Thanks for stepping up to do the work of two parents after we lost Dad. —Christopher

Photo by Carlos Molina

Seth Kushner's portrait photography has appeared in *The New York Times Magazine, Time, Newsweek, L'Uomo Vogue, The New Yorker* and others. He was chosen by *Photo District News* magazine as one of their 30 under 30 in 1999 and is a two-time winner of their Photo Annual Competition. Seth's first book, *The Brooklynites*, (with Anthony LaSala) was published by powerHouse Books in 2007. Currently, Seth is working on CulturePOP Photocomix, and profiling real-life characters on ACT-I-VATE.com and WelcomeToTripCity.com. Seth resides in his hometown of Brooklyn, New York with his wife, son and way too many cameras and comics. **www.SethKushner.com**

For my dad, who gave me my first comic book. My mom, for storing my collection. My wife for putting up with my Wednesday shopping sprees. My son, who will someday inherit it all…and hopefully organize them. And, to all of the above for their continued love and support.—Seth

Published in the United States by powerHouse Books, a division of powerHouse Cultural Entertainment, Inc.
37 Main Street, Brooklyn, NY 11201-1021
telephone 212.604.9074, fax 212.366.5247
e-mail: leapingtallbuildings@powerhousebooks.com
website: www.powerhousebooks.com

First edition, 2012
Library of Congress Control Number: 2011946061
Hardcover ISBN 978-1-57687-591-9

Printing and binding through Asia Pacific Offset
Book design by Eric Skillman,
with thanks to Kayla Carpitella
Dean Haspiel: Creative consultant
India Kushner: Art coordinator
Jared Gniewek: Proofreader

A complete catalog of powerHouse Books and Limited Editions is available upon request; please call, write, or visit our website.

10 9 8 7 6 5 4 3 2 1

Printed and bound in China

 powerHouse Books

ACKNOWLEDGMENTS

Thanks go out to everyone who took the time to be featured in this book and/or on www.nycgraphicnovelists.com, but especially to Dean Haspiel, who served as our sounding board and always gave his encouragement and two cents through *Leaping Tall Building's* development. Huge kudos also go out to Jimmy Palmiotti, who went to bat for us more times than

we can remember, and Joe Quesada, who graciously made time for us (a few times) while running an entire comic book company. Rich Fowlks was a real trooper in designing and tweaking our book pitch. George Khoury and John Morrow gave us permission to use George's Jim Lee interview. Jared Gniewek expertly combed over the final draft for that extra polish. And, of course, there's Dan Goldman who gave us not one—but two!—titles.

Thanks to Simon Fraser, Irwin Hasen, Joe Kubert, Mike Cavallaro, Kevin Colden, Anna Lombardi from La Repubblica for giving us European exposure, the crew at powerHouse Books (Craig Cohen, Daniel Power, Wes Del Val, and Will Luckman), and Joe Monti for securing us our deal.

For help securing subjects, thanks to Kris Adams, David Hyde, Adam Philips, Joanna Gallardo, Kristan Morrison, Kimberly Cox, George Belliard, Mike Chen, David Mack, Beth Fleisher, Eric Reynolds, Alex Cox, Amy Franklin, Darren Passarello, Steve Saffel, and Cynthia Von Buhler.

For help securing art, thanks to Gregory Pan, Lorraine Garland, Jon B. Cooke, Melissa Dowell, Sal Abbinanti, Allison Binder, Leigh Walton, Marilyn Small, Denis Kitchen, Sarah Delaine, Michael Kelly, Jamie Parreno, Stacey Kitchen, and Jo-Ann Belisle.

For media promotion, thanks to Heidi McDonald, Geoff Boucher, Whitney Matheson, Jennifer Contino, Brian Cronin, Arianna Rinaldo, Andy Serwin, and Dirk Deppey.

Christopher: To my mother, Janet Breton, and my niece, Taylor Marie—I couldn't have done this without either of you. I also want to thank Elise Ignatz Cat, Darlene Elkanick (who saw me through many hairy deadlines), Lili and Vyvyan, my family (Ryan and Caroline, Meagan, Shaun and Christy), Joe Sinnott for his ever-present stubborn Irish guidance, Ian Fischer, Christian Guzman, Michael Clayton, Dalfonzo Williams and family, Linda Armes, Andra Passen, Pocho Morrow and Gray's memory, Tom De Haven, Patrick Dodson, Dr. Thomas Inge, Dan Herman and Louise Geer, the rest of the crew at Hermes Press, Ethan Young, Jon B. Cooke, Reilly Brown, Tom Brevoort, Laura Lee Gulledge and Kurt Christenson, Dan and Louise Herman at Hermes Press, Bruce Evans, Greg Tumbarello, Bob Schreck, Jared Gniewek and Anne Zakaluk, Claudette Visco, Mike and Laura Allred, Abbot and Beth Street, Johnnie Walker, Mark Siegel, Karen Green at Columbia, Mark Waid, Cindy Jackson and Ray Bonis at Virginia Commonwealth University, and Beth Fleisher.

Finally, to my family in New York: Greg and Jennifer Mitchell Mayer and Olivia, Electra, Elijah, and Lola; and Corey Hall, for being the cooler younger brother I never had.

Seth: Thanks to: Jeff Newelt for his support and continued social media advice. Martin Cuevas for holding my flash. India Kushner for art gathering. Howard Wallach for always being there.

To Carlos Molina, The Slipper Room, Lucky Cheng's, Rodeo Bar, Dr. Jack Sherman, and Keith Mayerson for help with locations.

Special thanks to Jacob Covey, Harvest Moon, Todd Hignite, Lauren Weinstein, Ben McCool, Dave Roman, Leela Corman, Alex Robinson, Nathan Schreiber, Gabrielle Bell, John Cassaday, Miss Lasko-Gross, Nikki Cook, Ben Katchor, Evan Dorkin, Christine Norrie, Kat Roberts, George O'Connor, Gahan Wilson, Mike Dawson, Tim Hamilton, Nick Abadzis, Katie Ryan, and Kristy Caruso.

Chris Ware's pencils, Chicago